DRAWING FOR
PRODUCT DESIGNERS
KEVIN HENRY

Laurence King Publishing

Drawing for Product Designers

Published in 2012 by
Laurence King Publishing Ltd
361–373 City Road
London EC1V 1LR
Tel: +44 20 7841 6900
email: enquiries@laurenceking.com
www.laurenceking.com

Reprinted 2013, 2014 (twice), 2015, 2016, 2017, 2018

A catalogue record for this book is available from the British Library.

ISBN: 978 1 85669 743 9

Series and book design: Unlimited
Project editor: Gaynor Sermon

Printed in China

Author's dedication:
**To my wife Doro for such long and unbending love and to
my daughter Klara for the joys that only children can bring.**

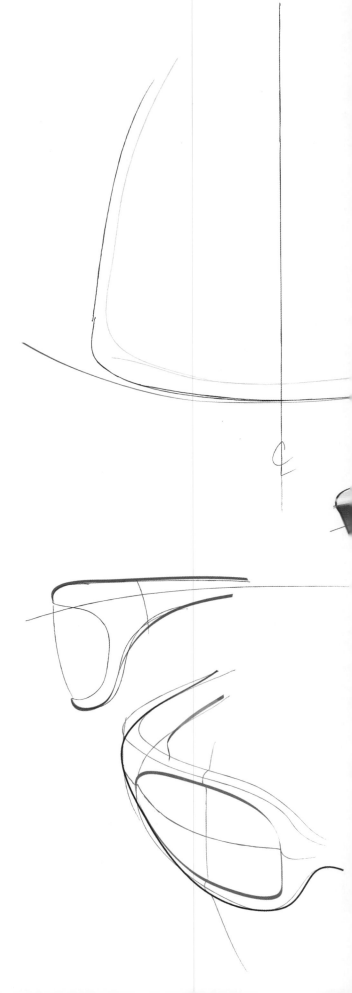

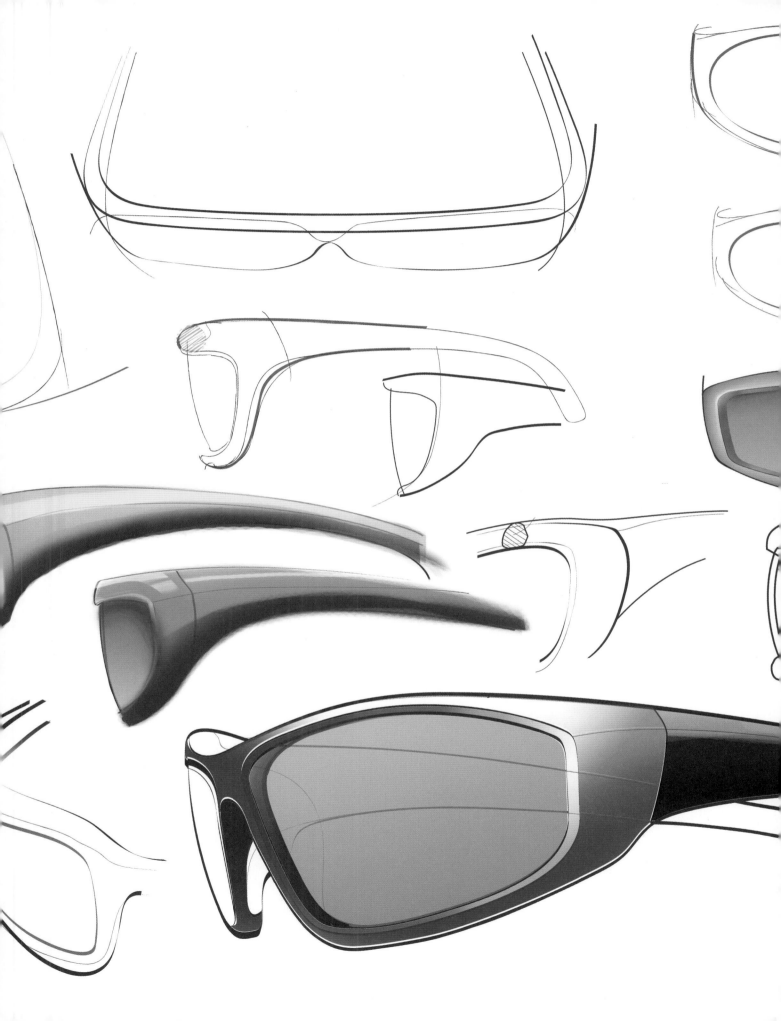

CONTENTS

INTRODUCTION: DRAWING CONNECTIONS

Fig. 1
This sketch from HLB's Boston office is an early iteration of a design diagram intended to visualize complex research data in a way that will make it clearer to both the design teams and the client.

Why read this book?

Sketching remains the fastest and most direct method for designers to get ideas out on paper, whether they work in a collaborative setting or solve problems alone. It can be differentiated from drawing by its level of refinement: drawing tends to be more deliberate and accurate, following on from the initial sketching process. Sketching should not, however, be thought of as simply giving form to objects and spaces; it should be seen more universally as a tool for thinking, planning and exploring. It is used by a wide range of people including scientists, mathematicians, engineers, economists and coaches to help explain, provide instruction or simply think 'aloud' on paper. In a world of increasingly complex and instantaneous information, quickly sketched visualizations can help simplify and compress data far more efficiently than language. Sketching can also help visualize interactions or scenarios for smart devices such as mobile phones or services more generally.

Sketching, like writing, works in two ways – it can be active (like writing) or receptive (like reading) – but it is different to writing primarily because of its immediacy: sketched marks often correspond one-to-one with what they represent. And while some technical knowledge might be required to understand technical drawings, most sketches can be 'read' by anyone, anywhere, with seemingly little effort.

Drawing's real power lies in its immediacy and speed; its capacity to materialize thoughts and ideas quickly so that they can be expanded upon or shared before they disappear. The designer uses lines and marks to shepherd ideas into existence while they are still only partially formed in his or her mind. This process – a cumulative rather than linear one – allows the designer to go back to a sketch and add to, or subtract from, it or simply revisit ideas on paper and continue the thinking process begun earlier. Such sketch ideation is not simply a matter of documentation or observation; instead it is a highly creative and dynamic act where the power and poetry of line can capture character and begin defining form or clarifying connections, thereby enhancing communication. Sketching can be used to show cause and effect, time-based interactions or form factors.

Fig. 2
The design process is extremely varied. It relies on many different ways of recording, organizing and refining ideas including: Post-it notes, quick sketched doodles or handwritten notes, colour coding or spatial organization, diagramming and flowcharting. Sketching is vital to every one of these methods because of its speed and provisional nature.

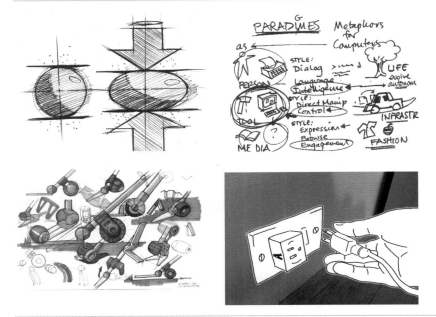

Fig. 3
The many ways in which sketching can assist in the design process include general diagrams, cause and effect sketches, quick ideation sketches, scenario-based sketches and concept renderings. While all these forms are different they also have a great deal in common.

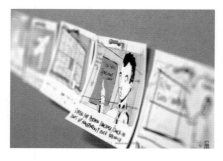

Fig. 4
These storyboard sketches from Gravity Tank are used as a preliminary tool to flesh out a particular problem or set of issues. The simple 'cartoonish' sketches provide a quick and approximate method for getting the details of potential stories out, and are a refined way to envision potentially larger and more detailed stories. The final deliverable presented to the client is often a high-fidelity video presentation with sound and minimal animation, to create an engaging and captivating story.

Over time these skills evolve into a singular, consolidated method as the designer matures and gains the confidence required to push and pull unrealized ideas on paper or a computer screen. Understanding the ways in which these skills can work separately, as well as how they can be leveraged and merged for stronger visualizations, is critical to any design practice. Sketching, drawing and visualization in general become inseparable from design thinking.

In order to create a bridge between freehand sketching skills and digital-based visualization tools, I have devised a unique system that utilizes the language and techniques of both approaches: analogue and digital. The method is grounded in the long and rich history of perspective, which informs contemporary computer software, as well as current and past theories of the cognition and vision so critical to understanding how humans see and think. The explanations and tutorials in this book clearly demonstrate how to visualize ideas quickly and effectively. Applying the logic and processes of computer-aided design to analogue sketching helps to amplify and clarify many drawing techniques while allowing for a smoother transition between paper and computer.

For this book, hundreds of hand-drawn sketches have been scanned or re-traced in the computer and line art from computer models has been created specifically to demonstrate the connection between the analogue and digital. The reader will learn to think fluidly in a three-dimensional world and, through practice, be capable of building complex design ideas that are structurally sound and visually clear. Central to the book is the idea that many design disciplines are blurring their boundaries. Skills that have been important to architects and industrial designers are becoming equally important to illustrators and information designers, and vice versa. This is reflected in the reality that designers (of every discipline) are using similar digital tools (vector-based graphics, raster-based photo manipulation software tools, computer-aided design and time-based animation software).

Using this book

Learning to sketch and draw effectively is not merely a technical skill but one that requires a deeper understanding of the mechanics of vision, cognition and representation. The history and evolution of drawing is amplified by the history of human psychology, creating a powerful and unified narrative (chapter 1, Understanding Sketching and chapter 2, The Psychology of Sketching). While many students feel strongly that sketching and drawing are innate abilities, I believe that anyone can learn to draw if they are provided with clear explanations, instructions and properly paced exercises. For this reason the book is structured around a single narrative that merges history and theory, and gives in-depth explanations alongside step-by-step demonstrations.

Fig. 5
The sketch by Mexico City-based designer Emiliano Godoy represents an exploration process to define the concept of the cup and saucer in the photograph. While the sketch bears similarities to the photograph it also leverages sectional details, various orthographic views and shading to help understand the form.

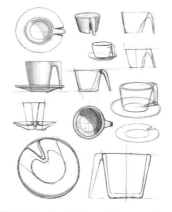

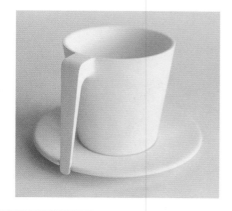

Fig. 6
This scenario from Teague Design is intended to communicate a particular type of on-screen interaction. Sketching in low fidelity over time can help the designer get ideas out quickly for later refinement. See chapter 8 (Exploring Forms in Space) for more detail.

The first two chapters introduce students to the history and psychology of drawing. Chapters 3 and 4 are foundational and delve into the mechanics of visualization and its connection to visual thinking. Chapters 5, 6 and 7 discuss processes and focus on the particulars of form and line, demonstrating just how critical these are to confident design ideation. Chapters 8, 9 and 10 deal with application and are concerned with issues beyond simple sketching, including colour, explanation, articulation, information graphics and composition. All these can help take good design ideation to the next level and make it easier for a client or colleague to engage with it. Finally, chapter 11 discusses how the skills and processes described in the previous chapters can be combined at the macro level of creating design stories.

As anyone who sketches easily and effectively knows, sketching can be a transcendent process – if the pen were to suddenly run out of ink the thinking process would grind to a halt. Ideas seem to flow from the brain through the pen and onto the paper; and occasionally onto the computer screen. For individuals who are not proficient in sketching the process can be slow and tedious. If learning to sketch can be compared to learning to ride a bike, there is a moment when they simply have to let go and 'experience' the freedom that speed and confidence in sketching can provide. For this reason, the physical connection to the act of drawing is central to this book. Designers, like dancers, musicians and athletes, need to build 'muscle memory' in order to make the most of their skills. Repeating the tutorials is designed to flex those muscles.

When sketching is mastered the designer should feel as though he or she is creating on paper; making rather than merely recording. For this reason, I have searched for clear analogies, examples and metaphors wherever possible to provide a mental map of what is going on at every level. I have personally created the majority of the visual explanations in the book, relying on the same techniques I teach, including analogue sketching, computer-aided design and graphic illustration, to ensure continuity. In the cases where I have included examples from other designers to help amplify the book's central themes I have included contextualized captions and credits.

UNDERSTANDING SKETCHING

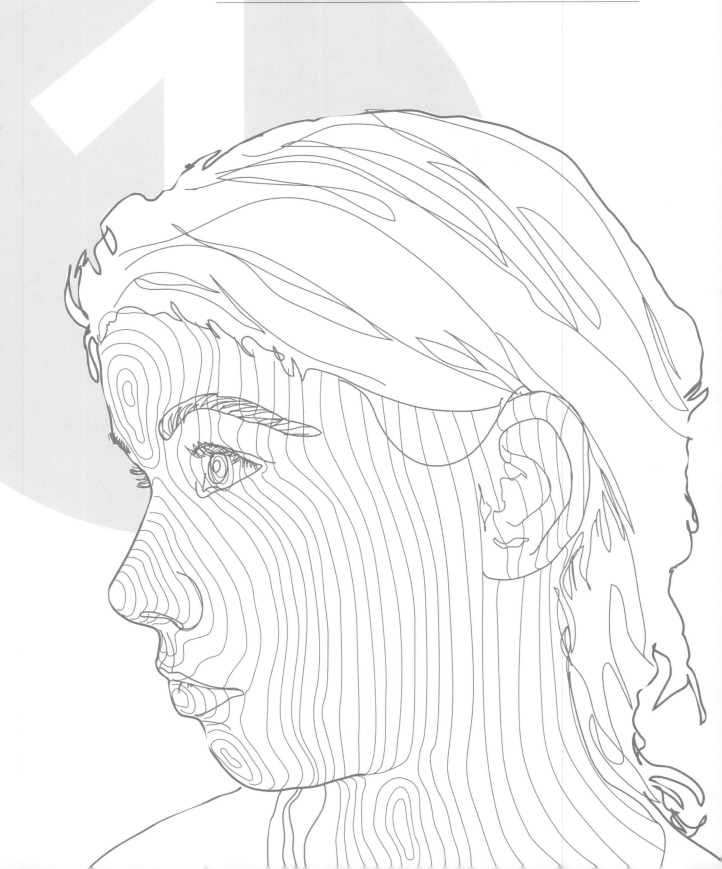

The natural ambiguity of lines

The first thing a student needs to understand is that lines do not really exist in nature, yet lines and edges are primarily what designers rely on to sketch ideas. There are no lines in flowers or fruit or faces or fish, only outlines and edges, both of which change as the object or the viewer moves. The photograph of my daughter (Fig. 1) can be reduced to a series of curves and contours (re-traced in Adobe Illustrator) that define recognizable shapes such as eyes, lips and ears. These natural features and openings are defined by their edges and occasionally, like the internal lines of the lips, by their contours.

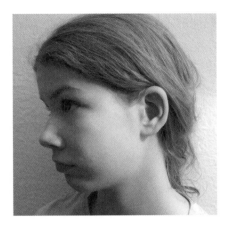 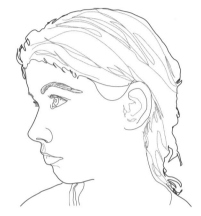 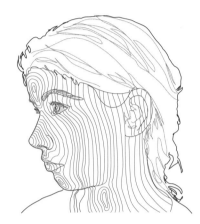

Fig. 1
The photograph represents the highest fidelity image, while the traced sketch represents the lowest fidelity. Adding contour lines raises the fidelity slightly, making it easier to understand the three-dimensionality of the face. Shading and shadows on a sketch can also increase fidelity.

The skin's surface, however, is a continuous membrane of flesh no different to the skin of an orange. It masks the underlying structure of the skull much as the smooth surface of a plastic object hides the geometry of its internal structure. Let's use the example of an inner tube (or torus in CAD terminology), which can be fiendishly difficult to draw given the fact that the skin is a continuous uninterrupted surface – like an orange skin or as on a face. Only a seasoned sketcher could draw this object using only three or four lines or arcs. The most direct method is to construct the form out of sections, which requires knowledge of the internal form. This is precisely what a computer program does. The addition of modelling (shading and shadow) along with highlights helps to better define the form's three-dimensionality. In order to draw a partial torus, the most effective way is to create the whole wireframe and then cut away what is not needed. So while drawing accurate linework is crucial to good visualizations there are many other things to consider, including reflectivity, point of view, direction or orientation and fidelity.

Fidelity is one of the most crucial terms used throughout this book to differentiate between the various modes of realism in visualization. The term high fidelity (hi-fi) dates back to the 1930s when it was used to refer to audio or visual images that were so realistic as to be indistinguishable from the original. The term lives on in the design world to differentiate refined and realistic from quick and schematic. Interaction designers and industrial designers alike use it in sketching or wireframing to distinguish quick initial ideas from more resolved and refined ones. The term is used throughout the book.

Fig. 2

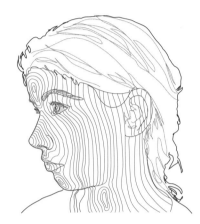

Torus with rough inner structure

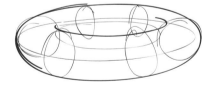

Torus with wireframe

Rendered torus showing part of wireframe

Fig. 3
This sketch of a water jug includes shadows and highlights, and can therefore be considered 'high fidelity'.

Fidelity is also a critical term in sketching and prototyping. Quick sketches tend to be low fidelity (low level of realism) while tighter line drawings (like the one of my daughter, for example) could be thought of as medium fidelity (realistic enough to be recognizable as my daughter).

While a photograph is the ideal example of high fidelity, a tight line drawing that has been rendered, as in the water jug (fig. 3), to include shade, shadow and highlights can also be considered high fidelity. Fidelity is ultimately about tricking the eye much as a realistic painting does. But the designer has to be able to create the accurate sketch geometry of an object in order to raise the fidelity that comes through rendering light, colour, shade and shadow. Knowing when lower-fidelity sketches are more appropriate than higher-fidelity ones is a key aspect of any designer's workflow.

Why sketching in an age of computing?

Students often ask why they need to learn to draw at all when they can get the job done with a computer. My standard response is that they will only get out of the computer what they are able to put in to it (garbage in = garbage out). Software cannot miraculously visualize what someone is thinking but requires specific input, which in turn requires knowledge of sketching and drawing – a perfect loop with each process informing the other. While computer-aided design softwares differ in their fundamental approaches to creating geometry (surfaces versus solids, for example) they all require the designer to 'build' form through sketching using the same types of geometry – lines, arcs, circles, curves, etc. (see fig. 4).

Fig. 4
Sketching on a flat sheet of paper is very similar to 'building' on a flat computer screen. There is always an underlying structure to objects, whether sketched or built, and even the process of manipulation can be very similar – such as removing a slice from an object or filleting the edge of a cube.

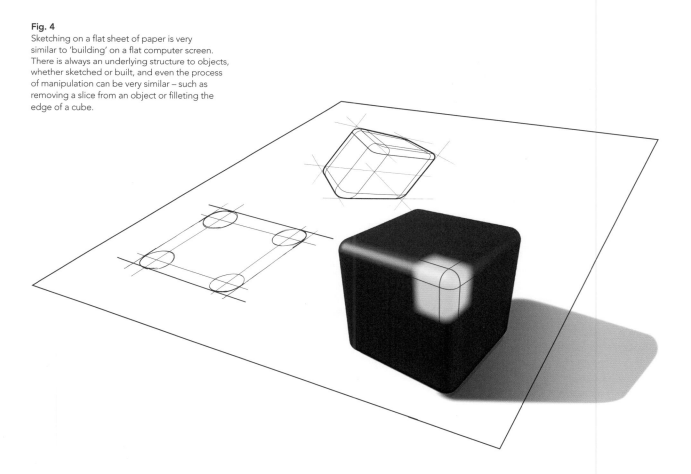

Let's look at a single example: a detergent bottle. The illustrations in fig. 5 show a few steps from the sketching process. Note that the sketches in this case are largely confined to flat planes as they would be in many CAD programs, and serve as boundary edges that define the object's primary sectional geometry. The screen shot (fig. 6) shows the very beginnings of a surface model of a similar detergent bottle created in SolidWorks – the one surface is comprised of five separate sketches. The designer, whether working in analogue or digital modes, goes through a very similar process to arrive at the final form. The more aligned these activities become the easier it will be to transition back and forth. This is the goal of the book: to bring these activities together by interrelating their processes and vocabulary.

Thinking about computer-aided design software as an entirely new technology is to miss the close connection between these modes of drawing. CAD combines the logic of the original projection systems – from orthographic to three-point perspective – and translates it through complex algorithms and well-designed interfaces into software that describes geometric form digitally.

Fig. 5
Building computer models is like 'building' design sketches. The two processes complement each other and require knowledge of planes, projection, dominant and subordinate curves, and operations like trimming or extending surfaces.

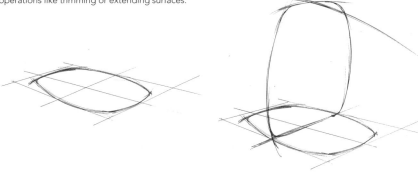

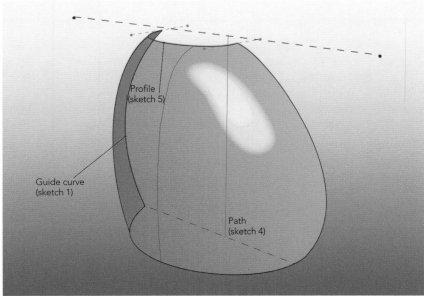

Fig. 6
The two sets of languages, while not identical, are intimately related as indicated in the hand sketches for a detergent bottle (fig. 5) and the SolidWorks screen shot of an initial surface for a detergent bottle (left).

In the illustration below (fig. 7) I have overlaid Paolo Uccello's original fifteenth-century drawing of a chalice with a sectional profile that was then revolved 90 degrees (in red). The computer-generated form lines up with the original Renaissance drawing surprisingly well. I created this 3D model not using CAD software but rather a vector-based illustration tool, Adobe Illustrator, which now has some simple CAD-like capabilities incorporated into the software. The sophistication of Uccello's drawing reminds us that Renaissance artists understood the underlying laws of geometric projection; these laws have been further codified into digital software including 2D graphic software.

The freehand sketch of a Thermos mug (fig. 9) relies on knowledge of orthographic projection as well as an ability to imagine the resulting form when it is revolved 360 degrees in space. The act of sketching a series of circles (in perspective) along a central axis, all of which touch a dominant profile, is analogous to a revolve in a computer-aided design program. In fact, it could be argued that extrusions, lofts, sweeps and most other CAD features are created in nearly identical fashion when sketching freehand. This connection between CAD and sketching is examined further in chapter 6 and chapter 8.

Fig. 7
(Right) Uccello's famous chalice predates CAD wireframes by 500 years. What appears to be a polygonal surface model was carefully crafted using the techniques of perspective and orthographic projection discussed on page 19.

Fig. 8
(Below) Statue of Filippo Brunelleschi in Florence, Italy.

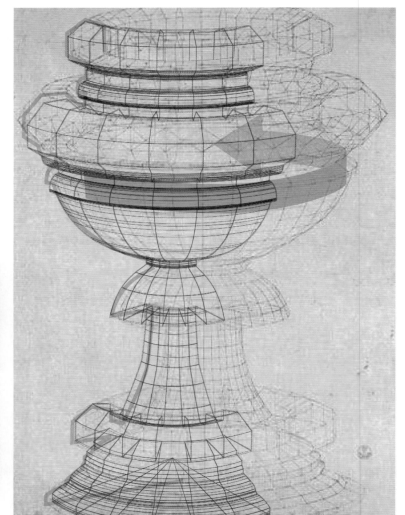

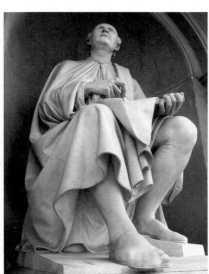

Milestones in the evolution of drawing

Paolo Uccello's chalice drawing shows just how closely related fifteenth-century manual perspective drawing is to twentieth-century computer modelling. And while Uccello's wireframe is static and can neither be rotated nor zoomed, its construction builds on the foundation first established by Filippo Brunelleschi (1377–1446) and later codified by his friend Leon Battista Alberti. Artists including Pierro della Francesca, Leonardo da Vinci and Albrecht Dürer continued to refine the practical knowledge while mathematicians like Girard Desargues, Simon Stevin and others developed and refined the theories. Computer modelling is now going through a similar evolution, and its refinement owes a huge debt of gratitude to these earliest pioneers, who not only empirically worked out perspective methods but then codified that knowledge into instructions much like the modern-day algorithms that run software. Oxford professor Martin Kemp describes it this way in his book *Visualizations: The Nature Book of Art and Science:* 'When we look into the implicit "boxes" of space behind the screens of our televisions or computers, we are distant legatees of Brunelleschi's vision.'

Filippo Brunelleschi (fig. 8) was an Italian architect and engineer who was responsible for designing, engineering and overseeing the construction of the dome for the cathedral Santa Maria del Fiore (known as the Duomo) in Florence in the fifteenth century. Although formally trained as a goldsmith, like so many artists of the time, Brunelleschi moved into architecture and engineering quite naturally, merging his knowledge from multiple disciplines (especially mathematics and geometry) with a hands-on sensibility for material and process. He sought to prove the systematic nature of vision and representation through an empirical method now referred to as Brunelleschi's 'peepshow' (see over the page).

Fig. 9
The insulated Thermos mug is sketched and modelled in analogous ways.

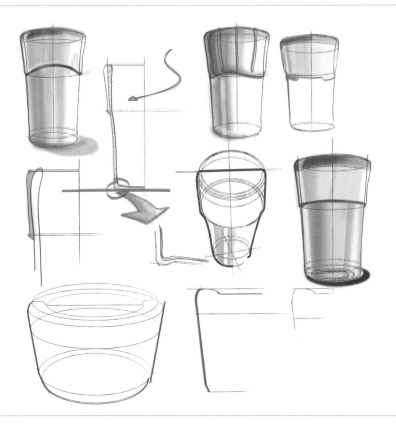

Idea

Brunelleschi's peepshow, as the apparatus is often called, was an ingenious empirical demonstration of perspective. The architect painted a perspectival depiction of the baptistery of San Giovanni in Florence on a panel and drilled a hole through it corresponding with the central vanishing point. Brunelleschi then held the panel with the front facing the baptistry and the back opposite his eye. In this way he could stare through the painting at the actual baptistry. By holding a mirror in front of the painting he could see projected the painted image. By removing and returning the mirror to the same position he could easily verify how close to reality his image actually was.

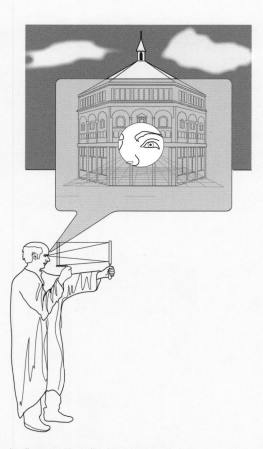

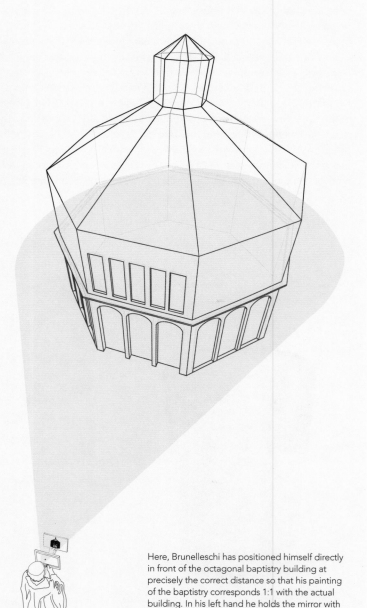

In this illustration Brunelleschi peers through the back of the painting he made of the baptistry at a mirror that reflects back the image. He has aligned the painted image to correspond as closely as possible to the real building. By removing the mirror he quickly sees the actual structure. Returning the mirror he can compare the painted image to the reality.

Here, Brunelleschi has positioned himself directly in front of the octagonal baptistry building at precisely the correct distance so that his painting of the baptistry corresponds 1:1 with the actual building. In his left hand he holds the mirror with the reflected image from the painting. In his right hand he holds the painting with the back facing him and a small hole to peer through.

Innovation

Brunelleschi demonstrated the existence of a direct link between human vision and projected reality. His mirror proved that reality can be captured accurately and displayed on a flat surface. The image coming into the eye (cone of vision) corresponded to the network of lines receding to a central vanishing point. As the viewer changes orientation, the network of lines changes accordingly.

Alberti formalized and codified the peepshow method in his treatise 'Della Pittura' (On Painting), 1435–6. Perhaps the most astonishing thing about this book is that it contains only text. While Brunelleschi relied largely on drawings to prove his method, Alberti, who was trained as a lawyer before turning to architecture and the arts, relied entirely on textual descriptions. The illustrations that appear in modern translations were subsequently added as an appendix. While it might seem improbable to describe a visual process through words alone, both Ptolemy's *Geographia* and Euclid's *Elements* were also based more on descriptions than visualizations.

Pythagoras (sixth century BC) and Euclid (fourth to third century BC) were among the first individuals to detect a system of logic behind numerical phenomena. They provided a mathematical language for describing geometry – point, line and plane – in addition to a repeatable method for creating regular forms such as equilateral triangles and polygons. These simple descriptions were used to develop more complex axioms and propositions. Euclid's descriptions of a line, for example, are terse and exact: 'A line is length without breadth', and 'The extremities of a line are points'. Such a descriptive step-by-step accounting is essentially an algorithm, which the dictionary defines as: 'A process or set of rules to be followed in calculations or other problem-solving operations'. Euclid's *Elements*, which was revived in the fifteenth century and became the most widely printed book after the Bible, provided a foundation for perspective drawing as well as a model for the logic of computing nearly 2,500 years later.

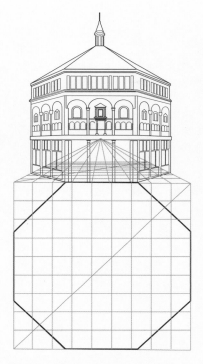

The octagonal plan of the baptistery makes it relatively easy to draw using Florentine workshop methods based on grids. Well-constructed tile patterns commonly appeared in Renaissance paintings before the codification of perspective.

Defining geometry in a manner that everyone can agree on is difficult. Euclid defines a line as length without breadth, while Alberti defines it as a point extended directly in space. A plane is a series of lines side-by-side, and finally a volume is a series of planes stacked one on top of the other. A line, therefore, might be considered one dimensional; a plane is two dimensional; a volume is three dimensional. A line has only length; a plane has length and width; a volume has length, width and depth.

Alberti, in his treatise, transformed Euclid's system into a far more practical method. His description of a line, for example, while reminiscent of Euclid's, is far more visual: 'A straight line is drawn directly from one point to another as an extended point. The curved line is not straight from one point to another but rather looks like a drawn bow. More lines, like threads woven together in a cloth, make a plane.' These descriptions provided apt visual counterparts for other artists struggling to understand this new codified system of drawing.

Idea

Alberti improved Brunelleschi's system by adding a second plane (picture plane) through which the viewer's line of sight is intersected, resulting in accurate transversals (the lines that determine depth on a tile floor, for example). These intersecting points are projected across to intersect with the orthogonals that recede back to the vanishing point.

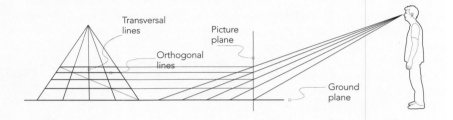

Innovation

The picture plane (often referred to as Alberti's window) provided a useful metaphor for thinking about vision and representation. Euclid had previously defined vision as a cone constructed of visual rays with the vertex at the centre of the retina. This 'cone of vision' (also known as the visual pyramid) intersects the flat picture plane (see illustration above), resulting in an image seen from a specific vantage point. Change the vantage point (angle of view) or the distance from an object and the image changes with it (see left illustration).

The base of the cone or pyramid is defined by the plane furthest away. When looking straight out on to the horizon the depth of view is infinite. When staring at an object on the floor the depth is finite: the cone of vision ends at the floor like the beam of a torch.

Alberti's metaphor of the window, which acts like a flat but transparent plane that captures the depth of any view and flattens it on to a two-dimensional surface, was critical to the evolution of perspective.

The cone or pyramid of vision is illustrated in red. Changing the distance or orientation of the object or the viewer (vantage point) changes the image on the retina of the eye.

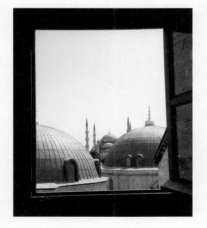

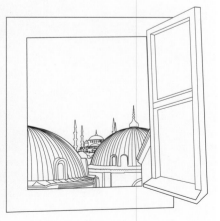

This photograph taken through a window in Hagia Sofia has been re-traced to illustrate Alberti's idea of the picture plane as window.

The Italian painter and mathematician Piero della Francesca (1415–92) further consolidated the ideas developed by Brunelleschi and Alberti, adding greater rigour and method. Art historian and author James Elkins describes Piero's process: 'Before they can be used in the proof, rays must become lines, "eyes" points, and angles triangles.' Piero managed to translate the power of geometry into a language of drawing, and in the process connected the accuracy of orthographic projection to the dynamism of one-point perspective; validated by the power of the diagonal, which serves as a verification tool for the exact placement of every nodal point in the perspective view. A kind of hinge exists between the orthogonal and perspectival planes, around which the orthographic projection swings into perspectival space. The diagonal, in conjunction with the boundaries of the plane and orthogonal and transversal lines, allowed for the creation of a reliable network of intersecting lines and resulting nodal points that connected the flat orthographic view on the face with the perspectival view on top (fig. 10)

The sequence below (fig. 11) shows how the pentagon is slowly mapped point for point from the front plane (orthographic front view) up to a one-point perspective view on top of the cube. The diagonal on the top plane is a 'mirror reflection' of the diagonal on the front plane, only viewed in perspective.

Fig. 10
The illustration demonstrates the multiple steps involved in mapping a single point from the orthographic view to what will become a perspective view (one-point perspective). The diagonal in conjunction with the single vanishing point makes all of this possible.

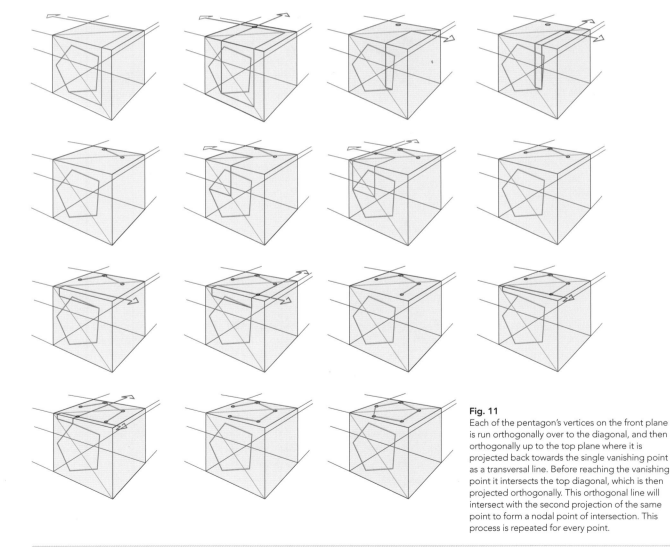

Fig. 11
Each of the pentagon's vertices on the front plane is run orthogonally over to the diagonal, and then orthogonally up to the top plane where it is projected back towards the single vanishing point as a transversal line. Before reaching the vanishing point it intersects the top diagonal, which is then projected orthogonally. This orthogonal line will intersect with the second projection of the same point to form a nodal point of intersection. This process is repeated for every point.

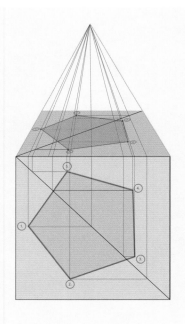

Idea

Piero della Francesca put perspective on a firmer footing by extending what his predecessors had done. His deep understanding of mathematics and geometry, combined with the practical experience he gained in Florentine workshops, allowed him to connect perspective more directly to orthographic projection. On the left is a pentagon in plan view 'hinged' to a perspectival plane upon which the same pentagon is drawn. The diagonal cuts through both views providing a critical reference line in the perspective view to help define locations of critical nodal points in space.

Innovation

Piero established a clear and mutual relationship between an orthographic view hinged to a perspectival view via the diagonal. Critical points in the orthographic view are projected through vertical and horizontal lines along the diagonal up to the perspectival plane where they are accurately mapped in space.

Fig. 12
Piero's method reconciles the power of orthographic with that of perspective. In contemporary terms this is the process a designer would employ to 'chase' points quickly up, down and around a sketch to establish crucial geometry for rapid ideation sketching. This process is about speed over accuracy.

The 'rediscovery' of perspective initially focused on reliably reproducing what was already present: the baptistery of San Giovanni, for example. However, artists and engineers realized that they did not have to mimic (mirror-like) the pre-existing reality demonstrated by Brunelleschi's peepshow, but could use it to help invent new worlds or new artefacts. The engineer Mariano Taccola was using sketching as an exploration tool by the middle of the fifteenth century, but it was the German artist Albrecht Dürer (1471–1528) and his Italian contemporary Leonardo da Vinci (1452–1519) who leveraged this emerging visualization technology to portray reality as well as to explore physical phenomena and quantify form.

Dürer took Alberti's window to the next level by building an operable window frame with a sheet of parchment substituting for the glass pane, which could be swung open for charting points and then closed for plotting them (see fig. 13). This primitive perspective machine required two people to operate it. One of them held a taut piece of string connected to a pointer or stylus at any point on an object while the other moved a type of crosshair, or adjustable set of vertical and horizontal strings, to mark each coordinate within the frame. Once the crosshair was set the string was withdrawn and the window closed, so that the point could be pierced into the parchment, thus creating an accurate constellation of points by which to map the object.

Drawing involved connecting the dots; a process described earlier by Piero della Francesca where the rays are lines and the eyes are points. Dürer's first perspective machine was refined by adding an actual gridded window and a stationary eyepiece to help focus the artist's sight while he translated the information to a similarly gridded or mirrored sheet of paper placed on a table (fig. 14). The whole process was anything but intuitive and fast, but it did deepen the theoretical foundation upon which perspective was grounded; and anticipated the Cartesian coordinate system developed more than 100 years later by the French mathematician René Descartes (see p. 83, The scaffold metaphor).

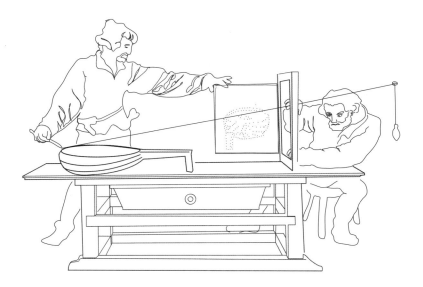

Fig. 13
Albrecht Dürer built some of the earliest 'perspective machines' to help codify the drawing process. The metaphor of the 'window' has persisted all the way up to the present day of computer-aided design.

Fig. 14
Another Dürer machine used a stationary point and a 'gridded window' through which to view the object as an aid to accurate drawing.

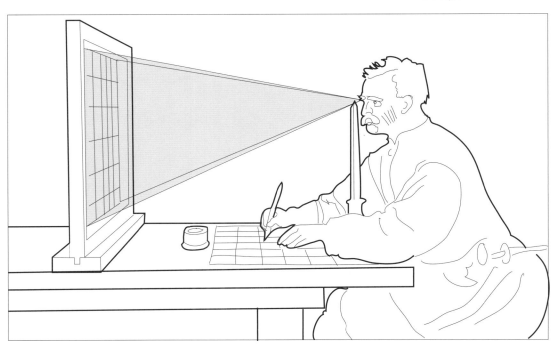

Idea

The gridded picture plane as further refined by Dürer allowed for the accurate mapping of any object. In fact, Dürer applied drawing systems to the exploration of many problems, including an early form of descriptive geometry, human proportions and physiognomy. Dürer's primitive perspective machine provided tangible proof of earlier theories of perspective by physically connecting the 'rays' of vision to the object through a 'window' or gridded frame. As primitive as this system might seem, it is a precursor of early computer drafting programs like Ivan Sutherland's Sketchpad, working as it does off a system of inputted points plotted in space.

Innovation

When viewing objects in a natural setting or in a built environment such as a building or other structure, the vanishing points will converge on the natural horizon line. This same horizon line will cut through the eye level of every person standing in the landscape, regardless of how far away they are (see bottom picture).

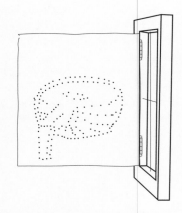

(Above) Rays of vision are captured as points in Dürer's gridded window frame. This approach can be thought of as a precursor to early CAD programs where points are physically plotted in space with a pen tool.

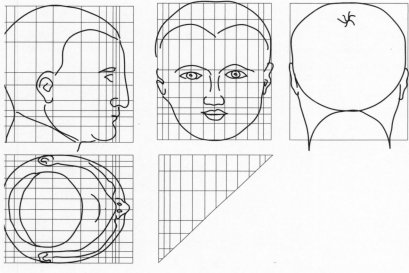

(Left) Dürer's gridded plane aids in accurately depicting human proportions. Notice that the grid lines are not uniformly spaced but are consistently projected from view to view.

(Below) Perspective is so consistent that similar height objects (or people) can be scaled simply by referencing the horizon line. In the example below the horizon line passes directly through their eyes.

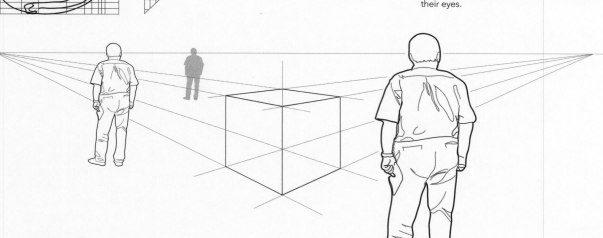

Leonardo da Vinci, perhaps more than any other artist of the Renaissance, used sketching to record not only what exists but also to explore and explain what might exist were it more visible. His research into the nature of light, shade and shadow helped him to better visualize the world in his paintings and frescoes while adding greater depth to his illustrations of the human body and complex machines. Through direct observation and diagrammatic drawing Leonardo was able to theorize on issues as disparate as aerial perspective and the afterglow of reflected light on the moon (earthshine). His inquisitive mind put sketching to the task of understanding and recording anatomy, hydraulics, projectiles, motion and the make-up of the eye itself. He wrote in his notebooks (volume 1): 'Drawing is based upon perspective, which is nothing else than a thorough knowledge of the function of the eye.' Leonardo's drawings of the human body work in much the way modern medical imaging technology does today, through slicing, sectioning and dissecting the body to expose underlying structures and mechanisms. Leonardo also understood the limitations of static perspective receding to fixed vanishing points, and that humans use binocular vision as well as visual cues like shade and shadow to understand objects in space.

Leonardo da Vinci illustrated Luca Paccioli's book *De Divina Proportione* (The Divine Proportion) on sacred geometry, and drew the first skeletal representations of geometric solids with complete accuracy.

Idea

Leonardo da Vinci not only mastered perspective sketching but was also able to leverage all forms of quick visualization – perspective, orthographic, section cuts, details, etc. – to work out problems, much as a designer, mathematician or scientist does today. His notebooks remain the quintessential example of creative sketching. Leonardo's mastery over the medium allowed him to explore everything, including the nature of seeing, using the tools of visualization. But he also made important contributions in the areas of light and atmospheric effects on vision that continue to affect the way we sketch and render today.

Innovation

Leonardo worked to visualize mathematical and geometrical forms for the Renaissance mathematician Paccioli; for royal courts he studied and visualized phenomena as diverse as sun mirrors, catapults and flying machines, much as an engineer today might work out mechanical linkages on a product or device. His drawings are the essence of design visualization, relying as they do on orthographic, perspective and quickly scribbled notes.

Brunelleschi's accomplishment in accurately drawing the baptistery in Florence before anyone else is certainly heroic. It was, however, primarily a technical feat. It was Leonardo da Vinci and Dürer who clearly demonstrated the ability to think with a pen, which, after all, is what design is really about. Today, the pen works seamlessly in tandem with computers and other technologies to marshal ideas on to paper or screens so that they can be reviewed, commented upon and further refined. It is the quality of the thinking that is valued above all else; yet conceptual and technical knowledge are difficult to separate out. Students struggle with this integration and often treat the acquisition of sketching as merely a technical skill; one that even gets in the way of being creative. In fact, sketching has to be fast, cheap, plentiful, suggestive and exploratory just like thinking, which, as it turns out, is a very visual process.

THE PSYCHOLOGY OF SKETCHING

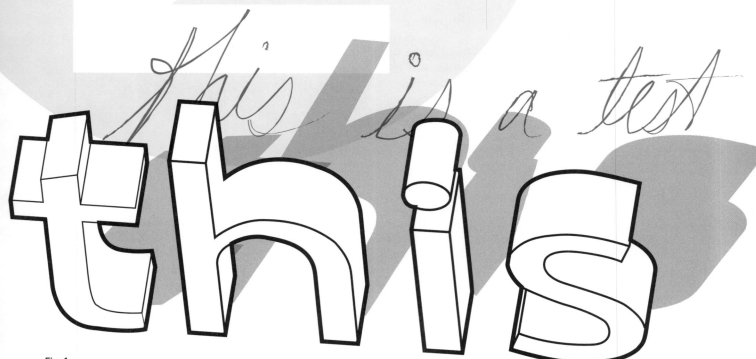

Fig. 1
Cursive handwriting is both unique and categorically familiar. No two handwriting samples are the same, yet we have little problem reading them because we clearly discern the 'model' or cursive prototype within the unique adaptation that is the individual's handwriting.

The psychology of vision

The evolutionary psychologist Steven Pinker claims that humans rely less on words than on visual images, auditory images and propositions or rules of logic in order to think. Even commonly used metaphors and analogies employ visual and spatial attributes to provide us with a quick and easy context in which to communicate and build thoughts. Donald Hoffman, author of *Visual Intelligence*, describes the act of seeing as one of construction: scanning, comparing, categorizing and confirming. According to him we utilize a kind of internal library of forms organized by category against which the brain checks and confirms – a process involving logic combined with iconic, short-term and long-term memory. Thinking, like seeing and sketching, is a constructive process.

Hoffman claims that as babies we begin building our individual libraries by cataloguing shapes into broad but flexible categories, which accounts for why we are able to distinguish a chihuahua from a St Bernard while still recognizing their mutual 'dogness' (fig. 2). Such a catalogue helps us to detect a 'family resemblance' between, say, a shallow bowl and a plate or a cup and a soup bowl while still identifying the specific characteristics of each (fig. 3).

Fig. 2
From an early age we can discern these two entirely differently shaped entities as being from the same 'family'.

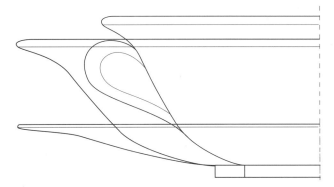

Fig. 3
The profiles of the bowl and plate are nearly identical except for their depth. A bowl is really a deep plate or, conversely, a plate is a shallow bowl. A cup is a more intimate bowl with a handle (affordance) for grabbing and holding. Viewing the various profiles in the sketch demonstrates the interrelationship or 'family resemblance'.

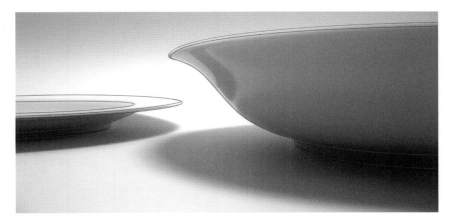

Handwriting is another good example of interrelationship: humans can read almost any cursive script while still recognizing the common underlying alphabet (fig. 1). Our brains recognize the particular as a variation of the general. Another example of this is our ability to recognize objects regardless of the vantage points from which they are viewed – a phenomenon known as shape invariance (see fig. 4, over the page). Our capacity for developing coding rules or flexible descriptions for entire classes of objects facilitates the rapid identification of objects that is so critical to sketching.

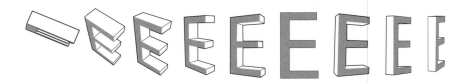

Fig. 4
All the E's are identical in font type and size. The main difference is the vantage point from which they are viewed. Except for the first E, the brain has little trouble recognizing them as being identical, which demonstrates the power of shape invariance.

Fig. 5
Graphic software can take two distinct shapes and 'blend' them, creating a kind of transformational history.

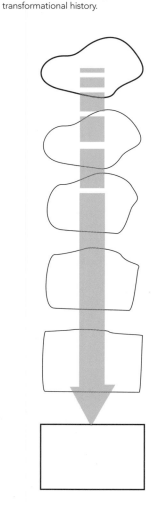

Through practice a designer's brain can be trained to project what something might look like when rotated or manipulated, based in part on these coding rules, descriptions and shape invariance.

Survival in evolutionary terms has required us to project our senses beyond our immediate bodies. And while we can't reach out and touch or taste something that is 20 metres away, we can see, hear and smell it from that distance. In fact, we not only hear a rapidly approaching car from far off but can also sense the direction from which the sound is coming and approximate the car's distance from us, and even its approximate speed, all in a split second. Such a survival mechanism brings with it the added ability to imagine or consider things that are not physically in our hands (or within our sight) but which instead reside in our heads (our library of forms). We can also assign causality – 'Where there's smoke there's fire' – for example, imagining what a particular form looked like before it was stepped on or squashed. Psychologist Michael Leyton refers to this as a generative theory of shape. Various software packages now incorporate rule-based processing to create simple primitives and complex forms or to transform one shape into another (fig. 5). Such developments allow designers to think more fluidly about how to manipulate form even through sketching. But how does the psychology of seeing directly impact the process of sketching or visualizing ideas?

The mechanics of vision: several theories

The incredible speed with which the brain interprets information (millisecond) makes it impossible to observe ourselves seeing, but nevertheless our brain, in conjunction with our eyes, is actively constructing perceived reality out of all the data that comes in: seeing is anything but a passive activity. The word 'recognition' is made up of the prefix 're' (once more) and 'cognition' (to perceive or sense). To recognize is to see familiarity in things through a repeated occurrence or a pattern (family resemblance for example). But what exactly is a pattern and how do we detect one? Pattern recognition was among the first phenomena psychologists studied in the twentieth century to better understand vision, and many of their ideas continue to impact our understanding today. Before we look more closely at the current cognitive science behind vision, let's review a few significant contributions to the psychology of vision, which have provided a wealth of concepts and metaphors as well as a vocabulary of terms critical to sketching.

Fig. 6
Transposing a familiar melody such as Beethoven's 'Ode to Joy' to another key moves not only the notes but also the negative spaces or internal relationships between the notes. Melodies, like visual designs, have multiple sets of relationships that define them. For the Gestaltists the 'whole' in this case would include the notes, the spaces between the notes and the time sequence.

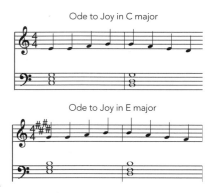

Gestalt psychology

Gestalt psychology began in Germany, in the early part of the twentieth century, initiated by a group of psychologists who explored the visual and cognitive mechanisms behind pattern recognition. The German word 'gestalt' translates into English as shape, figure or form and is often used interchangeably with 'design' in Germany today. Gestalt psychology was initially inspired by the writings of the Austrian philosopher Christian von Ehrenfels, who first noted that a musical melody transposed to another key (raising or lowering the individual notes) remained recognizable to the ear because we hear (actually recognize) the whole melody rather than the individual notes (fig. 6). Wolfgang Köhler, one of the original Gestaltists, described this phenomenon as: 'The whole is different than the sum of its parts', later revised as 'The whole is greater than the sum of its parts'.

Max Wertheimer, a Czech psychologist and a senior member of the Gestaltists, was travelling through Germany on holiday in 1912 when he noticed a curious phenomenon: the simple sequence of blinking lights at a train crossing simulated motion in his brain. Wertheimer exited the train at Frankfurt, purchased a toy stroboscope and began conducting simple experiments with various drawn lines which, when revolved, created the illusion of motion.

He and his colleagues Kurt Koffka and Wolfgang Köhler undertook a series of experiments over many years to better understand this and other visual phenomena. They began codifying what they observed into simple laws of pattern recognition with names like the 'law of good continuance' and the 'law of closure'. These laws provided a concrete way to think about the brain's innate tendency to see 'whole' patterns within sets of smaller discrete parts, whether through proximity, similarity or directionality. While Gestalt psychology deals primarily with static two-dimensional patterns it is important to remember that sketching is a 2D pattern of a 3D representation.

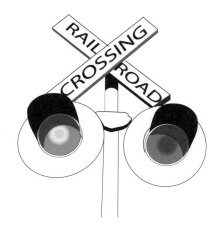

Fig. 7
The alternating blinking of lights at a train crossing tricks the brain into sensing motion where there is none.

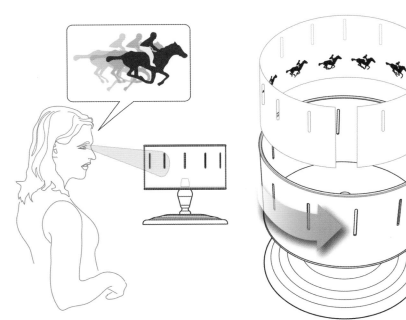

Fig. 8
In 1877 Eadweard Muybridge sequentially photographed horses in motion to prove a bet wagered by Leland Stanford that all four hooves of a horse were off the ground when it was in full gallop. When placed in a zoetrope (or in his own invention, the zoopraxiscope) his photographs anticipated motion pictures, yet no one could explain why until the Gestaltists began their experiments decades later.

Fig. 9
Gestalt Laws include:

①

Proximity: objects that are close tend to be grouped together.

②

Similarity: objects that are similar are related.

③

Good Continuation: objects that suggest movement are related.

④

Closure: objects that suggest a shape are viewed as closed.

⑤

Prägnanz: reality is organized or reduced to the simplest form possible.

⑥

Figure and Ground: images tend to break down into either figures or aspects of the landscape they are part of (see p. 41).

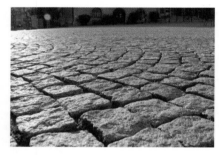

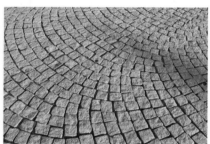

Fig. 10
Gibson's central concerns involve our ability to read the environment around us as having structure. These photographs are examples of texture gradients, surface details that allow animals or humans to pick up real information from their environment – judging distance, for example, or even seeking out places of shelter from predators.

J.J. Gibson's theories of dynamic interaction

J.J. Gibson, an American psychologist, began his academic career at Smith College in Massachusetts, where the Gestalt psychologist Kurt Koffka was teaching after fleeing Nazi Germany. While Gibson embraced and admired the work of the Gestaltists, he soon developed his own theories focused less on static imagery and vision and more on the dynamic interactions between humans and animals and their natural surroundings. This was partially inspired by work he did during World War II while developing training films for fighter pilots; an experience that made him acutely aware of the challenges faced by pilots who had to interpret the landscape quickly so as to make split-second decisions. Gibson began to develop what he termed an ecological approach to visual perception, pushing the psychology of vision past the static pattern-detection of the Gestaltists into the new and more dynamic realm of motion.

Some of Gibson's theories are especially powerful when it comes to understanding sketching. His concept of the texture gradient provides a psychological explanation for how our brains perceive the real space Renaissance artists had become so expert at representing on flat picture planes. Humans decipher space based on depth cues, and the texture gradient is similar in a sense to the orthogonals and transversals employed by artists such as Piero della Francesca and Paolo Uccello to suggest accurate depth perception. A simple example can be seen in the photographs (fig. 10), which represent typical paving patterns found in many old European town centres or marketplaces. The texture created by the patterns creates what Gibson called a texture gradient, and signals to our brains that the smaller the stones, the further away they must be. According to Gibson, the brain 'picks up' this information and perceives it as distance cues.

Fig. 11 (opposite page) shows a simple 3D convexity modelled in Rhino. The view is slowly rotated into a position parallel to the eye; notice how the convexity appears to flatten out as it is rotated. The brain constantly assesses information as we move or as objects in the environment move: if the convexity were an enemy bunker a pilot would need to be at a lower vantage point to detect it. Rendering utilizes the gradient effect to deceive the eye into perceiving volume on a flat image plane (paper or computer screen).

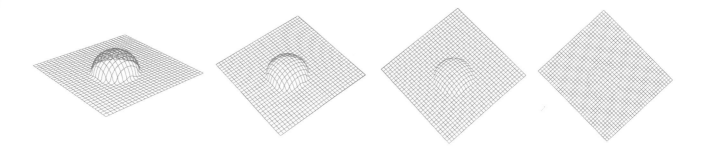

Two other critical concepts from Gibson's work are shape invariance and optical occlusion. On page 26, the letter 'E' was shown from various vantage points to illustrate shape variation. This recognition of known objects remains invariant in our brains, thus overruling vision so that a table remains a table despite where we are positioned in relation to it in space (fig. 12). This is the brain's way of being efficient with resources. If our brains understand the invariance of objects they can certainly be of assistance in imaging what something might look like when viewed from different angles when sketching. Again, it all comes down to rules.

Optical occlusion refers to the phenomenon whereby the edges of an object that are not viewable by the eye are still understood by the brain to exist. The skilled designer learns to 'sketch through' objects as if they were transparent in order to accurately place critical edges or geometry and ground the objects on a common plane relative to each other. Sketching only those parts of an object that are viewable to the eye adds to the designer's work because, paradoxically, more of the information has to be guessed at.

Fig. 11
These 3D models of simple bumps (convex forms) were created to demonstrate the challenges Gibson observed for pilots flying over a landscape. When viewed from directly overhead as in the last model the convexity flattens out much like a hill or valley might from 30,000 feet. Shade and shadow help to define form and its relationship to ground.

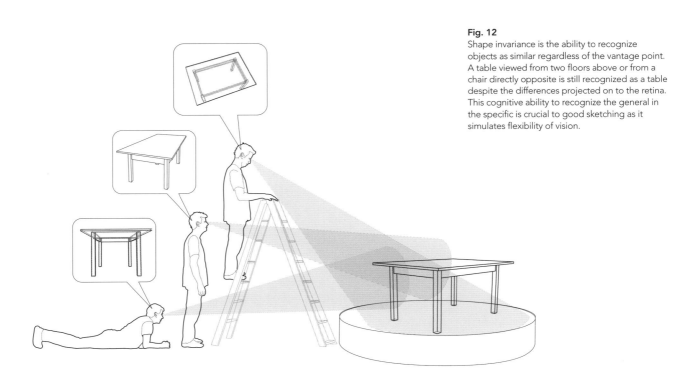

Fig. 12
Shape invariance is the ability to recognize objects as similar regardless of the vantage point. A table viewed from two floors above or from a chair directly opposite is still recognized as a table despite the differences projected on to the retina. This cognitive ability to recognize the general in the specific is crucial to good sketching as it simulates flexibility of vision.

Sketching occluded edges and surfaces hidden by other objects or surfaces is easier on the brain and faster on the body or hand. Computer modelling programs have a setting to turn on these occluded (hidden) edges to make it easier for a designer to work (see fig. 13 below). These occluded edges become the ghost lines of quick sketching (see chapter 7).

Gibson's ideas have been questioned now that imaging technologies exist that make it possible for physicians and scientists to actually watch the brain watch the world. Nevertheless his work, accomplished at a time when technology could not probe our consciousness at a neural level to map the actual firing of synapses, contributed much to how we think about vision and cognition. His attention to the importance of surface gradients alone provides the designer with a clearer understanding of rendering's power to capture the imagination.

Fig. 13
Hidden lines in CAD programs are typically represented with a lighter line weight to suggest that they would normally be obscured from view.

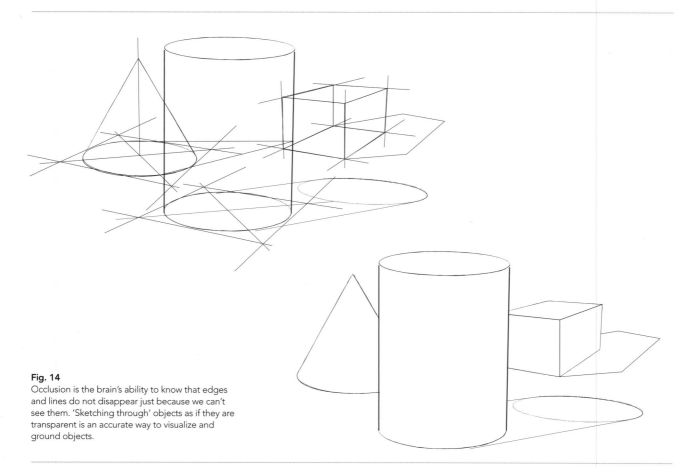

Fig. 14
Occlusion is the brain's ability to know that edges and lines do not disappear just because we can't see them. 'Sketching through' objects as if they are transparent is an accurate way to visualize and ground objects.

But perhaps Gibson's greatest contribution to design remains his concept of affordances, the result of his ecological approach to vision. Don Norman, author of *The Design of Everyday Things,* worked with Gibson and prefers the term perceived affordance. He defines it as the 'actionable properties between the world and an actor (a person or animal).' To Gibson, affordances are a relationship. They are a part of nature: they do not have to be visible. In the world of designed objects they 'afford' the user the ability to lift up a cup (a handle) or raise the volume (a button). The manner in which our brains interpret the world of objects is essential to the way in which we represent objects.

Fig. 15
The photographs show serving plates designed by Crucial Detail. They clearly communicate their underlying structure and form through the power of gradients. The wireframe from an earlier iteration of the serving plate shows the power a gridded set of contour lines has to represent a similar form without any gradients. When the two powerful tools, line and rendering, are combined the brain is very easily convinced that what it is seeing is three-dimensional. Quick sketching relies on both these skills. It also relies on the ability to imagine form from a variety of angles and 'draw through' an object, or imagine the 'occluded' edges that remain hidden by other objects or surfaces, such as the back edges on the wireframe. Photographs by Lara Kastner.

Irving Biederman: recognition by components

Irving Biederman is a neuroscientist working on human vision and artificial intelligence (AI). Whereas Gibson focuses heavily on reading and comprehending surfaces, Biederman is more concerned with an underlying set of shared structures. His recognition-by-components theory, while largely discredited, remains very useful as a metaphor for sketching and thinking about form more generally. The idea is quite elemental: a group of idealized geometric shapes (known as geons – short for geometrical icons) are stored in the brain for comparison with what we see in the world. Geons comprise an efficient library (36 in all) of simple shapes such as cubes, cylinders and cones which, combined, can create millions of recognizable objects. The quick sketch of a water bottle below (fig. 16) relies on a geon approach: the main body is cylindrical, the bottom surface is partially spherical and the transition from the main body to the neck is also partially spherical, while the top of the neck and the cap are cylindrical.

Fig. 16
(Right) This sketch of a water bottle has been created using a series of geometrical shapes.

Fig. 17
(Below) According to Biederman's recognition by components theory, this US fire hydrant is actually the intersection of several basic geons: sphere, cylinder, truncated cone, polyhedron, cube, etc. The illustration demonstrates the process of intersecting these forms to arrive at the composite we all recognize as a fire hydrant. This process of intersection commonly occurs in computer-aided design and involves Boolean operation.

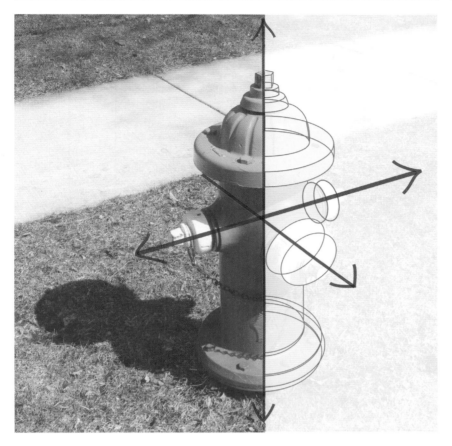

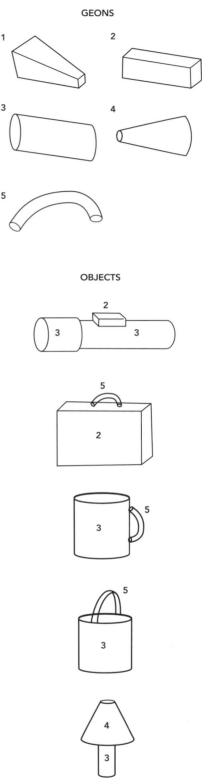

GEONS

OBJECTS

In a seminal paper on geon theory Biederman wrote: 'Three striking and fundamental characteristics of human object recognition are its invariance with changes in viewpoint, its ability to operate on unfamiliar objects, its robustness in the face of occlusion or noise, and its speed, subjective ease, and automaticity.' Notice that the terms invariance and occlusion, to which he has added robustness, speed, subjective ease and automaticity, remain critical components to his theory. Neuroscientist Kevin O'Regan, commenting on Biederman's research, writes: 'What I have added… is the suggestion that "seeing" does not involve simultaneously perceiving all the features present in an object, but only a very small number, just sufficient to accomplish the task in hand.' This last idea is perhaps the most critical to good sketching as it's an exploratory process without a clear end result. Designers need to be flexible and open to opportunities that might emerge in response to their own initial first marks placed on the page. They need to tolerate the ambiguity that comes with probing or, as O'Regan points out, not perceiving everything at once. Biederman's geon theory is a great model for quick 'bottom-up' sketching approaches, working from simple shapes and adding or subtracting from them to arrive at more refined ideas – much as a computer builds basic models around rules or descriptions (primitives). Such strategies will be explored in greater depth (chapter 6, Shape Morphologies; chapter 8, Exploring Forms in Space).

Fig. 18
Biederman's illustration of the geon theory (re-drawn) from his co-authored paper 'Geon Theory as an Account of Shape Recognition in Mind, Brain, and Machine' (1993).

Drawing on both sides of the brain

Educator and author Betty Edwards wrote her influential book *Drawing on The Right Side of The Brain* 30 years ago, drawing on research from cognitive scientist Roger Sperry's work with split-brain patients suffering severe epilepsy. One of Sperry's key insights was that the left side of the brain controls the right side of the body while the right side of the brain controls the left side. Sperry described the left side as the rational/verbal side and the right side is more intuitive and adept at processing spatial/temporal information. Edwards believed strongly that her drawing students could shift from what she called the L-Mode to the R-Mode and in the process free themselves from the natural tendency to logically identify (verbalize) what they were looking at: to see the world rather than name it.

Edwards' book was intended for artists observing and recording their world as opposed to designers tasked with envisioning a world not yet in existence, who, as a result, need to access both sides of the brain (rational/verbal and spatial/temporal). The juggling that has to occur between these acts gets to the heart of what design sketching is all about. Let's look more closely at what current neuroscience can tell us about cognition and vision.

Recognition

One of the first things to understand about human perception is that the eye can focus on only a very small fraction of the world. When we look out into our environment everything appears to be crystal clear when in fact our eyes are only focusing on a very narrow sliver of reality (approximately 2–3 per cent). The brain focuses on an 'as needed basis' to make resource allocation as efficient as possible, and does this so quickly that we are unaware of it.

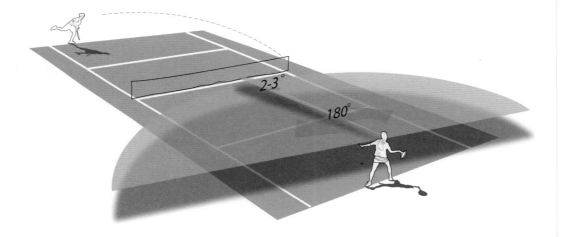

Fig. 19
It is a common misconception that the world is entirely in focus at all times. The reality is that the world is out of focus until we specifically choose something to focus on. The 2-3-degree cone that we can focus when directed at an object like a tennis ball is just enough to compete effectively while using precious resources sparingly.

Not only is our focused view of the world highly reduced, it is inherently flat. When we look out into the world we are viewing what cognitive scientist Colin Ware calls the 'image plane', which is equivalent to a photograph or painting rather than a truly three-dimensional world. The dimensionality of this plane is restricted to the up-and-down and side-to-side axes – height and width. In order to really understand depth or what is referred to as the 'towards and away' axis, we need to crane our necks or physically move our bodies, which is far slower and less efficient than moving our eyes from side to side or up and down. According to Colin Ware our brains are ten to a hundred times more efficient at interpreting information along the 'up/down' and 'side to side' axes than the 'towards and away' axis. Vision, in other words, is very much like looking through Alberti's window (see p. 18).

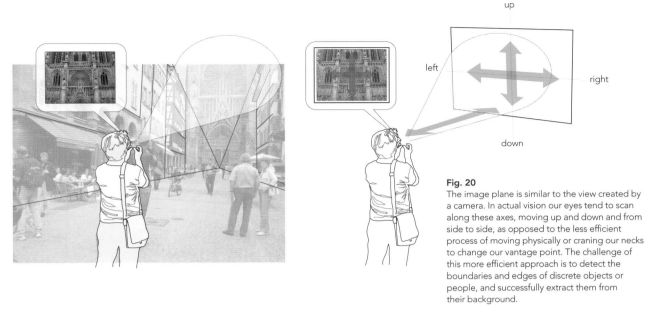

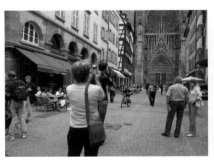

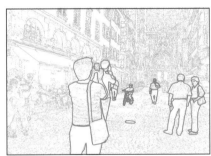

Fig. 20
The image plane is similar to the view created by a camera. In actual vision our eyes tend to scan along these axes, moving up and down and from side to side, as opposed to the less efficient process of moving physically or craning our necks to change our vantage point. The challenge of this more efficient approach is to detect the boundaries and edges of discrete objects or people, and successfully extract them from their background.

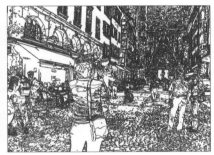

Fig. 21
Here, the same photograph is used to reveal the complexity of deciphering discrete objects in space – something we humans do every second of our waking day. For the normally sighted person it is not a challenge to distinguish the individuals from the buildings and each other, even though they overlap and intersect: the brain is 'binding' together the individual outlines that define people and objects in space.

Ware writes: 'There is no such thing as an object embedded in an image; there are just patterns of light, shade, color, and motion. Objects and patterns must be discovered and binding is essential because it is what makes disconnected pieces of information into connected pieces of information.' Binding, simply put, is the neuronal process that leads first to very low-level pattern detection, which is processed into higher forms of pattern recognition before ultimately leading to a comparison process with the information already stored in our brains. When we are looking specifically for something those patterns will stand out, essentially calling our attention to them – priming our vision. And conversely those things in our path that we are not interested in simply disappear. As Ware points out: 'in some ways, pattern finding is the very essence of visual thinking… to perceive a pattern is to solve a problem.' Seeing, like sketching, is about creating meaningful patterns that communicate easily.

Fig. 22
The signals travelling back to the brain from the eye are translated from light (electromagnetic radiation) into biological processes, thus setting up a chain of events that are progressively interpreted into ever finer patterns in sections of the primary visual cortex.

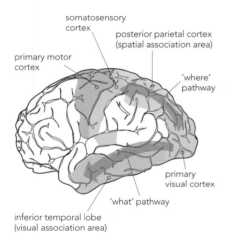

somatosensory cortex

posterior parietal cortex (spatial association area)

primary motor cortex

'where' pathway

primary visual cortex

'what' pathway

inferior temporal lobe (visual association area)

Fig. 23
The 'what' and 'where' pathways, also known as the dorsal and ventral streams, are where objects and space are distinguished in a progressively finer set of processes that build on each other to determine the contours of objects and space. The pathways are critical to recognition, but also to committing an action like reaching for a knob or lifting a pen to sketch.

The patterns that eventually come to form recognizable objects first enter the eye as light signals (electromagnetic radiation) which are converted by an array of photoreceptors (transducers in the form of rods, cones and ganglion cells) into the beginning of a chain of biological processes which will allow them to travel via the optic nerve back to the primary visual cortex located at the very back of the brain. The optic nerve, however, is a relatively small pathway so the incoming signals have to be spatially encoded or compressed before being sent via the ganglion cells to the primary visual cortex. This compression process, which occurs in the retina, involves enhancing the edges of the object, much like photomanipulation software might sharpen or enhance the edges of a shape or region in a photograph.

Once in the primary visual cortex the signals move up two separate pathways, referred to as the ventral and dorsal streams (also known as the 'what' and 'where' pathways). It is in these streams that the biological signals work together to identify objects in space through being either excited or inhibited. The process is a quick but incremental one with the initial inputs moving through the visual areas along the ventral stream to arrive at spots deeper inside the brain.

The 'what' and 'where' pathways move across both sides of the brain. The rapid detection of patterns and subsequent comparison to stored information in the 'what' pathway is so fast as to be imperceptible. The 'where' pathway, on the other hand, is more concerned with helping direct the body in specific actions such as reaching, swinging or sketching. Knowing when to close the hand around a desired object when picking it up off a table may seem mindless but a tremendous amount of machinery is in place to make this feel effortless. Sketching might best be thought of as 'seeing in reverse' because the process involves slowly putting down provisional marks, making sense of them and responding by adding to, subtracting from or refining them to finally create recognizable patterns. Even the experienced designer with good sketching skills exerts a great deal of mental energy to shape thought based on quick and provisional marks in order to build meaning where there is currently none.

Ambiguity

Good ambiguity is intentional

Ambiguity is related to fidelity in many ways. Good ambiguity is intentional and works like a good low-fidelity sketch: it focuses the conversation on a sketch's many possible interpretations as opposed to its final resolution, which is typically a middle- or high-fidelity sketch or rendering. The right amount of ambiguity allows even the designer to see possibilities that may not have been intended. The competent quick sketch is read as an idea in motion rather than a fully resolved idea. The sketches opposite (fig. 24) from Cooper and Associates are quick, low-fidelity sketches intended to spark conversation around high-level possibilities, as opposed to conversation around final form factors, colour, materiality, etc. The sketches shown in fig. 25 are slightly higher-fidelity sketches intended to convey initial ideas of how a product might work and even look.

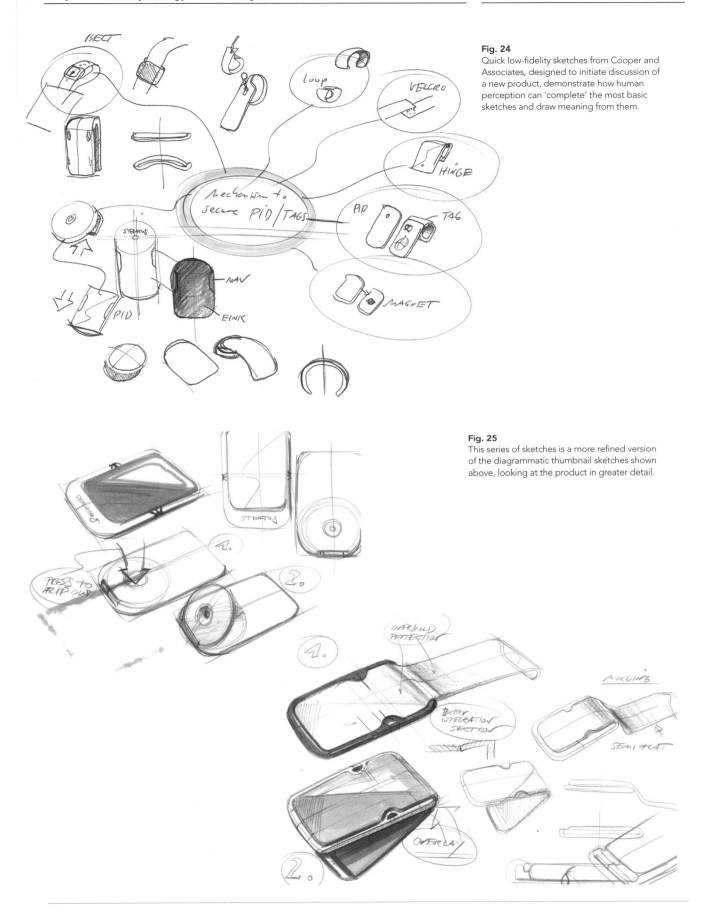

Fig. 24
Quick low-fidelity sketches from Cooper and Associates, designed to initiate discussion of a new product, demonstrate how human perception can 'complete' the most basic sketches and draw meaning from them.

Fig. 25
This series of sketches is a more refined version of the diagrammatic thumbnail sketches shown above, looking at the product in greater detail.

Bad ambiguity is accidental

Bad ambiguity is more of an accident and occurs when the designer still lacks the knowledge to sketch in a way that maximizes readability without minimizing possibility. Bad ambiguity tends to come down to mechanics, and how we see and interpret drawings. This type of ambiguity has a long history in the annals of psychology because of the limitations inherent in representing the three-dimensional world on a flat two-dimensional surface. Psychologists have studied visual ambiguity to better understand vision and cognition, and comprehending some of the standard pitfalls and how they 'work' on the brain tells us a lot about good sketching. The Penrose triangle (fig. 26), referred to as an unstable or impossible image, is a classic case in point. It is a visual paradox similar to verbal paradoxes like Oscar Wilde's quote 'I can resist anything except temptation'. Wilde may have wished to appear clever but the actual meaning of what he said refuses to close or be grounded, much like the Penrose triangle.

An overview of classic forms

A good place to begin reviewing bad ambiguity is with the classic forms named after the scientists who developed them, such as the Kopfermann cube, the Necker cube, the Ponzo illusion and the Rubin vase.

Herta Kopfermann worked with the original Gestalt pioneers – Wertheimer, Koffka and Köhler – in the 1930s. His cube (fig. 27) illustrates the fact that continuous lines will be read two-dimensionally while corners created by two intersecting lines will be read three-dimensionally. The continuous lines in this case are the front top edges and back bottom edges of the cube, which are co-linear and therefore read as existing on the same plane, thus flattening the drawing out. There is no differentiation between the foreground and background – another crucial Gestalt principle. Additionally, the front top corner (circled in red) is overlapping with the back lower corner, thus flattening the drawing further. The object's symmetry causes it to hover between a flat geometric form and a three-dimensional cube.

The Necker cube (fig. 28) – named for the Swiss naturalist Louis Albert Necker, who first published the image in 1832 – is also considered an unstable image. Due to the parallel set of lines/edges, the symmetry and the lack of line-weight differentiation, the cube has a tendency to move forwards and backwards the longer it is viewed. The symmetry is more complex than Kopfermann's cube, consisting of two different sets of shapes that rotate around a central axis, but the instability is still present. The lack of receding lines and variation in the line weights contributes greatly to the object being ungrounded. By applying colour to the corners or filling in the front plane, ambiguity is reduced.

Fig. 26
Correcting the Penrose triangle merely requires reorienting the correct edges to each other. Some of the impossible drawings for which the Dutch artist M.C. Escher is famous come out of similar manipulations.

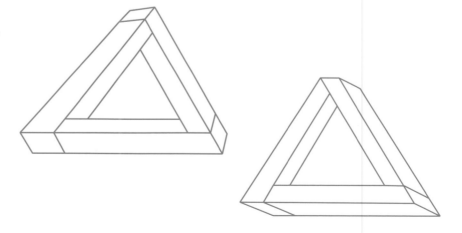

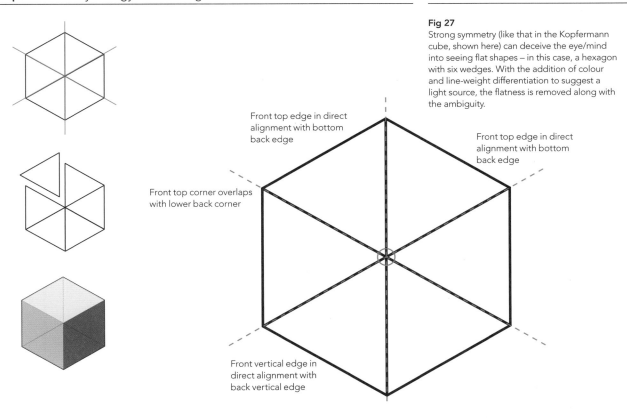

Fig 27
Strong symmetry (like that in the Kopfermann cube, shown here) can deceive the eye/mind into seeing flat shapes – in this case, a hexagon with six wedges. With the addition of colour and line-weight differentiation to suggest a light source, the flatness is removed along with the ambiguity.

Front top edge in direct alignment with bottom back edge

Front top edge in direct alignment with bottom back edge

Front top corner overlaps with lower back corner

Front vertical edge in direct alignment with back vertical edge

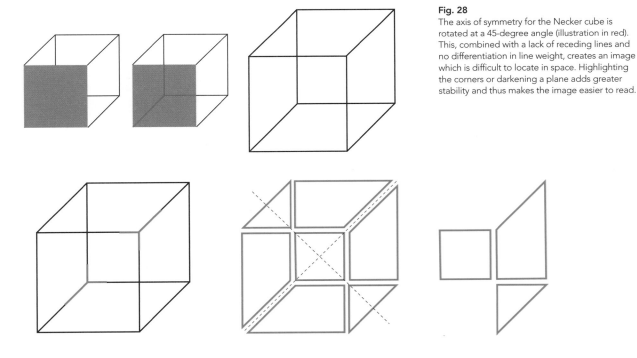

Fig. 28
The axis of symmetry for the Necker cube is rotated at a 45-degree angle (illustration in red). This, combined with a lack of receding lines and no differentiation in line weight, creates an image which is difficult to locate in space. Highlighting the corners or darkening a plane adds greater stability and thus makes the image easier to read.

Fig. 29
(Below) The height of the green centre panel is identical to that of the back wall, but because the wall is at the end of a receding set of lines the brain reads the panel as smaller. The power of receding lines cannot be overestimated.

Fig. 30
Two identical red rectangles have been superimposed over railway tracks. The power (or context) of the receding lines to suggest depth makes the top one naturally appear larger and longer.

The Ponzo illusion (fig. 29) is named after Mario Ponzo, who first demonstrated it in 1913. The illusion is clear proof of the power of depth cues: the mind tries to determine an object's size based on the background or spatial context. The photograph in fig. 30 was taken in winter to simplify the background while revealing only the receding rails. The superimposed red rectangles are identical in both length and height, yet the top one appears both longer and wider because of our natural tendency to read depth when we see receding lines. Context in sketching and drawing can be just as critical to comprehension as it is in a photographic image.

The power of context: figure and ground

Figure and ground relationship, a concept formalized by the Gestalt psychologists, remains a central part of most visual perception theories. The simplest way to think about it is to imagine a person (figure) standing in a landscape (ground).

In the sequence of images in fig. 31 certain aspects of the relationship have been isolated. The floating figures, for example, have no ground to stand on. Depth cues like the receding lines of the road, the diminished scale of the clouds, the cast shadows and the horizon are all natural cues that provide context.

Context is vital to good ideation sketching, whether in the form of a cast shadow (which literally grounds an object) or a hand holding the product, or a vignette to frame it.

The Rubin vase shown below (fig. 32) is the classic example of figure–ground instability. Unless one of the two is emphasized the resulting image will flip back and forth. The fact that the background forms a recognizable shape only confuses the issue further.

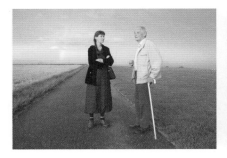
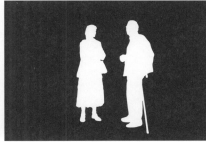
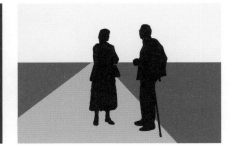

Fig. 31
Above left is the original photograph; the middle image shows the figures 'floating' and the right-hand image has the figures 'grounded'.

FIGURE/GROUND RELATIONSHIP

Background (clouds & sky)

Figure (person)

Figure (person)

Ground (grass)

Depth cue (road)

Ground (grass)

Fig. 32
The Rubin vase demonstrates how the eye hovers between two potential readings of the same image as it tries to ground it. Until either the background or the foreground becomes dominant the brain will struggle to determine depth.

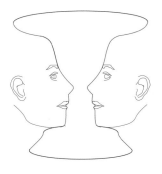

DEFINING
SKETCHING

What is sketching?

In this chapter we will begin by exploring various manifestations of sketching and end by looking at the many ways sketching has been impacted by the grid. Sketching is an explorative tool that can be applied as easily to form-giving as to diagramming research or mapping user interactions, and should not be thought of as a finished artefact but rather as the traces or evidence of an ongoing process.

Psychologist Barbara Tversky writes that 'sketches serve to amplify a designer's imagination and relieve limited-capacity working memory.' Amplification in the face of limited memory resources requires the designer to get still unformed ideas onto a sheet of paper for examination quickly before they disappear. These ideas have to be assessed, adapted, appended and either accepted or discarded so that the process can move fluidly. Bill Buxton, chief scientist at Microsoft, describes the process as: '… a quick way to generate and share many ideas in such a way that the ideas can generate more ideas…' Buxton expands his description with a list of attributes including: quick, timely, inexpensive, disposable, plentiful and ambiguous. Ambiguity in this case refers to low-fidelity sketches as opposed to the unstable or impossible ambiguity of the Necker or Kopfermann cubes. A good quick sketch conveys enough information to be interpreted while leaving a lot to the imagination of the viewer (including the designer). Tversky adds: 'This iterative process of constructing, examining, and reconstructing has been called a kind of "conversation"' in reference to the work of Donald Schön. A technical drawing, on the other hand, is considered closed and defined, and invites little or no interpretation, only a reading.

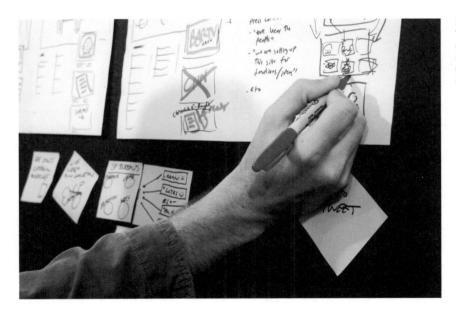

Fig. 1
The initial research phase of design often combines quick note taking with very rough and approximate diagrammatic sketches and even doodles to get ideas out for further refinement (Image courtesy of IDEO).

Sketching as a form of visual thinking

Drawing not only predates writing but also anticipates some of its primary characteristics, such as the use of discrete units, linearity and a spatial orientation that is often left to right. Barbara Tversky has noted the existence of similar graphic inventions among many pre-literate cultures and points out that many of these same approaches or preferences are naturally employed by children. She writes: 'These similarities and parallels suggest that the depictions of many concepts and relations are natural or cognitively appealing, that there are cognitive principles underlying the similarities.' As children learn to read and write they lose much of the ease and sophistication of earlier doodling, in part because of the inherent abstraction of language. Dan Roam, author of *The Back of the Napkin*, notes that nearly every child in a kindergarten class will raise their hands when asked if they can draw; ten years later only three of the children will raise their hands. This is what Betty Edwards addressed in her book *Drawing on the Right Side of the Brain* – the need for artists to move away from the 'logical/language' side of the brain towards the more visually intuitive. However, the issue for designers is how to leverage both the visual and the verbal skills, since each has its own powers as well as its own shortcomings.

For example, iconic drawing as a communication tool fails in capturing nuances beyond people, objects and simple activities. Attributes and relations, for example, are hard to represent because they are abstract: preparing hot food is

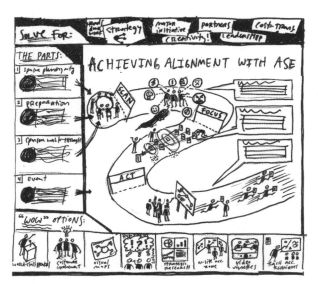

Fig. 2
The original napkin sketch for Xplane's Capgemini project shows just how simple and straightforward a rough idea can be and still communicate. In this case placeholders suggest information to come, but otherwise the overall composition is very close to the final concept.

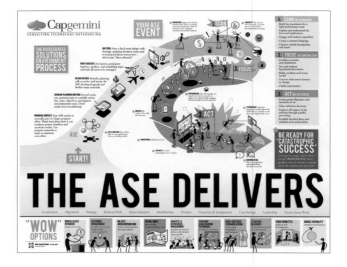

Fig. 3
The composition and structure of the napkin sketch is clearly present in the final poster. The fidelity is only fractionally increased with the addition of drop shadows to help ground the figures. The designers have added colour and type hierarchy while reorienting the overall direction to align it more along the natural left–right direction required when reading English.

more difficult to depict than the food itself. Single sketches lack the subtlety required to explore the temporal or even causal, which are better expressed through sequential sketches or rough diagrams. Of course, children are less concerned with the clarity of communication in their drawings even as they intuitively manipulate the spatial relations of hierarchy, scale and distance along with colour or line characteristics to create rich and dense images. These skills clearly lie dormant in us, waiting to be reawakened and utilized not as child-like drawings but as images that merge the power of quick and simple sketches with the sophistication of language and writing. Consultants like Dave Gray (Xplane) and Dan Roam rely on 'low-fidelity' iconic sketching to work through complex business-related problems. Combining the power of verbal and visual languages to communicate among varied stakeholders to arrive at clear visualizations.

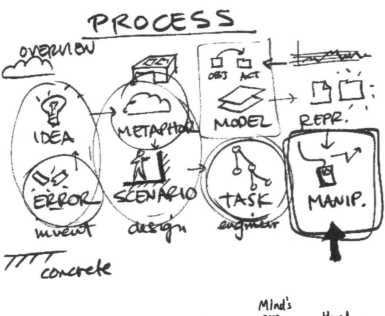

Fig. 4
Bill Verplank's process diagram explaining the eight stages of interaction design demonstrates the power of quick diagrams to combine iconic sketches, language, arrows, containers, spatial layout and sequence to convey complex ideas as succinctly as possible.

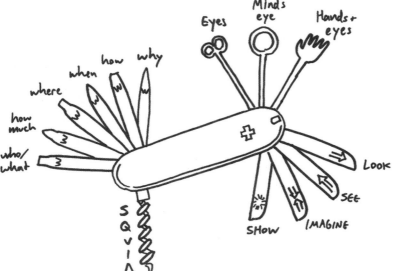

Fig. 5
Dan Roam cleverly uses the iconic Swiss Army knife and adapts it to his own purposes as a visual metaphor and mnemonic device for the visualization process. Each nested blade swings out from the larger handle to reveal a specific task, question or skill. Roam's work in visual thinking has precedents in classics such as Robert McKim's *Experiences in Visual Thinking*. Image copyright 2010 Dan Roam www.backofthenapkin.com

Diagramming is writing and sketching

The diagramming process utilizes a number of techniques favoured by writers interested in an economy of means. Metonomy, for example, allows a part to represent the whole (all hands on deck); a synecdoche relies on a symbol to represent the whole (a crown for the royal family). Good diagramming relies on these types of shorthand method to ensure speed while not getting bogged down in details that are not necessary for quick communication. When diagramming the designer should work provisionally; quickly utilize the page's spatial layout, colour, line weight, scale and position; leverage any graphic connectors to convey meaning. Rough diagrammatic sketches can be further scrutinized, revised and appended before being turned into a more polished diagrammatic drawing. Even at this stage decisions can be made to increase clarity, add new components or otherwise revise.

Given the fact that most design projects begin with a written design brief that is followed by a range of activities including observational research with photography and video, interviews, user maps, scenarios and competitive benchmarking matrices, it's helpful to keep the whole process as visual as possible. Standard research-based practices include 'war rooms' where all the visual collateral including jottings on Post-it notes, sketches, photographs, charts and diagrams can be assembled and reviewed, and kept in one place during the run of the project. The walls of the room become a record (a 3D sketch) of the process as it moves from information gathering through the winnowing down of materials into a more coherent set of definable issues that the team has agreed on.

Diagramming involves broad and generalized thinking that focuses on larger and more abstract issues such as organizational structures or the interaction of multiple inputs in a system as opposed to the actual appearance of things. Because the eye is not constrained by the horizontal lines of a ruled book, it can scan diagrams in a way that is similar to natural vision. The diagram is more of a visualized schema than a picture and takes advantage of spatial organization, scale and hierarchy to help convey importance visually as well as utilizing simple discrete shapes and colours to help differentiate ideas or inputs/outputs.

While diagramming may seem less accomplished than realistic sketching it is really just a different kind of sketching. It can assume many forms including what is commonly referred to as a wireframe sketch, for a website or interactive device.

Fig. 6
Large boards that can be slid in and out of view are often covered with Post-it notes that keep the information compact, organized and colour-coded so that it can be viewed with ease and speed. (IDEO's Palo Alto office, Courtesy IDEO)

Below is a diagram that works much like a flowchart to visualize the various interactions of a product. This might be as simple as a kitchen timer (figs 7 and 8) or as complex as a smart mobile phone. Diagrams like these are most often presented as flat 2D representations of aspects or components of the interface. This is the least ambiguous view and does not attempt to suggest illusionary depth. The orthographic view also has natural cognitive attributes that make it easy to understand, much like a map.

Fig. 7
Diagram for the interface of a kitchen timer for the Swiss company Zyliss by RKS Design. Through sequencing the flowchart demonstrates the various states, which are often nested under a single button with a jog dial.

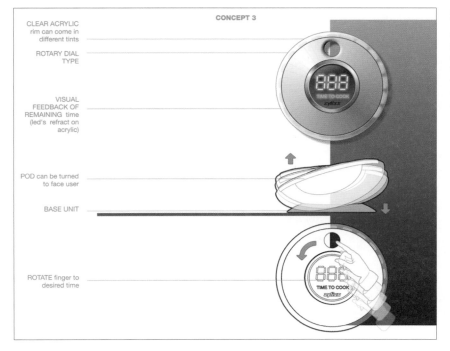

Fig. 8
This design of the Zyliss kitchen timer involved mapping out the menu interaction along with the physical or haptic interaction (button/jog wheel dial above). The considerations that go into a time-based interaction are very different to those for form-based sketching but it is increasingly important for product designers to understand and master them.

Fig. 9
The types of diagram used in sports reflect a basic level of realism: who is in what position, where are they going and in what order. Diagrams like these capture time in a single image and rely heavily on conventions such as arrows, dotted lines, x's and o's, and the use of colour to differentiate the elements.

Fig. 10
Diagramming in sand or dirt is a natural and age-old way to give directions.

Fig. 11
A footprint is an index: a physical sign resulting from an interaction. Reading it can reveal whether the person was wearing a shoe or walking barefoot, the general direction they were going in, their approximate weight, the speed of their gait and roughly when they passed by.

Natural mark-making: a precedent for drawing

Diagramming is clearly part of the original human impulse to communicate: to document the hunt so as to organize the group effort. This can be seen on the walls of caves at Chauvet or Lascaux in France, or in the playbooks of the US National Basketball Association (fig. 9). It is not a great mental stretch to imagine the footprints of animals in the snow, sand or wet soil serving as an early model for sketching and diagramming the direction from which they came. Such prints reveal a tremendous amount of information including the identity of specific animals, approximate time of travel (based on the freshness of the tracks), animal size and whether they were running or walking (spacing between tracks). As hunters, our species had to learn to interpret such information. Our hunting origins may also explain why the arrow has become such a universal symbol of direction.

Nature has an arsenal of tools for creating meaningful marks which we constantly read and extract information from, including the tides of the ocean and wind-sculpted patterns in sand dunes. Sunlight casts temporary and ever changing shadows over the landscape, which tell us where the sun is as well as the nature of an object's shape and surface (shiny, matt, etc.). Indeed, the eye's sensitivity to light, shade and shadow is so subtle and powerful that trying to render an object without understanding the light source or the many ways in which light reflects off various surfaces will result in unconvincing results. Our eyes and brains are exquisitely tuned to extract the information required to make sense of the world projected onto our retinas.

Fig. 12
The subtle blue-white gradients in this image help the brain to understand the topography.

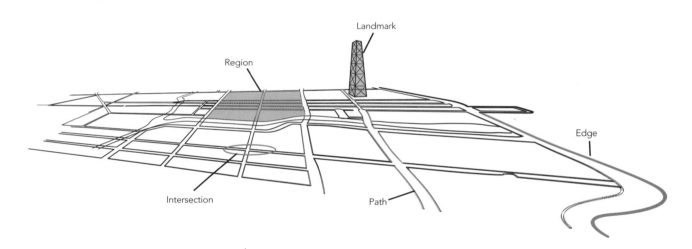

Maps: edges, paths, nodes, landmarks, regions

In his book *Image of the City* the architect and urban planner Kevin Lynch identified five classes of commonly found features used to structure the environment at an urban scale: paths, edges, nodes, landmarks and regions. On the microscale of sketching, edges, nodes, paths and regions factor into the way we read and create sketches. Edges correspond to the outlines of objects; nodes correspond to corners where multiple vertices intersect; paths can be thought of as the interior contours within an object; and regions can be thought of as the individual parts that make up most products (buttons, attachments, switches, caps, etc.). In the most fundamental sense, sketches are maps that we scan in order to make sense of an object's topography. Humans excel at reading geographic maps, which are flattened topography, because we envision ourselves walking through the depicted landscape; we can mentally shrink ourselves to fit inside the space of the map. Patterns, line weights and colours to help us distinguish larger regions from distinct arteries like thoroughfares, boulevards or common roads. Likewise, a good sketch allows us to 'handle' an object mentally and experience its form visually.

Fig. 13
The five classes identified by Lynch are illustrated in red using the city of Chicago: a path as defined by Michigan Avenue; the city's edge where it meets Lake Michigan; intersection where two streets meet; a landmark as represented by the Hancock building; an entertainment region defined by several streets.

Mapping: plan view

The convention of the plan view grew out of both the tracks made by animals and early map-making where the topography was flattened into a single comprehensive view. But lines alone don't provide enough detail to understand the 'valleys and peaks' of a natural landscape. For this we must rely on shade, shadow and gradients to create the necessary illusion of depth. In the mountain map fragment (fig. 14) the gradients confirm for the viewer what is convex and what is concave. Maps, like sketches, begin with boundary outlines and are slowly filled in with more detail – shading is an essential ingredient.

Fig. 14
Maps are sophisticated compression schemes of height, width and depth. Maps represent 3D data compressed onto a single flat plane.

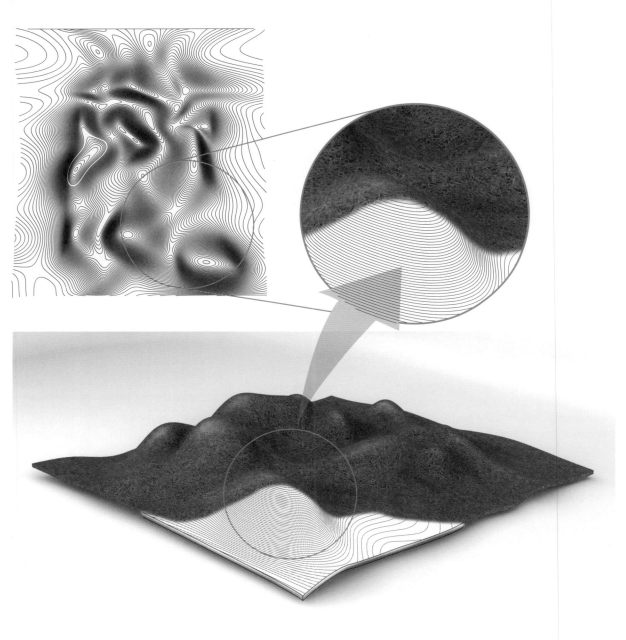

The human silhouette could be considered equivalent to a plan view. Some 2,000 years ago, Pliny the Elder wrote that the invention of painting, as recorded by the ancient Greeks, originated with '… tracing lines round the human shadow'. According to legend, the daughter of a potter traced the profile of her lover's silhouette on a wall before he went abroad so as to remember him while he was away. Her father is said to have filled in the profile with clay and modelled it to resemble a human, thus completing the first sculptural relief.

These tales epitomize the power of both sketching and modelling. However, a sketched or drawn silhouette can function only as the most primitive map until the interior details are filled in. After there has been enough time for them to burn into our memory they can be removed without total loss of function, (like the watch faces in fig. 16). An outline alone will remain ambiguous in the cognitive sense of the term, as shown in fig. 15, because it is hard to distinguish if we are looking at the front or the back.

Given the fact that our brains are far more efficient at deciphering the world along the flat x and y axes (the image plane), as opposed to the z axis (depth) the map seems an apt metaphor for diagramming and sketching. As Colin Ware describes it: 'A pencil line is nothing like the edge of a person's face, yet a simple sketch can be instantly identifiable. The explanation of the power of lines is that they are effective in stimulating the generalized contour mechanism.'

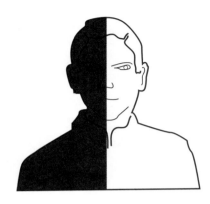

Fig. 15
While front-on silhouettes are great for creating tension in films they are virtually worthless for identifying a character. With this orientation it's difficult to even gauge whether someone is moving towards us or away from us when they are viewed from afar and in low light.

 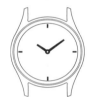

Fig. 16
Our familiarity with the layout of a clock has been so ingrained in our brains through repetition that the actual numbers can be removed without any loss of comprehension.

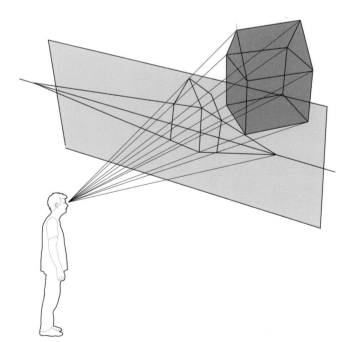

Fig. 17
The image plane (in blue), which the human brain is perfectly adapted to read, is very similar to the viewfinder in a camera. Even though we are looking into a three-dimensional world, it is faster and less resource-intensive to scan the surface of the image plane up and down and left to right, and mentally construct the depth information from depth cues, edge, texture and colour boundaries, and light cues. Skilled sketchers understand the projection process well enough to place points accurately in order to build whatever they see in their mind's eye.

The labels visible within the sketches include: REAR ADJUSTMENT ⇒ INTERNAL, MATERIAL BREAK, BOTTOM ACTS AS NECK SUPPORT UPON CONTACT, TRIGGER RELEASE OPTION, BRIM, VISOR REMOVES PUSH BUTTON RELEASE, INFLATED PADDING, FUNCTIONAL BRIM, CONCEPT 1, CONCEPT 2, REAR VENTILATION, CONCEPT 3

Fig. 18
These images of a bicycle helmet represent the full range of visualizations beginning with quick orthographics, a rendered sketch and finally a photoreal computer rendering. Such a range represents the typical continuum between initial low-fidelity sketches and a final high-fidelity rendering. Physical prototyping (not shown here) is also an essential part of this process.

The power of drawing conventions

Sketching and drawing rely on the power of conventions – common rules and procedures established by a community of users to facilitate quick exchange – just like language. And while language conventions continue to evolve subtly due to the abstract nature of spoken and written words, drawing conventions, based as they are on perception and geometric construction, have had centuries to cohere. Drawing conventions serve to limit the possible number of interpretations while providing clear procedures for creating specific drawing types. The three most common drawing types are orthographic, isometric and perspective. Additional conventions like section cut and details make drawings easier to comprehend. Sketching relies on these same conventions although it is done more loosely with less attention paid to accuracy. Throughout the book the various drawing systems will be referenced to teach sketching techniques, but for now let's review the drawing systems using a simple house as an example.

The identical house is shown in all the illustrations on the right, yet each of the drawing systems emphasizes slightly different views. Isometric and perspective are clearly the most related, but it is orthographic that allows for the accurate dimensioning of an object, space or structure for purposes of building or fabricating. All of the systems rely on projection.

The orthographic system assumes that the viewer is infinitely far away from the object so that only one of three planes can be seen, along with anything that is parallel to that view. While it is not representative of the way humans actually see objects, there is no distortion, which means the various views can provide accurate dimensional information for construction. The convention minimally displays a top, front and side view which are aligned. Orthographic will serve as the foundation for teaching perspective throughout this book.

Fig. 19
Orthographic

The isometric system is a subsection of a larger system known as paraline drawing which includes diametric, trimetric and axonometric. In isometric the three primary planes (top, front and side) are visible and parallel lines on the object are depicted as parallel in the drawing. Isometric variations, like axonometric, result from the angle of rotation away from the primary picture plane.

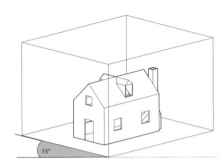

Fig. 20
Isometric

The perspective system comes closest to the natural way humans perceive the world. In perspective the three primary planes (top, front, and side) are visible and all lines parallel on the object recede to either one or two vanishing points (situated on the horizon line). While three-point perspective is possible it is less common. Perspective is excellent at representing the world as we perceive it; however, it is ineffective at accurately communicating dimensions. It is also optically more difficult to master.

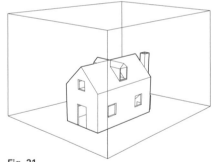

Fig. 21
Perspective

The section cut is an extremely powerful visualization convention that allows the designer to cut through an object or space and peer inside. Sectioning may be thought of as slicing at any angle to reveal what lies beneath the external 'skin', whether that is brick and stone, plastic, wood or any other opaque material. Slicing an apple in half produces a section cut. The section is also a very powerful conceptual tool because it provides a way of 'building' sketches more dynamically (see chapter 5).

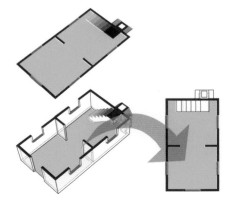

Fig. 22
Section cut

The grid: flat space

Renaissance artists and designers used the grid more than any other tool to develop and codify the laws of perspective. It had been fundamental to the Greek geographers Hipparchos in the second century BC and Ptolemy 400 years later in their quests to measure and map the world (longitudinal and latitudinal grid), and it was equally fundamental to Piero della Francesca in translating geometry from front view into perspective. Art historian Hannah Higgins (*The Grid Book)* points out just how central the grid has been to the measure of everything from the unit of building (the brick) to the organization of cities (gridiron) to the primary metaphor of our networked world (the internet as an informational web). Prior to Brunelleschi's peepshow the grid was a primary tool in the workshops of Florence for creating perspective-like space, in part because of the prevalence of tiled interiors. And, of course, Dürer applied the regularity of the grid to the human body to measure and project it more accurately and proportionately into other views. Today most software relies on grids, whether for graphic, text-based or computer-aided design programs. Even Gutenberg's moveable type implies a gridded page that accounts for every letter as well as every negative space.

Fig. 23
Tiles serve to uniformly grid the floor plane of a space. In order to create an accurate illusion of diminishing tiles in space, the vertical lines projected from the central vanishing point must be intersected by additional lines projected from vanishing points to the left and right. These intersection points mark where the horizontal lines (orthogonals) will be placed.

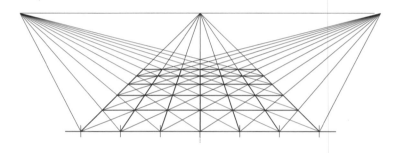

The way the grid works is to consistently subdivide space into ever smaller vertical and horizontal increments, thus creating a uniform mesh. This mesh can be laid over any design (linear or organic) and mapped by plotting points at intersecting lines (fig. 23). Dürer understood this when he designed his various perspective machines. Artists have long used the grid to transfer drawings from one surface to another, and to scale small sketches up simply by changing its unit measure. Finally, every graph or value-laden chart relies heavily on two- and three-dimensional grids to map the change of two or more phenomena against each other, thus providing the viewer with a snapshot of what is happening: for example, the increase in a city's population over a specific period of time (fig. 24).

Fig. 24
The bar graph relies on an underlying grid to accurately place data for comparison. A standard procedure places one set of criterion along the vertical y axis and another along the horizontal x axis to visualize two interlinked variables over time. An example of the graph's common use would be to chart the rise of a nation's population over the course of a century.

For rapid sketching, the grid can be incredibly useful for locating or mapping points accurately in space to create centrelines, diagonals, arcs and other sketch geometry (fig. 25). The coordination between eye and brain is reinforced through an awareness of the underlying gridded space, and as skills increase the grid can disappear slowly and serve more as a ghost grid for projecting symmetrical points across centrelines to build form quickly and accurately.

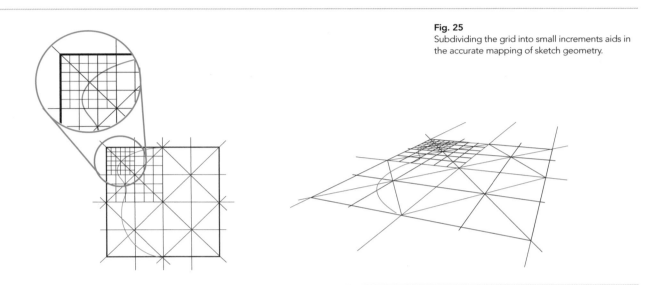

Fig. 25
Subdividing the grid into small increments aids in the accurate mapping of sketch geometry.

The French mathematician René Descartes, who is credited with uniting mathematics and geometry, understood that the grid could be extended indefinitely into space, creating a three-dimensional grid (fig. 26). Cartesian space, as it has come to be known, is a uniformly gridded space (in two or three dimensions) with numerical values overlaid on top of the grid. Anything set into this space, whether two- or three-dimensional, can have an exact set of coordinates assigned to it based on its distance to the origin (the intersection of all axes).

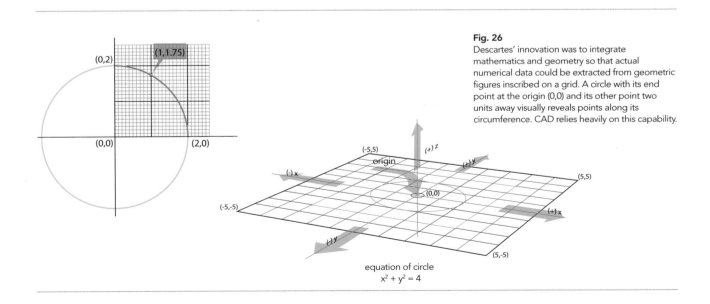

Fig. 26
Descartes' innovation was to integrate mathematics and geometry so that actual numerical data could be extracted from geometric figures inscribed on a grid. A circle with its end point at the origin (0,0) and its other point two units away visually reveals points along its circumference. CAD relies heavily on this capability.

equation of circle
$x^2 + y^2 = 4$

Descartes devised his system in around 1637 and it is now a central feature of every CAD/CAM system on the market. The hand icon (thumb, forefinger and middle fingers point 90 degrees away from each other) is commonly used to explain Cartesian space in many software applications.

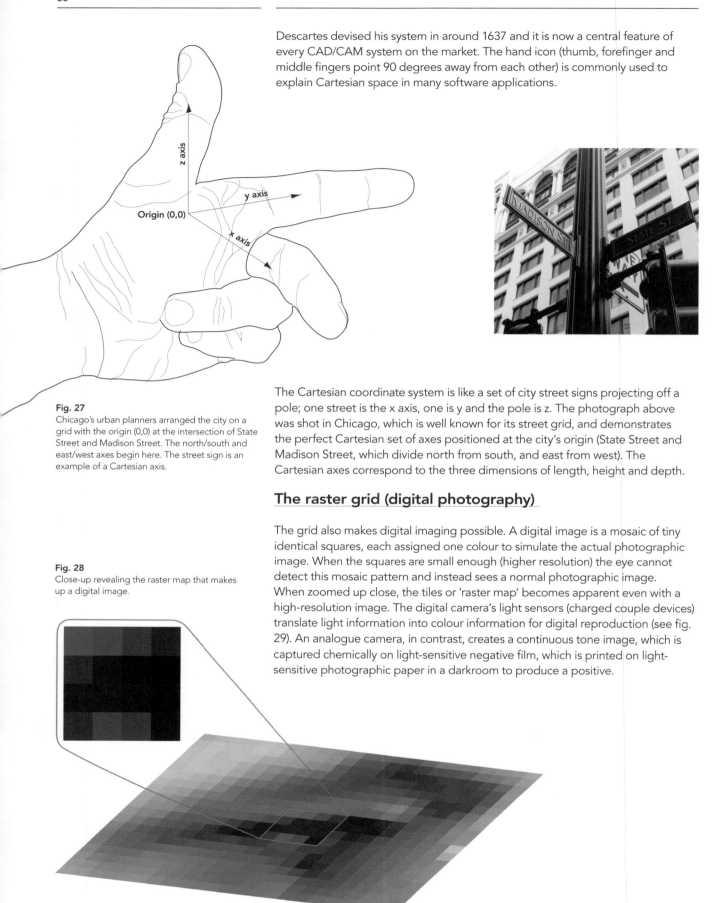

Fig. 27
Chicago's urban planners arranged the city on a grid with the origin (0,0) at the intersection of State Street and Madison Street. The north/south and east/west axes begin here. The street sign is an example of a Cartesian axis.

The Cartesian coordinate system is like a set of city street signs projecting off a pole; one street is the x axis, one is y and the pole is z. The photograph above was shot in Chicago, which is well known for its street grid, and demonstrates the perfect Cartesian set of axes positioned at the city's origin (State Street and Madison Street, which divide north from south, and east from west). The Cartesian axes correspond to the three dimensions of length, height and depth.

The raster grid (digital photography)

The grid also makes digital imaging possible. A digital image is a mosaic of tiny identical squares, each assigned one colour to simulate the actual photographic image. When the squares are small enough (higher resolution) the eye cannot detect this mosaic pattern and instead sees a normal photographic image. When zoomed up close, the tiles or 'raster map' becomes apparent even with a high-resolution image. The digital camera's light sensors (charged couple devices) translate light information into colour information for digital reproduction (see fig. 29). An analogue camera, in contrast, creates a continuous tone image, which is captured chemically on light-sensitive negative film, which is printed on light-sensitive photographic paper in a darkroom to produce a positive.

Fig. 28
Close-up revealing the raster map that makes up a digital image.

Fig. 29
A Bayer filter, an additional filter over the charged couple device (CCD), has three gridded layers of colour filters consisting of red, green and blue (RGB). Note, however, that 50 per cent of the filters are green because our retinas are much more sensitive to green than to the other colours.

The mechanics of vision: eyes and camera

The human eye, while a great metaphor for lenses of all kinds, captures information differently to a camera. Vision begins when light reflected off an object enters the eye through the cornea, which begins the first of several focusing procedures. The light signals pass through a clear, watery fluid, the aqueous humour, and then through the pupil, a central circular opening in the iris, which further focuses the light signals by appropriately limiting or increasing the amount of light. The light then travels through the lens which, like a camera, focuses it further by changing shape depending on whether objects are near or distant, and beams the light through the centre of the eye to reach its final destination within the photoreceptors of the retina. The focused light is projected onto the flat, smooth surface of the retina and converted into electrochemical signals by specialized nerve endings called rods and cones. These signals are delivered to the primary visual cortex where the edge detection process described in chapter 2 begins.

Fig. 30
A simple section cut through the eye to reveal some of its internal structure.

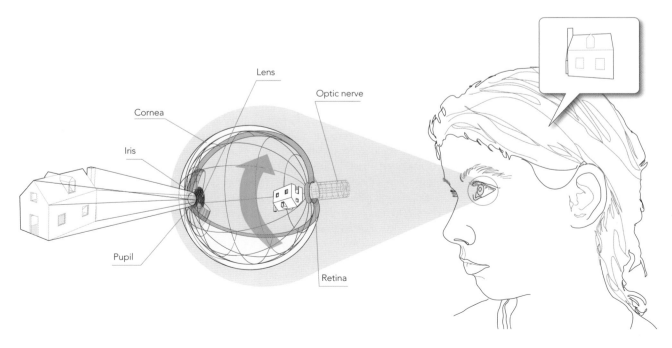

Fig. 31
The camera lens simulates the movement of the
eye through an assembly of lenses that can travel
closer or further away from the film or CCD,
depending on focus. The eye, by comparison,
focuses by changing the shape of the lens:
to focus on distant objects it must flatten out
(plate-like); to focus on close-up objects it must
become more convex or spherical (ball-like).

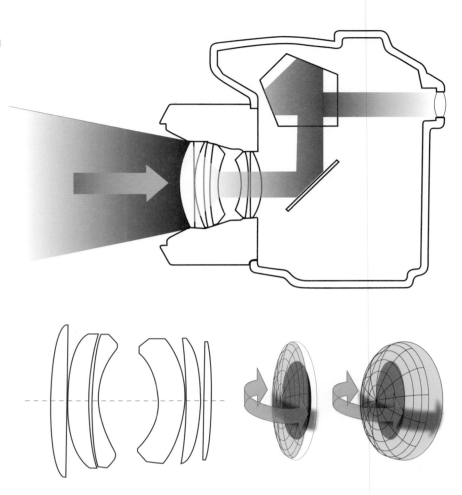

The camera lens, unlike the eye, has to be mechanically (or electronically)
manipulated to change focus. The image is projected to the eye via a series of
mirrors and a prism to reach the viewfinder. Digital cameras rely on circuits,
lenses, charged couple devices and LCD screens to display the image.

The biggest difference between human vision and the mechanical vision
of photography is that humans posses two eyes (binocular) while the camera has
only one (monocular). Two eyes make depth perception possible. We move our
eyes or bodies to 'build' a fuller picture of what we are looking at or when we
need more information. Nevertheless, much of our day-to-day vision relies
essentially on the flat image a normal camera could produce: the image plane.

In *Visual Thinking for Design*, Colin Ware writes: 'About a million fibers in
each optic nerve transmit to the brain a million pieces of information about the
world in the combined up-down and sideways dimensions. For each of those
points of information there is, at best, one additional piece of distance information
relating specifically to the away dimension, and this extra information must be
indirectly inferred.' The fact that our brains are wired in a way that preferences
the world as a flattened rather than a three-dimensional reality suggests we
are ideally suited to the task of sketching. The challenge is learning to train the
brain to represent or visualize in the same way that we perceive. This involves
internalizing phenomena like foreshortening and projection, which we will cover
in depth over the next few chapters.

Foreshortening

Foreshortening refers to the visual phenomenon where geometry projected forwards – especially near to the line of sight – appears shorter when compared to other views. The edge of the glass below, for example, appears shorter when laid on edge and projected forwards (fig. 32).

In the illustration at the bottom of the page (fig. 33) the lens assembly in a camera has been exploded to reveal the helical path it must travel to focus at certain depths. It also shows the path along which light travels through the lens assembly before bouncing off mirrors and a prism to arrive at the viewfinder in the correct orientation. This process of projection and reflection is very similar to that used in orthographic projection to develop a third view from two existing views. This is explored in detail in the tutorial on orthographic projection at the end of this chapter (p. 62).

There is only implied or illusory depth in sketching and drawing because the image is flattened and static. A sketch or drawing is therefore very much like a photograph even though a human with binocular vision produces it. This is one of the challenges of sketching: learning to record static images as if a single lens like a camera's shot them even though we see the world through two lenses. But, as Ware points out, our main way of perceiving the world is much more reliant on the flattened image plane than on true depth perception. Donald Hoffman's earlier statement that the eye receives images on the flat two-dimensional surface of the retina and requires the brain to interpret their three-dimensionality reinforces this idea.

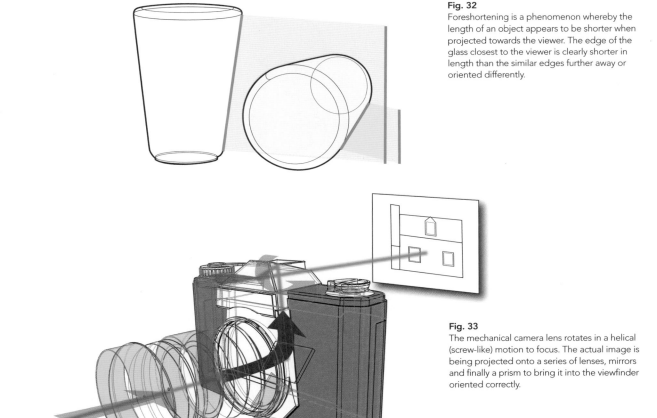

Fig. 32
Foreshortening is a phenomenon whereby the length of an object appears to be shorter when projected towards the viewer. The edge of the glass closest to the viewer is clearly shorter in length than the similar edges further away or oriented differently.

Fig. 33
The mechanical camera lens rotates in a helical (screw-like) motion to focus. The actual image is being projected onto a series of lenses, mirrors and finally a prism to bring it into the viewfinder oriented correctly.

Case Study

HLB Design Diagrams

HLB (Boston), like many design firms, uses diagramming to make sense of large volumes of complex and varied data gained from design research. Like sketching, the process is an iterative one that leads to increasingly refined visualizations which, while abstract (non-representational), are nevertheless spatial and easy to decipher at a glance. The series of diagrams shown on these pages represent the refinement process of visualizing how a company's competitors rank, using a numerical weighing system for the categories of cost, clinical, emotional and practical.

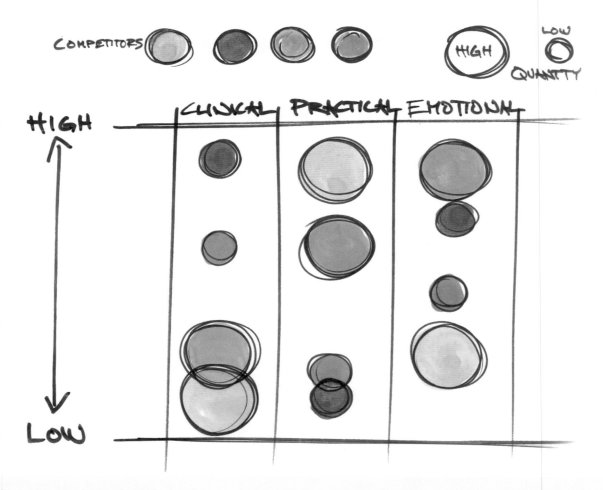

These first sketches are explorative. The initial sketches are a part of the analysis process. As the research team thinks through each competitor company, key criteria are identified and ranked. Colour and scale is used in the model to encode key types of data.

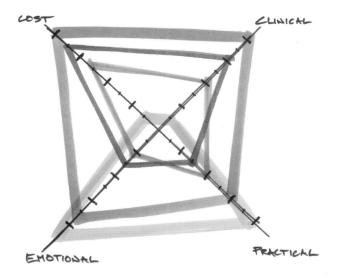

Hand sketches enable thinking to evolve quickly in advance of a digital model. The final diagram is an easy-to-read competitive landscape which, for maximum clarity, is free of excess labels: a visual key has been developed to identify companies along with their level of importance in each category. This is set off to the side so as not to interfere with the final diagram. The original hand-drawn matrix used numerical ranking and colour to sort the competitors. Note that the traditional Cartesian axes have been rotated by 45 degrees to create a more dynamic final diagram.

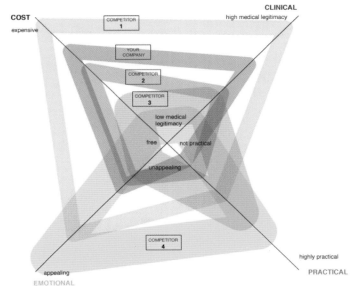

Tutorial

Orthographic projection

Orthographic projection is a network of horizontal and vertical projection lines that intersect to form points or vertices where two lines meet. To begin the process, one view must be known (top, front or side view, for example). The projection process can begin from this known view, moving at 90-degree angles horizontally and vertically. Standard orthographic drawing is laid out with the top view at the head of the page, front view directly below and the side view immediately to the right – which requires a 'reflecting plane' set to a 45-degree angle to translate the geometry over and down to the lower right quadrant of the sheet without distortion.

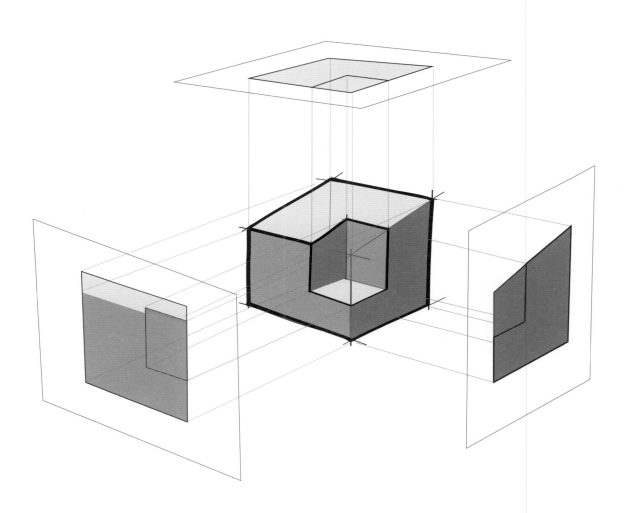

Reflecting plane

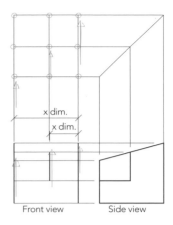

Side view

Front view Side view

1. Begin with the dominant view of the object – in this case the side view. Project lines from vertices (end points) in both the vertical and horizontal directions. These projection lines 'drive' the placement of geometry in the other views once there is a sufficient network of intersecting lines.

2. Lines projected vertically need to be reflected (rotated) 90 degrees to establish critical edges in the top view. To do this a reflecting plane set at a 45 degree angle is sketched. Angle is important because it's half of 90 degrees, thus eliminating distortion like the mirrors in a camera lens.

3. The dimensions of the front view must be determined beforehand. Sketch vertical lines to meet existing horizontal projection lines from the side view. Don't be concerned about the final appearance at this point. Sketch projection lines upwards to meet the reflected lines.

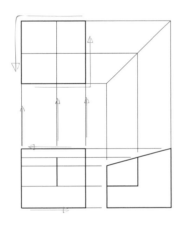

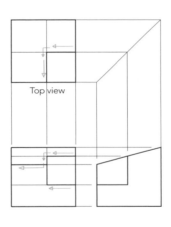

Top view

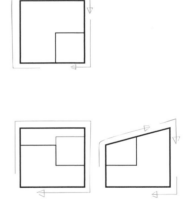

4. Sketch the perimeters of the top and front views defined by the intersecting vertical and horizontal projection lines. The remaining network of intersecting lines reveals where the last edges are to be placed. Networks like these can be confusing. Reference each view for help.

5. With outer boundaries of each view closed, sketch any remaining internal edges to finish the drawing. Mentally moving between the three views helps construct a three-dimensional understanding of the object. Orthographic views are used for dimensioning objects.

6. With darkened (bold) outlines the outside edges stand out. The flatness of orthographic views makes reading them difficult. Their strength comes through the ease of dimensioning. Equally important is the fact that anyone can extract dimensions with a scaled ruler.

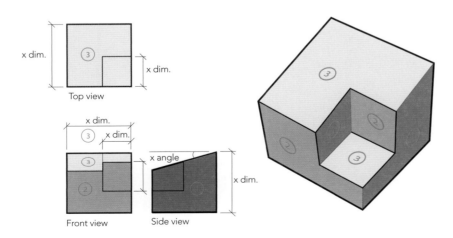

x dim.

3

x dim.

Top view

x dim.

3 x dim.

3

x angle

2

x dim.

Front view Side view

7. Even with the addition of colour, the orthographic view remains very flat because of its orientation – perfectly parallel to the viewer's plane of vision. In the perspective drawing each plane has been assigned a number from 1 to 3 and colour coded according to the view it is associated with. This has been transferred to the orthographic views. Note that only the front view has more than one colour because of the sloping plane. The perspective drawing enables an immediate understanding of the object but is not ideal for dimensioning.

Orthographic sketching

Loose orthographic sketches are one of the best ways to get ideas out quickly. Depending on the complexity of the geometry the process might initially require a single view. Most often designers will develop two views simultaneously; for example the dominant view along with one of the secondary views. In other situations three views are required to really understand the form. In the case of this Stanley knife the dominant view (side view) is the primary focus. Sketching the top view will help the designer with the product's overall form but the focus should be on the side view.

The sequence of sketches below represent a small part of the process of moving from the most basic geometry needed to define the footprint of the product to a more fully refined side view that can then be rendered for greater impact. The range of sketches have been included to show that a designer does not really need to know what the product is going to look like in the beginning but needs to start somewhere and build through iterations. Think of the below as a selection of crucial key frames in a much longer sketch animation. The step-by-step process on the following page shows the projection process for all three views even though a single view or a two-view is often enough.

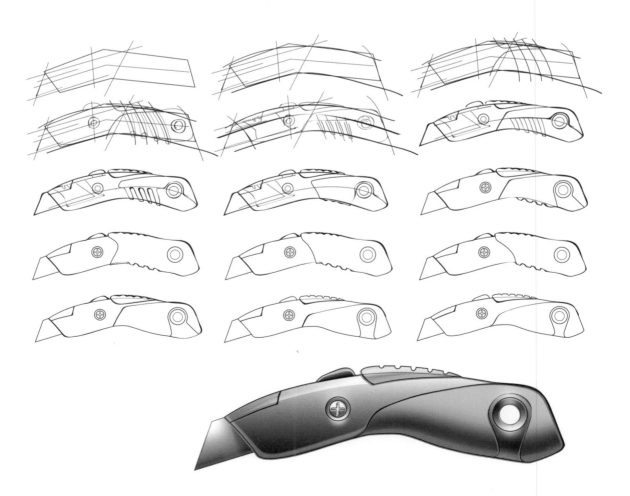

1. Begin with the simplest of layout lines to suggest the overall footprint of the product. In this case, the bend in the body of the product is indicated with straight lines although curves will be sketched over these lines. The projection lines have been drawn with a ruler but usually such sketches are done entirely freehand to keep the process moving. Two views are often enough to get started (front and side view). All three have been included here to clarify the interrelationship between views.

2. The first lines should be sketched as lightly as possible. They are there to help define the boundaries (envelope or footprint of the product). Over these more expressive lines or arcs can be accurately sketched. The projection lines help to register the geometry in the various views while assisting the designer in accurately shaping the product from multiple vantage points. It's not necessary to complete a single view before moving to the next view. They can be developed together.

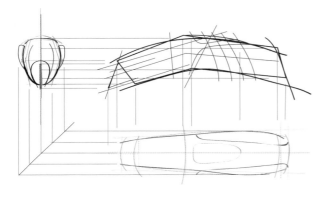

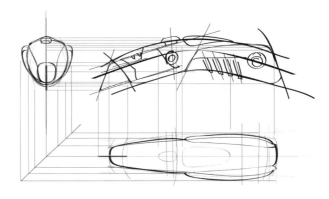

3. Secondary detailing can begin once the overall volume of the product is established. Much like the initial layout lines, secondary details like the grips in an overmoulded handle can be lightly and quickly sketched for possible placement. The whole point of this approach is to quickly place geometry knowing that it can just as quickly be changed or altered. This is not intended to be a control drawing but rather a quick and flexible concept; 20–30 drawings like this would be typical.

4. Now that the front and side views are developed somewhat it's time to move on to the top view. Note that not a single view is complete at this point: all three views are slowly being built and cross referenced. In reality, the top and side view would be the best candidates for sketching as they reveal the most about the product's overall geometry. Additional details like the blade release button and the blade carrier assembly are sketched to help accurately locate other components.

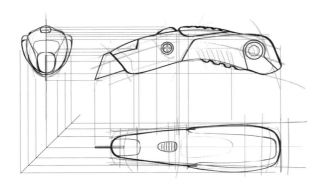

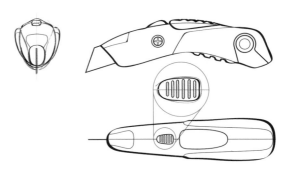

5. Line weights need to be adjusted. In this case a new sketch would be started with the original sketch as an underlay to help facilitate the process. In this process the details can be clarified. The outline is the darkest line and should serve to unify the body. Internal details like the overmoulded handle will be slightly lighter (thinner) and the fine details like the ribs on the release button will be the lightest (thinnest). Ghost lines can be left (like the blade assembly) or removed entirely.

6. Details like the grips on the button are added to the top view where they are easily read. Once the projection lines are completely removed the three views are much less obstructed. The front view has not been completely cleaned up. It is by far the hardest view to sketch accurately and less useful than the other two views given the extreme foreshortening. Nevertheless, any work done of any of the views makes perspective sketching that much easier because the geometry is familiar.

ORIENTATION

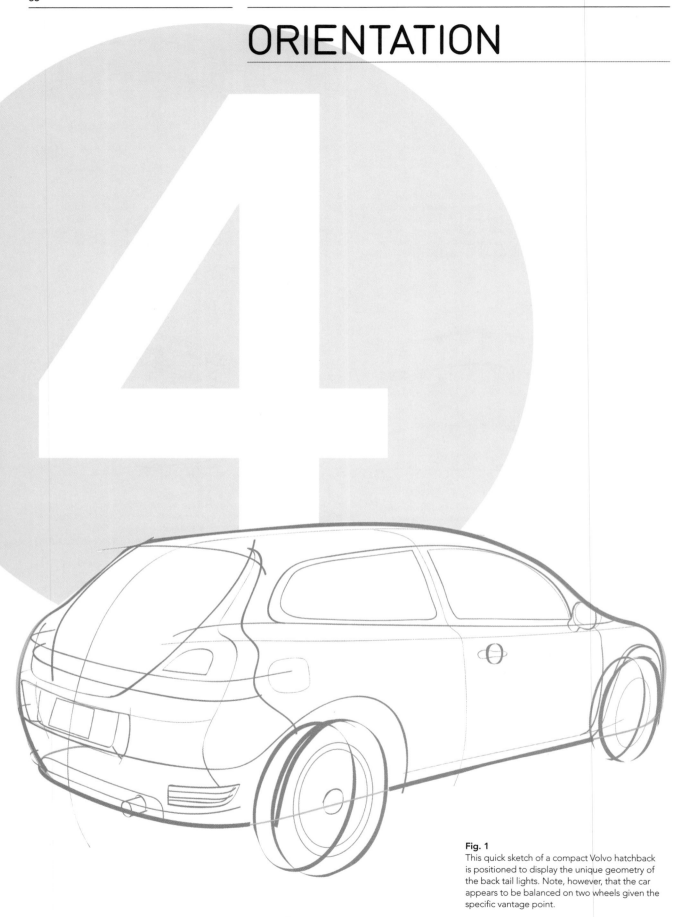

Fig. 1
This quick sketch of a compact Volvo hatchback
is positioned to display the unique geometry of
the back tail lights. Note, however, that the car
appears to be balanced on two wheels given the
specific vantage point.

Orientation, direction and point of view

As discussed in chapter 2, bad ambiguity is the result of factors including orientation (see Kopfermann's cube p. 39), lack of line-weight differentiation and deceptive or missing depth cues required to 'read' a sketch. Direction and point of view determine the way we perceive objects and spaces, so attention paid to these will lessen bad ambiguity. Context is another critical factor; a common mistake is to sketch an object in an unusual orientation because this is the easiest way to sketch it. A hand-held device should be shown in a hand or resting on the type of surface (table or desk) on which it is most commonly found as opposed to floating in space.

The majority of manufactured objects possess a strong sense of directionality: cars, drills or torches have directional biases based on their handles, direction of movement or the manner in which they are handled or operated. Directionality relates to the dominant and subordinate orthographic views commonly associated with objects. For example a car or chair is more recognizable from the side view than from the front or top view. For this reason, designers often make thumbnail sketches in the dominant view, to get ideas out quickly and establish key proportional relationships before adding in a subordinate view. Transitioning to perspective from orthographic is easier this way, as general proportions and critical geometry have already been fleshed out. When sketching in perspective the product should be positioned so that dominant and directional biases are emphasized.

For the same reason, symmetrical objects like bottles, plates or light bulbs, which have neither strong directional biases nor dominant views (other than front and rear labels), are not as affected by orientation.

Cognitive science research confirms that positioning an object (or sketch) in a way that clearly shows the interconnections between its various parts is essential to recognition. Adjusting the point of view (where the viewer is standing in relation to the product) has a big impact on how a sketch will be read. Views range from worm's eye to bird's eye, and wrap 360 degrees in all directions, making a lot of choice possible. This relates directly to the orientation of perspective or isometric drawings as they show multiple sides of an object simultaneously.

Fig. 2
This perspective sketch of a crutch includes a hand and arm to provide context. The ghosted-in centreline helps reinforce the main axes.

Fig. 3
Changing the vantage point (angle of view) so that the handle is clearly seen in relation to the body of the cup makes the sketch easier to read.

Fig. 4
These sketches of the Eames' LCW chair show how key features like the back leg can disappear when viewed from different vantage points. Its proportional relationships are most easily identified from its side view.

Fig. 5
The importance of orientation for comprehension is apparent in the mapping of the keypad on a mobile phone. Through repetition, the brain and hand commit the orientation to memory for greater efficiency. Dialing from an upside-down orientation requires conscious thought.

Front view Side view

Fig. 6
A simple illustration demonstrating the differences between a two-point perspective sketch of a chair and the respective front and side orthographic views.

Projection fundamentals

Orientation and point of view relate directly to drawing conventions. An orthographic positions the viewer directly in front, above or beside an object at an infinitely long distance, thus flattening the view to a single face. Both isometric and perspective position the viewer so that three faces are seen simultaneously. Orthographic views emphasize proportions and dimensions while isometric and perspective emphasize three dimensionality. Projection, however, is part of all the drawing systems and is therefore crucial to sketching and drawing. Projection occurs in many ways: a line is a projection between two points; a plane is a line projected into space; and complex surfaces are the result of projections between sectional sketches.

 In the illustration on the left (fig. 6) a simple 'chair-like' cubic form has been drawn in two-point perspective with the orthographic views projected onto parallel planes labelled front view and side view.

 This quick sketch of a hand trowel (fig. 7) demonstrates the creation of compound curved surfaces. Sectional sketches are connected by projecting a 3D curve from section to section to enclose the primary surfaces that make up the stamped metal trowel and the plastic handle. Understanding the many ways geometry can be projected requires understanding what makes up geometry: points (vertices), edges and faces (surfaces).

Understanding geometry

An object can be defined in the most fundamental sense as a series of connected surfaces enclosing space. These surfaces are either flat, curved or compound curved (double curved) and are defined by a single compound curved edge or a series of edges, which meet at a vertex. A cube, for example, has 12 edges, 8 vertices and 6 flat faces. If the corners of the cube were radiused the resulting geometry would be 24 edges, 16 vertices and 6 flat faces. Increasing the radius would eventually result in a cylinder with two flat surfaces (top and bottom), one curved surface (the side), two edges and no vertices. A good sketch or drawing has to account for all this geometry while the sketching process should, technically speaking, create it.

Fig. 8
Vertices (points), edges and faces (surfaces) are the components of geometry.

Fig. 7
The trowel surface and handle have been sketched by projecting a boundary outline that connects the sectional sketches together.

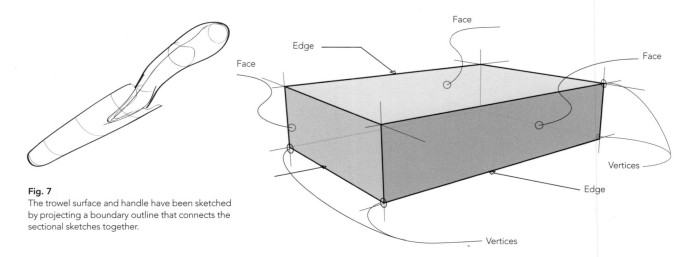

Fig. 9
This sequence is intended to highlight the surface changes required to transform a prism into a cylinder. The prism starts with 6 flat surfaces; changes to 6 flat surfaces and 4 curved surfaces (radiused prism); and finally to 1 curved and 2 flat surfaces (cylinder).

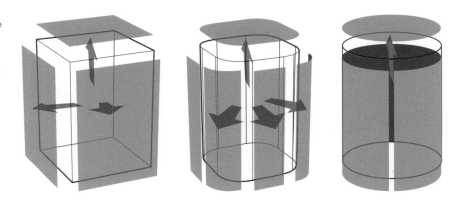

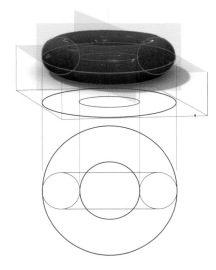

Orthographic system

The orthographic system creates geometry by projecting forwards and flattening every vertex, edge and face parallel to its primary plane – top, front or side. The resulting three views are unfolded and aligned opposite each other, which requires the viewer to mentally 'reassemble' the views into a full three-dimensional object or space (see fig. 6, opposite). The individual projection process is analogous to tracing each face of the object directly onto a sheet of paper. However, this analogy fails as soon as the geometry becomes more complex or is no longer parallel to the primary planes (illustrations of the house, sphere and torus – figs. 10 and 12). This type of geometry requires the designer to know where outside boundary edges and internal edges lie within the object, and project those that are perpendicular to one of the primary planes.

Fig. 10
(Above) When geometry is not flat, such as in a torus shape, the outermost edges have to be projected perpendicular to one of the primary planes. If there is internal geometry it, too, must be projected.

Fig. 11
An orthographic view is like a sectional slice through an object, which is then oriented in such a way as to display no distortion. These ski goggles show a plane passing through the centre of the product.

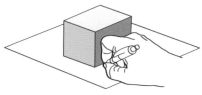

Fig. 12
Orthographic projection can be thought of as tracing every face of the object onto the flat surface of the paper through rotation. The challenge comes when the faces of the object are not parallel to the primary faces or when they are curved or compound surfaces.

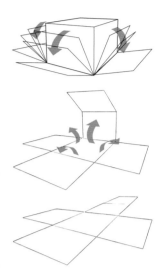

Isometric system

The isometric system creates geometry by projecting parallel sets of lines perpendicular from any of the primary planes. A simple way to visualize this process is to skew an orthographic view away from the flat picture plane (sheet of paper) and project perpendicular lines from that view back in space, to intersect with the network of projection lines coming from the other two skewed views. The resulting network will define the vertices and edges that make up the planar faces of a three-dimensional object (fig. 14).

Isometric projection creates an illusion of three-dimensional geometry. However, because all similar edges and faces remain parallel, the appearance is less than realistic; it hovers between the accuracy of orthographic and the illusion of true perspective. Cognitive scientist David Marr referred to isometric as 2.5D since it suggests an artificial depth rather than trying to replicate true optical depth. Parallel lines often create ambiguity, as illustrated by the Kopfermann cube. Front edges potentially obscure back edges and the manipulation of line weight or the addition of shade and shadow is required to avoid this.

Fig. 13
A die-cut cardboard box (which could be considered an isometric cube) reveals its six orthographic views when it is unfolded: each side of the cube represents a single view.

Fig. 14
(Right) The flat orthographic front and side views of a chair have been rotated (skewed) in space and stitched together in a three-dimensional view.

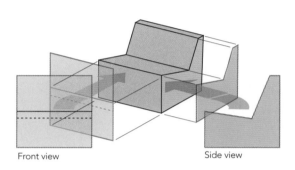

Front view　　　　　　　　　　Side view

Perspective system

The perspective system creates geometry in a manner very similar to isometric projection; the main difference is that all parallel sets of lines on the object project back to one or two vanishing points and create a network of receding edges and tapering planar surfaces. The vanishing points are positioned on a sketched horizon line, which corresponds to the natural horizon line that separates land from sky. Single-point perspective drawings, which combine an orthographic front view with true perspective, tend to appear static because the baseline of the drawing remains parallel to the bottom of the picture plane.

Fig. 15
The placement of a sketch above or below the horizon line directly impacts which faces (surfaces) are viewable.

Fig. 16
When a one-point perspective cube is rotated away from its parallel position to the picture plane it automatically becomes a two-point perspective and necessitates a second vanishing point. It also becomes much more dynamic in appearance.

Fig. 17
A joystick is a handy metaphor for orthographic and perspective projection. While orthographic is constrained to the vertical and horizontal axes, perspective can swivel very subtlety between vertical and horizontal, much as the human eye can.

The interrelationship between drawing systems

All the drawing systems discussed are related through the process of projection. It is useful to think of orthographic and perspective as being structured inside a transparent box. This will be the focus of chapter 5. Orthographic, on the other hand, should be thought of as an unfolded box (fig. 13, opposite page). While orthographic appears to be the simpler system it is an essential step to understanding both isometric and perspective. It is also the purest projection system because of its accuracy and lack of distortion. Isometric is not commonly used in product design but serves as a good bridge to an understanding of perspective. It presents three-dimensional objects in a type of perfect space where there is no distortion. Sketching isometrically is easier than sketching perspectivally but not as satisfying.

In order to become a confident sketcher the student is strongly encouraged to master orthographic projection for a couple of reasons. Orthographic sketches are faster than sketching in perspective and provide the critical understanding of an object or space required to transition into perspectival space. Once freehand orthographic is mastered, the ability to develop and refine initial concepts rapidly, relying on just one or two orthographic views, speeds up the design process.

The illustration (fig. 19) of a detergent bottle demonstrates the strong connection between orthographic projection and perspective. The perspective has been flattened and rotated into an orthographic front and side view. This demonstrates the systematic approach taken to 'building' the geometry, as it is understood in orthographic and then translated into the illusionary third dimension of perspective.

Fig. 18
The 3D orthographic of a simple house can be folded like an isometric box to enclose space. The top and side views, however, would need additional folding at the roof lines to close the space. As the roof panels when projected in orthographic cannot take into consideration angled planes, these surfaces would be too small when folded.

Fig. 19
This detergent bottle was built in SolidWorks and then compressed using the scaling tool in the software. Normally an object would be scaled in all three axes to make it proportionally larger or smaller. By scaling it along one axis only (the depth axis in this example), the bottle maintains its height and width and is compressed much like an orthographic drawing.

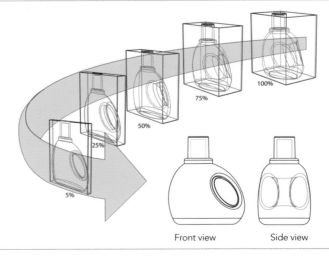

Front view Side view

Case Study

Gerrit Rietveld's Red and Blue Chair (1917)

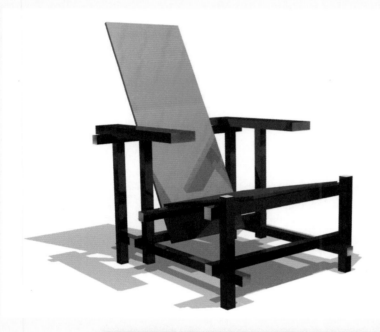

Gerrit Rietveld's chair was inspired by the theories of artists Theo van Doesburg and Piet Mondrian, who worked towards a completely abstract visual language known as Neo-Plasticism or De Stijl (the Style). According to historian Paul Overy, Rietveld initially made his Red and Blue Chair as an attempt to simplify functional requirements down to the bare minimum of planes and lines (battens). It was not until the 1930s that Rietveld added the yellow that referenced the paintings of Mondrian and van Doesburg.

The joint Rietveld used, known as the Cartesian node, reflects De Stijl artists' and designers' interest in the grid and the power of simplified geometry. Rietveld also designed a light fixture that utilized this intersection of the three primary axes in Cartesian space. He created a model of the node in the 1950s for a major retrospective of his work in Amsterdam.

Piet Mondrian's painting *Composition II in Red, Blue and Yellow* from 1930 (re-created in Adobe Illustrator).

Diagrammatic representation of Rietveld's Cartesian node.

The Schröder House designed by Gerrit Rietveld in 1924 expressed De Stilj's characteristic reliance on fundamental intersecting planar geometry.

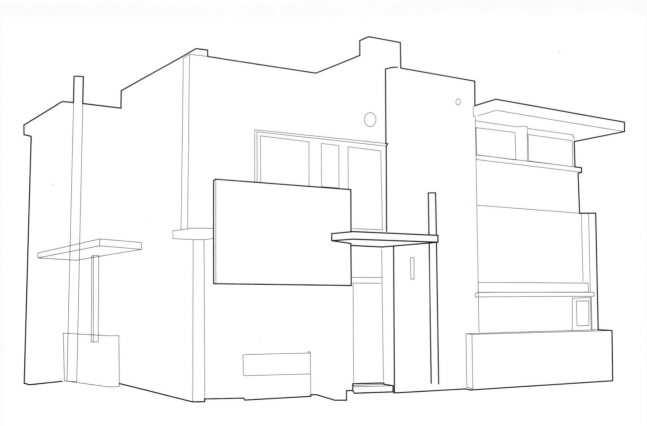

Tutorial

Rotated plan method

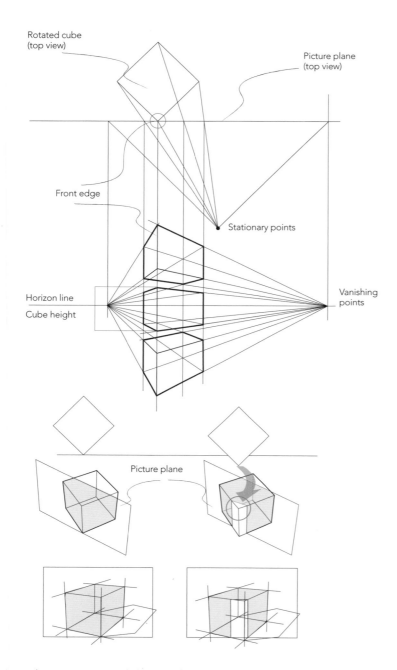

Rotated cube
(top view)

Picture plane
(top view)

Front edge

Stationary points

Horizon line

Cube height

Vanishing
points

Picture plane

To understand perspective it is essential to understand the relationship between the picture plane and the sheet of paper; these are one and the same. In the illustrations on the left the top image shows this relationship from above (the sheet of paper is represented by a line); the second shows a bird's-eye view of the relationship (sheet of paper is represented in perspective); and the final image shows the picture plane as seen from straight on (the sheet of paper is represented as a front view). The only difference between the two cubes is their placement in relation to the picture plane. The far cube is coincident with the picture plane while the nearest cube is slightly in front.

The sequence of nine illustrations represents the process of drawing a two-point perspective of a cube using the rotated plan method. The stationary point represents the viewer looking at the cube (from above, plan view). The first set of lines represents the cone of vision from the viewer to the vertices (points) of the cube. These lines intersect the picture plane and are then projected straight down. They will form the outside edges of the cube in perspective. The two other lines emanating from the stationary point and parallel to the two front edges of the rotated cube are used to determine the position of the left and right vanishing points. The placement of the horizon line is totally arbitrary, as is the placement of the front edge above or below the horizon. Wherever this edge is placed determines the vantage point.

The picture plane is synonymous with the sheet of paper and is typically positioned to coincide with the front edge of the object in rotated plan method. The edge can, however, be positioned slightly in front or behind the picture plane.

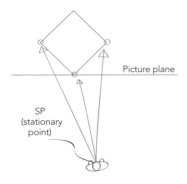

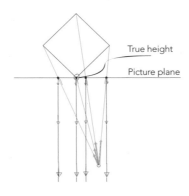

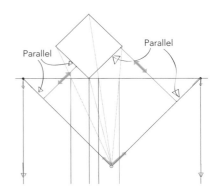

1. Determine the position of the viewer with respect to the object. This is called the stationary point and will impact the scale and orientation of the sketched object. From the stationary point rays are projected to every vertex on the object.

2. At the point where these rays intersect the picture plane, project lines vertically downwards to determine the cube's vertical edges. The one vertex that touches the picture plane represents the true height of the cube.

3. The next step involves creating the vanishing points needed to sketch the cube's horizontal edges. From the SP (stationary point) project lines parallel to the cube's two front faces up to the picture plane and project downwards vertically.

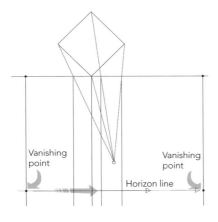

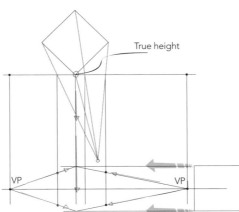

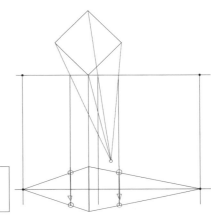

4. Determine how far below the rotated cube to position the horizon line (its placement is arbitrary). Connect the two vanishing points with a horizontal line. Sketch lines will be projected from the vanishing points on the horizon line.

5. Place an orthographic side view of the cube on, above or below the horizon line. Project the top and bottom edges of the cube horizontally until they intersect with the one vertical line that represents the true height. Lines from the vanishing points will be projected to this line to determine the cube's front edge.

6. Darken those outlines between the various set of edges (vertical and receding horizontal). These represent the cube's outside perimeter or boundary. Just as importantly the vertices (or end points) of these lines represent a new set of points for projecting the hidden edges of the cube's top and bottom faces.

7. Project from the vanishing points a new set of lines to those vertices. These lines will define the door and roof of the cube. Note that these projection lines intersect the back vertical edge of the cube, precisely forming a complete cube.

8. The final step is to differentiate the line weight. The outline of the cube runs around the perimeter of the surface and is the heaviest line of all. The front edge (the true height of the original cube) is the next darkest line. The lines that define the back, bottom and top faces or planes are the

lightest – although in this case they have been given a line weight heavier than the original projection lines to help differentiate them. They have also been rendered in a cool grey to help them recede in to the background.

Case Study

Method
(San Francisco)

The sketch below by Josh Handy, industrial designer at Method, is used as a means to think about form and how to build the computer model to create the rapid prototype (RP) parts. Given the simplicity of the bottle's geometry, the main focus of the sketch is on the top dispenser. Note that most of the sketches are orthographic side views, which provide the most definitive view. The CAD models are built in SolidWorks from these initial sketches.

On the opposite page is an array of rapid prototypes straight out of Method's 3D printer in its San Francisco office. Josh Handy uses these RP parts to help communicate possible design directions. Printing quick models has become another form of sketching in 3D.

The rapid prototype printing process for the bottles generally takes a few hours and allows the team to have something in hand. The refined CAD data is ultimately used by the tool- and die-maker to create multicavity moulds for production.

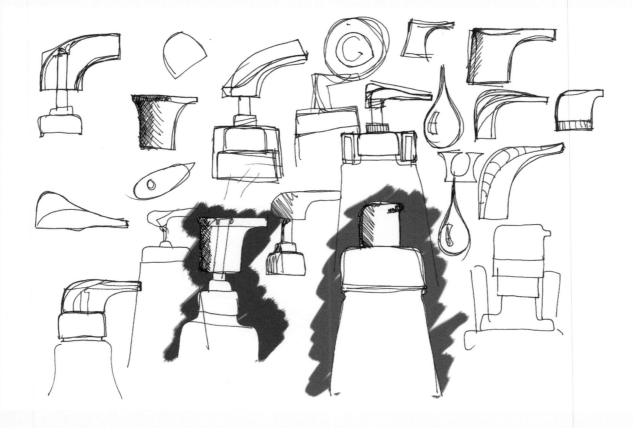

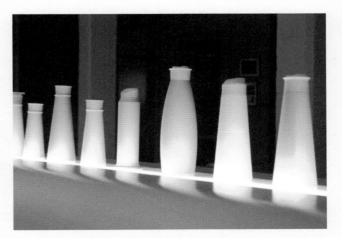

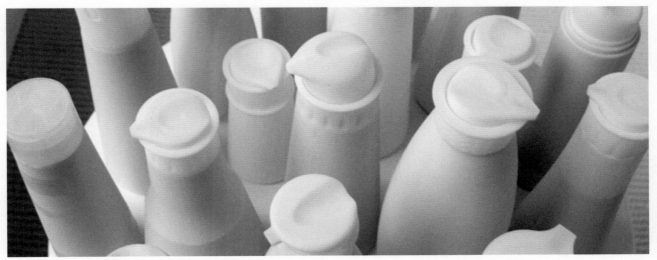

These 3D printed prototypes are dramatically lit for a line review after they have been cleaned up and painted.

Tutorial

(De)constructing the cube

This exercise helps emphasize the power of projection. It involves dynamically deconstructing simple cubes into more elaborate forms. The various faces, edges and vertices of the cube provide references for cutting away as well as creating new geometry. Crucial to this process is an awareness of the primary axes (x, y and z). The red arrows in the illustrations move along these primary axes except for the diagonal edges. The same process can be used to extend the shape of the cube in a constructive manner.

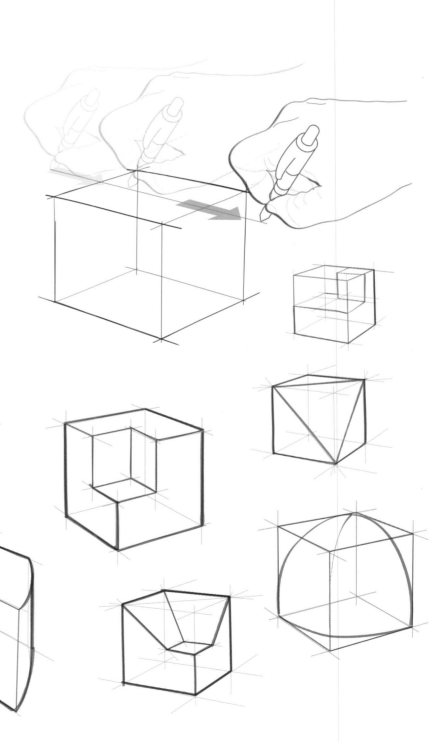

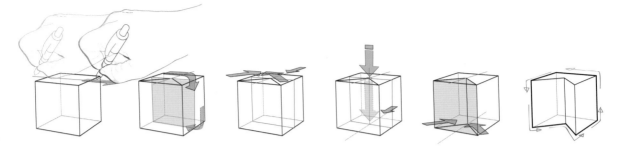

1. Begin with a simple cube sketched in perspective positioned to show three faces. Sketch a line across the top of the cube parallel to the front and back edges on the top surface or face. Project another line downwards along the side face and then along the bottom face and back up the opposite side to close the sketch and create a plane (red). Sketch a line to divide the top surface and sketch two diagonals on the top face to meet at the centre.

2. This initial network of lines makes it easy to add more sketch lines to further divide the internal space within the cube. That first set of lines created a plane that cuts through the centre of the cube. Sketch a line down along this new plane to the bottom face of the cube. This line establishes the centre axis of the cube and provides a point for a new set of diagonal lines to meet on the bottom surface. The cube now has a wedge defined within (red). Darken the outline to complete the sketch.

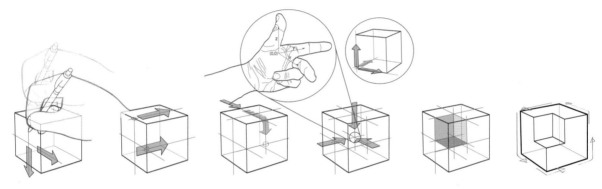

3. Now we will sketch a vertical line on one of the side faces. Sketch a second line perpendicular to that first line. I've circled the point where the lines intersect the edges of the cube. From here more sketches can be projected back in space. The goal of this exercise is to roughly subdivide the cube into eight smaller cubes and to remove the top front corner of the cube. This will require additional sketches projecting into the centre of the cube which will all meet to form a Cartesian node.

4. The Cartesian coordinate system is defined by the x, y and z axes, which define height, width and depth. Look at any of the corners on this cube – they are all Cartesian nodes defined by three intersecting axes much like the centre set of intersecting lines (circled in blue). With the planes defined it is simply a matter of darkening the overall outline and adjusting the internal line weight of the cutout as well as the internal lines at the back and bottom of the cube. Line weight helps greatly to diminish ambiguity.

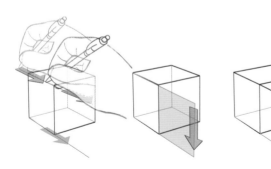

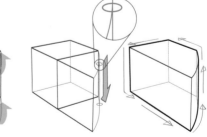
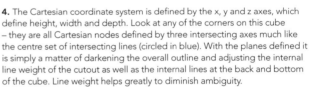

5. Now extend the top and bottom edges on the left face of the cube to build out in space, then project a vertical sketch line downwards to complete the plane (red). This plane is an extension of the existing surface. From the two vertices project lines back to the respective vertices on the front face. These sketch lines create a flat plane (red) that closes the new form, however we will use these sketch lines as references for two arcs that will create a curved surface.

6. The arcs that form the top and bottom segments of the curved surface are sketched similarly to the lines: they connect the vertices and close the surface (red). Because this surface doubles back on itself it would disappear from sight so another line must be added for greater clarity. That line must be tangent to the arcs (red circles) as it represents the outer edge of the curved surface. The final step is to darken the outline.

Tutorial

Unfolding geometry

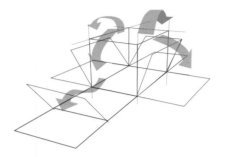

Learning to systematically deconstruct polyhedra is a great way to begin thinking in 3D space while also visualizing cause and effect. Because vertices and edges connect every polyhedron, unfolding the various faces provides an excellent opportunity to think about planes, folding lines and distortion as the faces tilt away. Being able to visualize a simple polygon as a flat unfolded pattern will make creating three-dimensional objects on the fly much easier.

Crease line

Cut line

Exercises like unfolding can increase a designer's visual sensibilities. Take the unfolded pattern for a cube and photocopy or scan it, print it out on heavy card stock and fold along the dotted lines to create a simple cube (polyhedron). Use this physical model as a sketching aid; unfold the cube and sketch it in its various states.

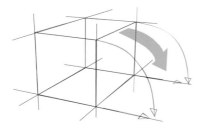

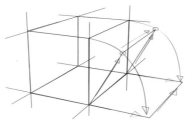

1. Quickly sketch a cube making sure to 'sketch through' so that all occluded (hidden) edges are visible. Determine which face to unfold first and sketch a quick set of arcs (1/4 circle) to determine approximately where the face would land when unfolded to the ground plane.

2. Sketch in several steps of the unfolding process for practice. Think of it as lifting weights for your sketching muscles. Use the quarter circles as references for where the plane would necessarily fall. If the arcs are sketched in perspective, they will help position everything accurately.

3. Continue sketching additional steps of the unfolding process by referencing the arcs and 'chasing' the lines from vertex to vertex to form the closed flat plane. This method builds muscle memory by reducing the process to a mechanical and repeatable procedure.

4. The biggest challenge in this process is sketching the arcs with reasonable accuracy. Think of them as partial ellipses sketched around a centre point and axis which is the bottom edge of the cube (see small detail above). If necessary, sketch in the full ellipse lightly.

5. Pay close attention to the receding lines of the cube while sketching the unfolding panels or planes. The cube is perspectival so every line recedes to a vanishing point. In this sketch, however, there is no horizon line or vanishing point – everything is approximated.

6. At this stage nearly every plane has been unfolded if we count the base plane, which is already sitting on the ground plane. But a cube has six planes or faces, which means there is a top to the box that needs to be added. For this we will take a different approach.

7. Referencing the front plane, project or extend lines forwards in space to create a new plane or face. The problem is knowing where to end the plane. A simple procedure for proportionately extending planes in space involves sketching a centreline and projecting a new line that originates in the uppermost corner and passes through that centreline.

8. Here we see the process in two steps: first the centreline is sketched through the existing flattened pattern (note that the diagonals help to accurately find the centre). Next a line is projected from the uppermost corner that passes through the centreline and intersects with the projected line to determine the length of the plane. Finally the line is connected.

9. Any polyhedron can be placed inside a cube to help with the referencing required to sketch the unfolding process. In the example above a pyramidal form is loosely sketched. The centres are determined by diagonals and lines are projected across the face. The side view of the form is projected on the side of the cube and projected down.

REGISTRATION

The glass box metaphor: seeing 'through' the object

The 'glass box' is a traditional metaphor used to demonstrate how each view in an orthographic drawing is projected from the object parallel to the opposite face of the glass box. If the box were made of paper it could be unfolded to reveal not only the orthographic views as projected, but also the alignment required of orthographic projection (see figs. 2 and 3).

For perspective, the glass box metaphor translates more specifically into the transparency required to accurately construct a multi-surfaced view in a single drawing. Transparency conceptually allows the designer to treat the object he or she is sketching as though it were made of glass or plastic, so that the back edges and side edges normally out of sight can be seen. This process goes back to the perceptual phenomenon called 'occlusion', discussed in chapter 2. Even when we can't see the back edge of an object because it is blocked by another object or its own front surfaces, the brain understands that those edges exist and can approximate where they are. Sketching 'through' the object is critical to the sketching process and will remain pertinent throughout the book. While it is easy with cubic and planar objects, it becomes more complex when surfaces are organic: this requires another skill that I refer to as building the necessary sketch scaffolding, which is what we focus on next.

The scaffold metaphor: building objects on the fly

While the glass box is a great metaphor for describing the projection of single views on to the flat surface of paper, the scaffold metaphor extends the transparency of the glass box by allowing the designer to build the reference scaffold necessary to sketch confidently in illusional three-dimensional space. Much as buildings are constructed by starting with the foundation and moving upwards, sketches, too, must begin with one view (an orthographic view skewed into perspectival space) to help to quickly establish the overall volume or footprint of the object or space. The scaffold might be a quickly sketched plane or a section accurately placed on a transparent plane. With the initial view sketched in place the designer can begin building the transparent scaffold system, adding more planes or sections on the fly as needed.

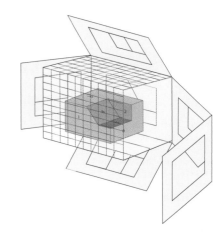

Fig. 1
The glass box, while only a metaphor, is a powerful way to understand how projection works. The six faces of the box represent the various picture planes for orthographic projection.

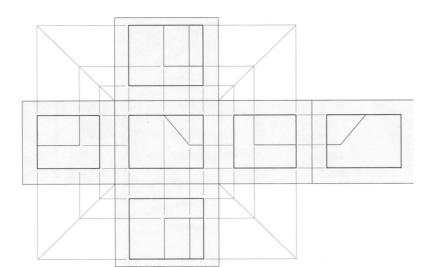

Figs. 2 & 3
(Above and left) Every vertex, line and plane is captured and flattened onto one of the six sides of the glass box to create a completely interconnected set of drawings once unfolded. The box also provides a mental model for quickly sketching reference planes while developing isometric or perspective representations. Because the glass box is transparent, it makes it easy to imagine an accurately placed plane upon which to build the first steps of a sketch. Once the box is internalized into the sketching process it no longer needs to be sketched but serves as a reference for accurate placement of critical geometry.

Fig. 4
The scaffolding required to renovate this church is similar to the ghost lines, centrelines, planes and other reference geometry used in sketching.

Fig. 5
(Above and right) Rapid sketching relies on connecting a network of accurate intersecting sections that reside on individual planes. These sections will ultimately be connected through the addition of a compound curve that is not defined by a single plane but instead connects the various sections into a unified whole.

Fig. 6
This rapid ideation sketch is much easier to execute with the aid of the orthographic thumbnails that define the primary geometry and the planes where the sections (ribs) will go.

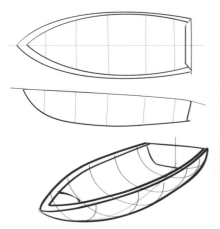

The process of building only what is necessary to continue the sketching process liberates the designer to work more intuitively, responding to possible changes. As the designer's skill improves, then less of this visual support scaffolding will be required.

Next we will look at the power of the section to help break form down into its smaller constituent parts. One way to think about this process is to imagine the ribs on a row boat, which define the geometry of the boat's hull. The ribs act as the skeleton over which the skin of the hull is stretched.

The section: conceptual pivot point for building form

While the section is considered primarily as a drafting or technical drawing convention, in rapid freehand sketching it is a critical conceptual tool for breaking geometry down into smaller and more manageable chunks. As discussed in chapter 3, a section results when an object is sliced (as if by a knife) to reveal the internal geometry at the point of the cut. If a complex object is sliced 20 times in a linear progression, the resulting sections will suggest the internal structure of the object, much like the ribs on a boat (figs. 5 and 6).

The computer mouse (fig. 7) has been placed in a Cartesian space defined by a gridded set of intersecting planes, revealing the primary orthographic views (front, side and top) as well as three section cuts (colour coded red, blue and green – fig. 8) placed along the length of the mouse's side view; these have been rotated twice, ending in an orthographic view for greater clarity.

The sketch process begins with a top view skewed into perspective followed by a side view, also skewed into perspective, and finally several sections (fig. 9). Each of these views can be thought of as sections that form a simple wireframe, over which the skin or surface of the mouse will sit. Like the ribs of a boat, the sections provide the necessary structure. This process has its physical analogue in the bucks of automotive models, which are then surfaced with modelling clay (see p. 86, fig. 10).

Fig. 7
A wireframe of a computer mouse has been centred within the Cartesian coordinate system defined by the three primary axes: x, y and z. The intersection of these axes creates the top, front and side planes where the corresponding top, front and side view orthographics reside. Section cuts 1, 2 and 3 correspond to the views below.

Fig. 8
(Below) The section cuts from the wireframe have been isolated for comparison. Understanding how to accurately sketch sections in perspectival space can greatly improve sketching skills.

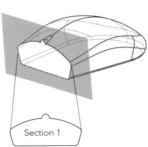

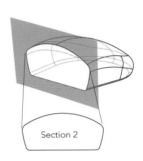

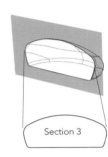

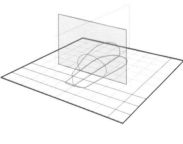

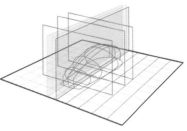

Fig. 9
(Below) The sequence represents a similar process to that followed by many designers in roughing out a quick wireframe. The grey plane represents each additional sketch.

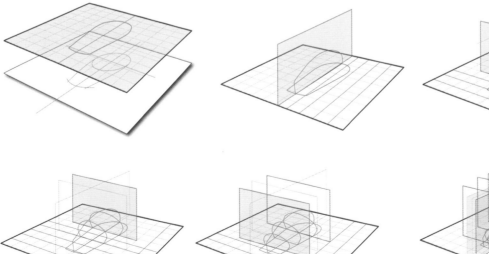

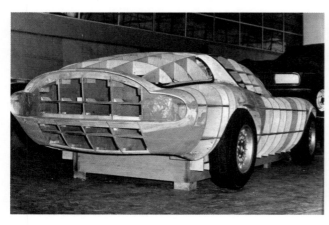

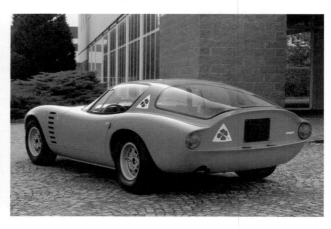

Fig. 10
This intersecting planar buck was used by the model makers at Bertone to create the first full-scale clay model of the Alpha Romeo Cangura (kangaroo) in 1964. The regularity of the intersecting planar sections makes the modelling process more accurate and keeps the form symmetrical, much like the repeating ellipses shown on the vase below.

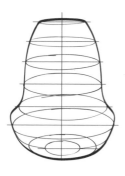

The ability to develop ideas based on sectional development is crucial as it allows the designer to 'see through' an object and imagine what the various sections look like at any given point or plane. Visualizing 'slices' through an object or space forces the designer to think orthographically, which provides a clearer sense of the proportional relationships of a design. Manipulating these slices can change the overall form much like squeezing a tube changes its outside surface appearance.

The outlines (black line in fig. 11, below) are what serve to connect the various slices into a cohesive whole (solid) and ultimately give the object its form. This is a multi-step process with tremendous flexibility – there is no single way of going about it; it all depends on the desired outcome. Note that all the geometry up until now has been two-dimensional. However, the outlines that hold the sections together are three-dimensional (compound curves). This is explored in greater depth in chapter 6. For now we will review a unique type of section, and one that poses perhaps the single biggest challenge for design students: the circle in perspective.

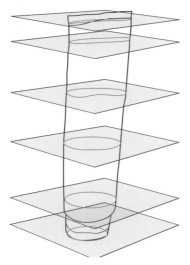

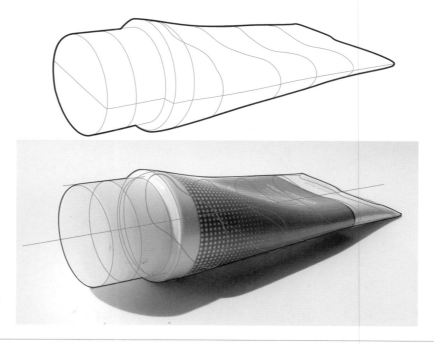

Fig. 11
These sectional sketches relate to a series of cutting planes that pass through the object at various points along its length. Freehand sketching works by the designer imagining what the various sections would look like.

Circles in perspective: the ellipse

Cylindrical forms surround us on a daily basis: wheels on motor vehicles, wristwatches, bottles, bowls and, increasingly, the buttons on mobile phones and electronic devices. However, these forms are rarely glimpsed from straight on in clean, unambiguous orthographic views but are seen more commonly from a variety of vantage points and perspectives, creating an elliptical shape in the retina. Cylindrical forms are created from a series of circular sections (fig. 12). The designer therefore needs to feel comfortable with rapidly sketching circles in perspective. These circles are difficult to draw freehand because their creation defies immediate and obvious logic. While a circle viewed straight on (orthographic front view) is defined by swinging an arc 360 degrees around a centre point thus establishing the radius, which remains consistent along the entire circumference, a circle viewed in perspective is defined by a major (long) axis and a minor (short) axis.

While the diagonal is the most common way to centre geometry orthographically inside a rectangular plane or face, this method fails when applied to the circle in perspective because of the natural distortion and foreshortening that occurs due to optics. When viewing cylindrical forms in perspective (fig. 13), the eye is only able to detect a portion of the front half – it cannot see all the way to the edges that correspond to the true centre. As the viewer gets closer to the cylinder, this percentage decreases. As a result, the centreline defined by the intersecting diagonal method lands behind the centreline (major axis) as defined by the actual ellipse. This may not appear obvious, but it must be remembered that an ellipse is a symmetrical shape along both the vertical and horizontal axis, and that when sketching circles in perspective (ellipses) this symmetry must be maintained.

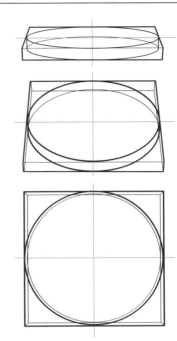

Fig. 12
These illustrations represent circles and ellipses as seen in orthographic top/front view (2D). When a circle sketched onto the face of cube, for example, is viewed in perspective this relationship becomes more complicated given the natural distortion inherent in perspective (foreshortening).

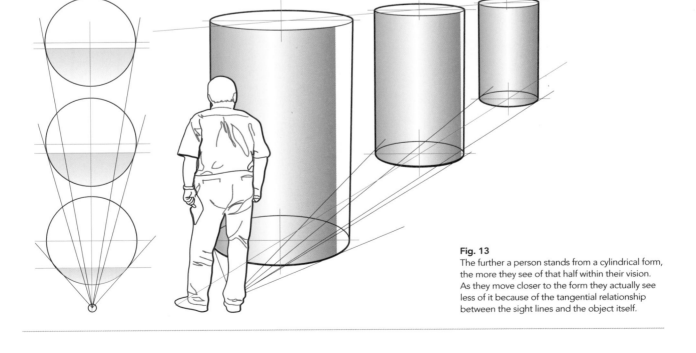

Fig. 13
The further a person stands from a cylindrical form, the more they see of that half within their vision. As they move closer to the form they actually see less of it because of the tangential relationship between the sight lines and the object itself.

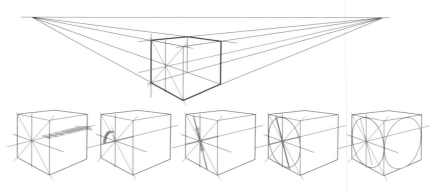

Fig. 14
The goal when sketching circles in perspective is to determine the major and minor axes, which are always at a 90-degree angle to each other. These axes also divide the ellipse into perfect halves vertically and horizontally. Here two centrelines are defined: one by the intersecting diagonals and the other by the exact centre of the ellipse (centre defined by vision).

The student must learn to see the elliptical shape as centred symmetrically along both axes in such a way that, when folded, the two halves are exactly equal. This is a process that comes through practice and through an understanding of the fundamental procedure for creating a circle in perspective through projection.

Fig. 15
An ellipse can be folded in half along either axis. The result is a perfectly symmetrical shape with the major and minor axes maintaining a 90-degree relation to each other.

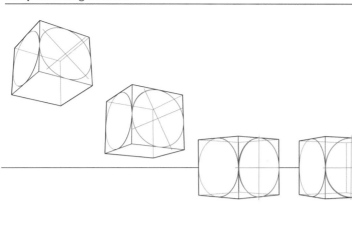

A few simple rules of thumb can assist greatly in accurately placing the ellipse at the correct angle (degree of ellipse). Vantage point is a critical determinant: when the circular form is above the horizon line the major axis will lean to the left vanishing point; when the circular form is below the horizon line the major axis will lean towards the right; and when the circular form is centred on the horizon line the major axis will be vertical. A second critical rule of thumb is that the minor axis determines the tilt or degree of the ellipse. This axis goes back to the vanishing point. The major axis will always be 90 degrees to the minor axis and thus the minor axis determines everything.

Getting accustomed to visualizing the minor axis projected back to the vanishing point, as well as the 90-degree relationship between the two axes, takes time and practice. Eventually it becomes second nature as the designer sees the direct connection between the degree of the ellipse in relationship to the rotation away from the picture plane, the position of the horizon line and the minor axis projected back to the vanishing point.

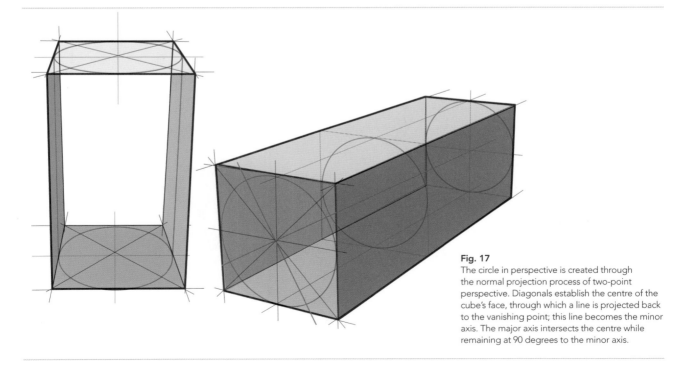

Fig. 17
The circle in perspective is created through the normal projection process of two-point perspective. Diagonals establish the centre of the cube's face, through which a line is projected back to the vanishing point; this line becomes the minor axis. The major axis intersects the centre while remaining at 90 degrees to the minor axis.

Fig. 18

Sketching the tops and bottoms of cylindrical forms accurately requires aligning the outside edges tangent to the ellipse at the major axis. The tube and corkscrew sketches represent some typical instances where the circle is seen in perspective on a vertical as opposed to a horizontal face. Note how the ellipses lean to the left side of the page because they are positioned below the horizon line.

Flat edge

Radiused edge

Fig. 19

Similar geometry in the form of a motorcycle wheel (from fuseproject's Mission One Motorcycle) leans to the right because it is positioned slightly above the horizon line.

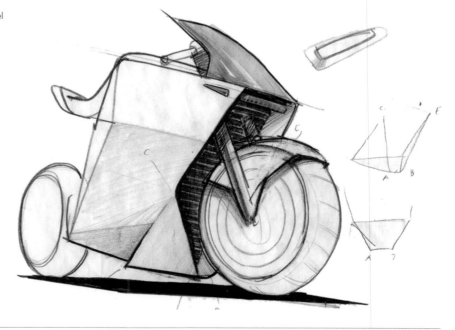

The sketches shown below (fig. 20) from Insight Product Development for Herman Miller, represent a wonderful example of the circle in perspective. The largest sketch on the page shows the product positioned well below the horizon line so that the ellipse leans back towards the left vanishing point (highlighted in red). Note how the same product laid down flat creates an elliptical shape with the major axis aligned horizontally. This same design has been re-sketched below to show how the 'degree' of the ellipse relates to the angle away from the picture plane of the object. Understanding the mechanics of sketching a circle in perspective is not difficult. However, mastering the technique requires keeping the dynamics clear so that it becomes intuitive. Ellipse templates are commonly used to help tighten up freehand ellipses and demonstrate the angle of the ellipse.

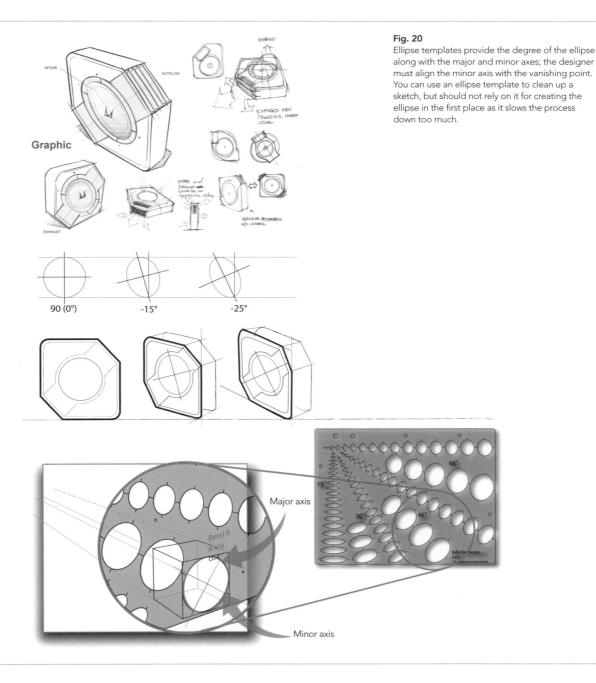

Fig. 20
Ellipse templates provide the degree of the ellipse along with the major and minor axes; the designer must align the minor axis with the vanishing point. You can use an ellipse template to clean up a sketch, but should not rely on it for creating the ellipse in the first place as it slows the process down too much.

Case Study

Myto chair

The design process at KGID, the Munich-based design consultancy founded by Konstantin Grcic, moves fluidly from hand sketches to physical models to computer models and back to sketches, more models and finally full-scale prototypes, rapid prototypes and computer data for tooling. Quick sketches are often translated into simple materials like paper, cardboard, wire and even tape to make them more physical and provide feedback. The quick models are analysed and then used to generate the first computer models or another round of sketches. The computer models might also be used simply to print out more accurate paper patterns for higher-fidelity models.

The Myto chair's name was inspired by Italian manufacturer Cagiva's Mito motorcycle. The chair was produced in collaboration with the German chemical giant BASF and Italian manufacturer Plank, and was inspired by a new polymer from BASF and the challenge of updating a design classic: the cantilevered chair. The drawings, while simple, communicate the design intent and allow for the real process of refining the concept through intense physical prototyping, which KGID is well known for.

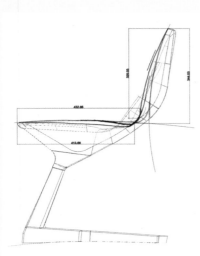

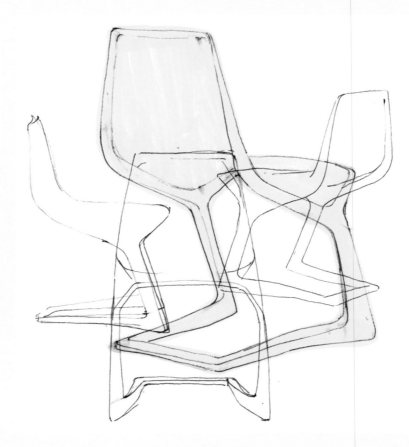

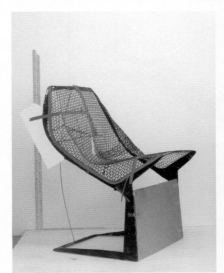

These photographs are a tiny sampling from the development of the Myto chair. This physical prototyping occurs in stages before any real testing for strength can occur.

Case Study

Mission One Motorcycle

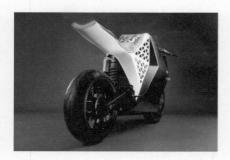

The Mission One Motorcycle, designed by Yves Behar and fuseproject is a state-of-the-art high performance electric motorcycle. Close attention was paid to merging rider ergonomics with the iconic aesthetics for which fuseproject is well known. The battery pack is housed in a lightweight aluminium structure shrouded in a stealthy honeycombed skin, under which all the mechanical elements are integrated, from the flush front headlight to the aerodynamic recesses for legs. The team described their challenge as being to create '... a design that would be accepted by motorcycle enthusiasts while also being immediately recognizable as a vehicle fueled by alternative energy'. Because an electric motor emits no sound, the design of the bike had to convey power through its form, thus defining what electric bikes should look like.

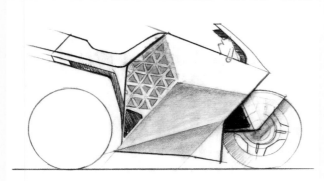

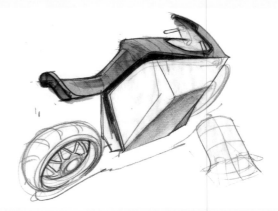

(Above) These rendered orthographics use simple shading to describe the motorcycle's geometry and colour, to help translate the patterns.

(Right) The vantage point of this sketch puts the viewer in position to feel the power of the motorcycle. Note the circles in perspective on this quick sketch.

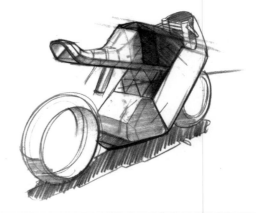

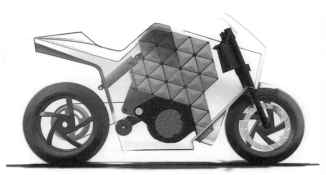

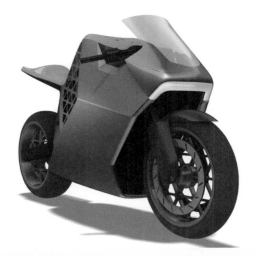

These images include CAD renderings (left and above) and a full-scale prototype (below). Fuseproject designers use corrugated cardboard to mock up the front panel of the motorcycle prototype. The cardboard massing adds to the 'stealthy' geometry while the computer rendering appears softer.

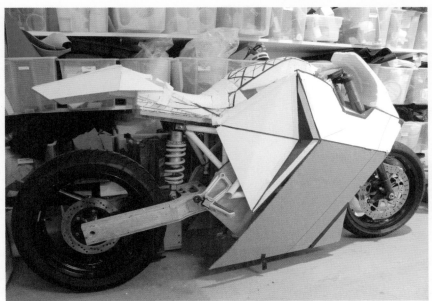

Tutorial

Sketching a tape measure

Sketching a tape measure is a perfect way to start working on basic forms in perspective. The form's low-relief, three-dimensional qualities pose some fundamental challenges for beginners. The goal here is to move through the process quickly and methodically, building the shape in steps while referencing the initial geometry laid down earlier. The most difficult part of the exercise is the ellipses. Be aware that there are two centres in a circle viewed in perspective: the centre defined by the diagonals (geometric) and the centre as perceived by the human eye (optical).

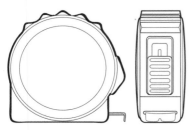

Understanding the object from a two-view perspective already makes the perspective sketching process simpler.

1. To create an accurate ellipse, bisect the face of the cube with diagonals to find the centre. From here project a line back to the vanishing point. This line can be thought of as the axel around which the wheel spins.

2. Next draw a line perpendicular (90 degrees) to the axel to create the major and minor axes of the ellipse around which the sketch is symmetrically drawn. Note that the original diagonals and the new axes do not coincide.

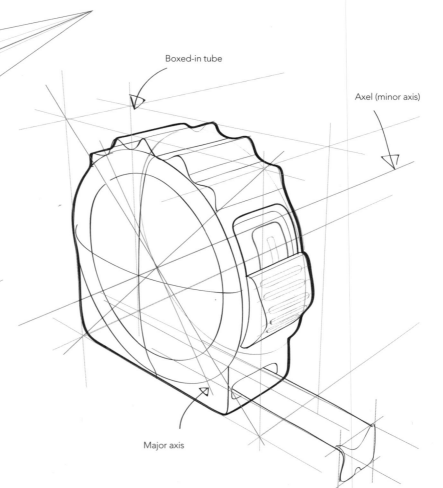

Boxed-in tube

Axel (minor axis)

Major axis

3. Create the second ellipse by repeating the first steps or sketching a slightly smaller parallel ellipse on the back of the cube. Sketch the small internal ellipse using the same major and minor axes.

4. Now the most difficult part of the sketch is done (the ellipse), begin building around it. Referencing the front view orthographic, project a series of lines to roughly box-in the base of the tool.

5. With the base lightly boxed-in there's a reference for sketching the radiused corners. Experienced designers will sketch the base with the radiused corners in a single sketch but for the beginner the boxing-in method is useful.

6. Project a series of light lines from the front profile to the back profile to eventually position the grip. Sketch a series of arcs on the face of the tool as reference for the locking mechanism and slot. These will be radiused in the next step.

7. Project lines from the centre of the major and minor axes that intersect with the previous projection lines. These will be used to help sketch the grip. Radius the opening for the lock mechanism. Sketch in the interior slot.

8. Sketch the profile for the grip on both sides of the product and project lines across to connect the high and low points of the profile (see detail). Lightly sketch the profile for the lock mechanism and project lines across to connect the profiles.

9. Sketch two contour lines across the face of the product to suggest the convex surface. Extend the centreline that was originally used to sketch the lock mechanism. Off that centreline sketch the opening for the metal tape. Project lines for the grips on the lock mechanism.

10. Lightly sketch in small ellipses on either side of the projected lines – these will help define the grips on the lock mechanism (see detail). Project two lines to define the width of the metal tape through the newly sketched opening.

11. Detail the sliding hook at the end of the metal tape by projecting lines to rough in the geometry. Follow this with a series of quick ellipses (if necessary) to help define the radiused edges. Sketch lightly and darken later.

12. A sketch like this can be endlessly tweaked with more detail and colour added. The main thing is to add line-weight differentiation. Begin by sketching a bolder outline around the perimeter of the product. Sketching the edge that defines where the grip meets the body of the product will help differentiate the various surfaces. In the final sketch there are at least three to four line weights (note the parting line that cuts the product in half down the middle and the vignette).

FORM

Fig. 1
This computer mouse sketch began with
intersecting orthographic and sectional profiles
over which compound curves for the outline and
parting line were laid.

The Cartesian grid reconsidered

The Cartesian grid is the ideal tool for situating flat sketch geometry, whether orthographic or sectional. However, it doesn't help greatly when the sketch cannot be confined to a flat plane. This is the case with a compound curve or 3D sketch, which resembles the outer edge of Harry Bertoia's Diamond lounge chair for Knoll Furniture (fig. 3).

The line of the chair moves along multiple planes simultaneously. Like the track of a roller coaster – no section of which is flat – in this case the warped grid (mesh) of Bertoia's chair literally reveals the subtle curvature through line only.

Let's look at the example of a simple computer mouse (fig. 1) with its intersecting profiles and sections. In order to close it up and form a unified surface a compound curve must be created. This curve is unconstrained by any single plane or combination of planes as it moves across the various profiles, and touches the various sections at tangent points to create the illusion of a solid object. The process of creating a compound curve begins with the intersections of orthographic and sectional profiles; the outline can then be sketched in followed by the suggestion of a parting line. When the wireframe is removed, the simplest of sketches remains. The number of sections and profiles can be reduced once the process is understood, as economy is a desired goal.

Fig. 2
The matrix of vertical and horizontal wires (rods) on Harry Bertoia's Diamond chair have been warped into a compound curved surface to fit the human form. This wire-mesh grid is both sculptural and ergonomic, conforming nicely to the human body. The process of creating such a seat involves fabricating a compound form over which to weld the structure.

Fig. 3
Here are two sketches of Bertoia's Diamond chair. The second has had the compound curved mesh surface removed, revealing only the most basic outlines. It is far easier to read the exact shape in the first sketch because of the grid. Much like J.J. Gibson's gradient mesh, this grid mesh helps the brain perceive the complex contours with incredible accuracy.

Shape morphologies: subtractive, additive and composite

I use the scientific term morphology intentionally to describe the creation and manipulation of form through sketching as well as computer modelling because it provides the clearest analogy of how designers often add, subtract or otherwise 'morph' form through manipulation. While in biology morphology refers to the study of the structure and configuration in plants and animals including shape, colour and pattern, in linguistics it refers to the study of morphemes, the smallest units of language, and how they can be combined or compressed to create meaning. In chapter 2, I briefly discussed the power of categorization in recognizing family resemblances in objects. I used the example of a cup, a plate and a soup bowl and their formal interrelationships: a bowl is really a deep plate or conversely a plate is a shallow bowl, while a cup is a small bowl with a handle. This flexibility in thinking about form generation is essential to rapid ideation sketching. As with words, we combine and subtract components to create new and different meanings. This relates directly back to Irving Biederman's geon theory (p. 32), which is really a combinational method for building complex forms from simpler components. Shape morphologies are a more dynamic way to manipulate form through additions as well as subtractions, based on the underlying skeletal structure or wire frame.

Fig. 4
This curve was produced by Odellie Crick, wife of Nobel Prize-winner Francis Crick. Odellie, an artist, was asked to visualize the double helix for the 1953 issue of the journal *Nature*. The same outlines are noticeable on a spiral staircase.

Fig. 5
The first sequence of sketches involves simple 'geon-like' additions. The second sequence is more complex and relies on the underlay (ghosted image of the cylindrical form) to provide the necessary skeleton over which the form is adapted and quickly manipulated to arrive at a possible final form.

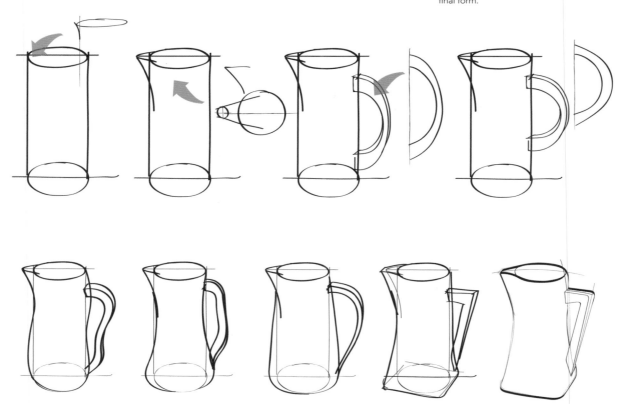

Since designers need clear and repeatable strategies for creating form; shape morphologies can assist in that process. In the following section we look at three such processes: an additive process, a subtractive process and a composite process that combines both. We then turn our attention to sketching and its direct relationship to computer-aided design (CAD).

The additive process

This is quite simple and natural: forms are added to existing objects to expand and focus their function or appearance: a spout and handle added to a cylinder turns it into a more useful object for pouring hot or cold liquids and also makes it more recognizable in terms of typology (see figs. 5 and 6).

The subtractive process

This is more complicated, as it morphs an object by removing material to focus or define it. An obvious example would be a rectangular piece of wood turned on a lathe to create wooden spindles or balustrades (fig. 7).

A similar approach can be applied to vessel forms or bottles to arrive at a more appropriate form. The cups designed by Mexican industrial designer Emiliano Godoy (fig. 8) demonstrate this approach: the material that is removed forms the handles or 'grips' of the product, suggesting a more sensuous experience as well as a more sculptural form.

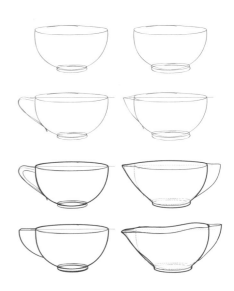

Fig. 6
These sketch variations are derived from the same basic underlying sketch and have been morphed and compound curves added to create different typologies.

Fig. 7
The wood lathe shapes material through a subtractive process by aligning cubic material between the head stock and tail stock, and carefully removing it with the aid of a sharp chisel. The process requires multiple steps and a variety of different tools. The result is a symmetrical object because the raw stock is centred on an axis similar to the revolve process in CAD.

Fig. 8
ÑOM ÑOM ÑOM, designed by Emiliano Godoy, was intended to suggest what hard objects like ceramic bowls might look like if they '.... were able to modify their shape according to their owners' habits'. The concept was developed, according to Godoy, while thinking about the imperfections of small batch productions of ceramics.

The composite process

This moves back and forth between adding and subtracting, much as a ceramicist might add, subtract, pinch and stretch a form. The flexibility of shape morphologies allows a constant back-and-forth movement of processes once the sketched material is thought of as an underlying structure with an external skin that can be altered, manipulated and morphed – which is what computer modelling is essentially about.

Fig. 9
Sketching cylindrical forms is analogous to shaping physical objects. On the right is a sequence showing the tapering of a conical form.

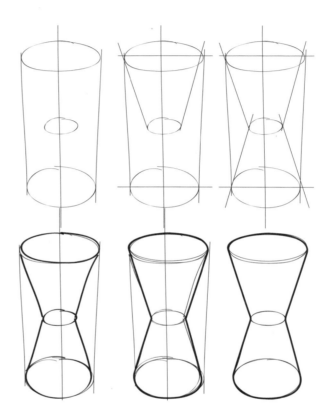

Fig. 10
This sequence of sketches demonstrates the composite method of form development: in the first instance a cubic form is softened at the corners (radii) before cutting the top and bottom halves at a taper that meets in the centre. The remainder of the operations are additive and subtractive.

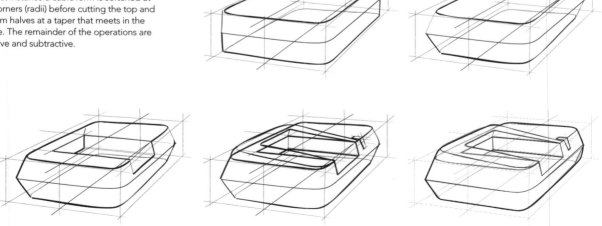

Sketching and computer-aided design

Imagining form as something plastic that is able to be directly manipulated is the ideal way to think of computer modelling (CAD). The sketching process is used to quickly explore ideas, and is quickly followed up with a physical model or computer model before a design is returned to the drawing board (paper or computer) for additional changes. This iterative process needs to be as seamless as possible, which means that none of the various steps should feel disconnected from the rest. Throughout the book it is noted that sketching and computer modelling are interconnected. Let's look more deeply into this connection.

In the world of CAD there are two primary types of modelling program – solids and surfaces – and while their fundamental approaches are quite different, the results can look very similar. Solid modelling is based on 2D sketches defined by flat planes that generate 3D forms based on specific parameters, like extruding a sketch a certain distance or revolving a sketch a certain number of degrees: if you change the parameters, the form changes accordingly. Surface modelling includes a category of forms called 'primitives', which are created in two or three simple steps: draw the defining shape (a 2D square, for example) and drag its height to get a cube. Primitives include forms such as the cube, cylinder, cone, tube, torus, paraboloid and ellipsoid. Creating them takes little pre-thought but they are very limited in terms of final designs. Other 3D forms created by surface and solid modellers are more complex and require greater forethought and effort; these include extrusions, revolves, sweeps and lofts. While this list is not exhaustive, it provides enough examples to explore the interconnection between CAD and drawing.

Extrusion is like it sounds – a 2D sketch is pulled along the z axis to create a 3D form. The extrusion is the simplest of operations in CAD, relying on a single sketch. The depth (or height) of the extrusion is input via a keyboard or dragged via a direction arrow on screen. Extruding a 2D circle will result in a cylinder. The limitation of extrusion is that the 2D geometry is pulled straight along a linear path. The exception (in some software programs) is the ability to build in draft so that the form tapers inwards or outwards as it is extruded.

Revolve is also easy to imagine – a 2D sketch is revolved around an axis to create a 3D form. The degree of revolution can range from a fraction up to 360 degrees which will close the shape in a full revolution. Half a circle revolved around its centre will result in a three-dimensional sphere. Paolo Uccello's chalice (see p. 14) is a revolve.

Sweep is the result of two interactions – a sketch profile and a path. The sketch profile literally tracks along the path to create a complex 3D form. The final swept object can be either a closed or open surface. If the path is too tight and the profile is too large to bend successfully around it the attempted sweep will result in failure. A typical swept surface is a drainpipe.

Loft is a more complex operation, commonly used to create compound curved surfaces. Lofting is the result of projecting multiple sketches or sections on various planes separated in space. Complex lofts often rely on guide rails, which are additional geometric sketches that help constrain the connection process and add in additional desired detail. Ergonomic handles are an example of lofted geometry.

Extrude

Revolve

Sweep

Loft

Fig. 11
The objects were drawn in Adobe Illustrator, but were created very much as they would be with either freehand sketching or computer modelling. They represent the basic CAD operations: extrusion, revolve, loft and sweep. The power of the computer to visualize geometry is something every designer should leverage to increase their conceptual knowledge and sketching skills.

Efficient ideation sketching links to the other processes downstream as directly as possible – especially computer modelling. Sketching serves not only as a quicker way to realize ideas but also as a method for conceptualizing how the object might be built in the computer. This back-and-forth approach will mutually reinforce these critical skills, bringing them closer together and speeding up the design workflow.

Figure 13 shows a simple flat extrusion followed by a lofted compound curved surface for the top of a computer mouse. The sketching process, much like the modelling process, requires a set of sections and a central contour (guide curve) to establish the convexity of the surface. Connecting the sections via this guide curve results in the desired geometry in CAD. Sketching a compound curve connects the various sections in an analogous manner on paper.

Fig. 12
Curved surfaces come in many flavours, from simple to compound, and occur often in designed objects. A simple compound surface is a quadrant on a sphere; a softened (radiused) cube will result in flat, curved and compound curved surfaces; while the razor has a series of nested compound surfaces on the handle for a better ergonomic feel.

Fig. 13
Alberti defined a plane as a series of lines side-by-side. The process of sketching planar or compound curved surfaces with a pen or with CAD software is very similar and relies on sectional sketches laid side-by-side.

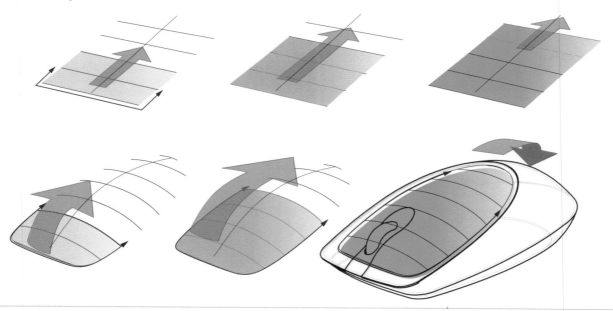

Warping: compound curvature and 3D sketching

This chapter began by considering the Cartesian grid as a curved or warped mesh. Creating such warped grids to place compound curves accurately is both slow and unnecessary. In order to speed the process up, we will look at warping surfaces through simpler 3D sketching techniques and begin by returning to the earlier example of a carafe (p. 100). This time, instead of a spout being added on a flat surface it will be added to a curved surface. In figure 14 I have added a curved and gridded surface, which is a time-consuming process.

Above this gridded surface sits the flat plane with the desired profile for projecting. Note that the flat profile will follow the curvature of the plane upon which it is projected. This is still too time consuming; the easier and faster approach is to lay down a simple curved surface (ungridded) and use the procedure for normal perspective sketching. Establishing a quick and approximate centreline on the curved surface and sketching the desired profile so that it is centred (fig. 15) over the curving line. The process is lean and quick, and connects back to critical orthographic sectional projection. This time, however, the stretch is projected on to a curved rather than a flat surface or plane.

Fig. 14
Creating a curved grid on which to sketch geometry would be useful but too slow to be practical. The goal is to sketch in a way that acknowledges the curve without the extra work that is illustrated below.

Fig. 15
The two quick orthographic views were done first, to get the overall proportions of the product right. This process alone makes the transition into perspective very fast as the primary geometry and proportions – the details of the spout and the curve at the top – have all been worked out. Executing the perspective is fast and efficient, and involves translating the orthographic information into perspective information.

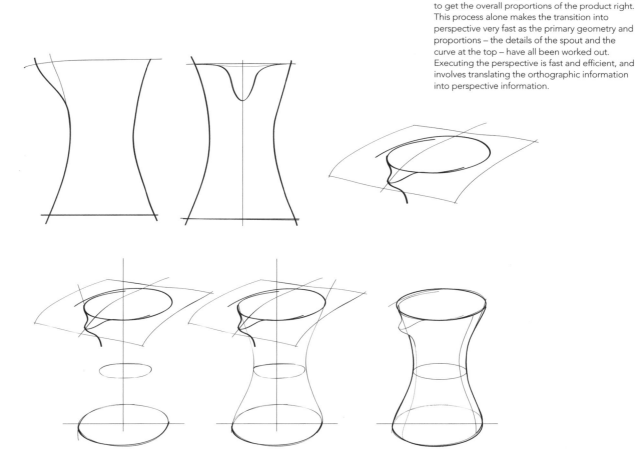

Wireframes

The quick carafe sketch on the previous page (fig. 15) is really a simplified wireframe similar to what a CAD program would create. The careful but quick placement of sketch geometry is accomplished with an economy of means while still suggesting how this concept might be built in the computer. At this point sketching should hopefully feel direct and physical, and its connection to computer modelling should be more apparent. Ultimately, the flatness of the paper needs to disappear as the designer comes to believe (and physically feel) that the sketched line is identical to the outline and contours of the desired form. The sketching process should feel more like constructing forms with pliable pieces of wire that define complex surfaces through 3D outlines and a mesh of interior contours. Although sketched wireframe surfaces are generally simpler than CAD wireframes, these sketches can take on greater dimension with the addition of colour, light, shade and shadow, which will be explored in depth in chapter 9. For now, it is enough to understand that a network of quick but well-placed sketches can create wireframes analogous to those created in the computer.

The wireframe mesh of the shoe last (fig. 17) makes Harry Bertoia's Diamond lounge chair look simple. However, the model, built in Rhino, is based on the quick sketch to the left. The same geometry from that Rhino model was imported into SolidWorks and rebuilt (fig. 18). The difference between these two CAD wireframes is quite startling, even though the final forms and the sketch geometry used to create them are virtually identical. What is important is not the difference between the dense mesh that Rhino creates and the minimal wireframe SolidWorks creates; rather, it is the fact that both wireframes can be shared between software programs, as can the sketch geometry. The file is universally readable by many programs because the software has encoded the geometrical data into the sketch and wireframe. While sketching on paper certainly can't do this, it can prime the designer to think downstream to the modelling phase. After all, a computer wireframe, like a sketched wireframe, is a more organic version of the scaffold introduced earlier.

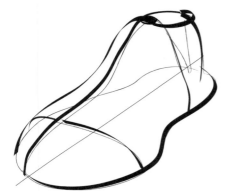

Fig. 16
Quick sketch of a shoe last.

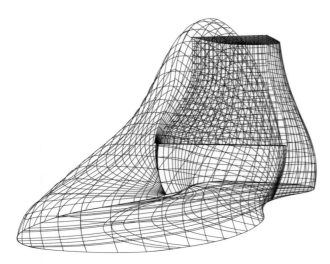

Fig. 17
Wireframe mesh of the shoe last created in Rhino.

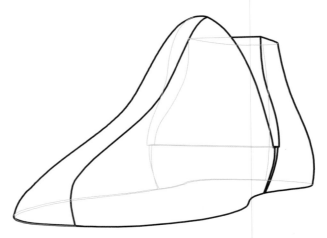

Fig. 18
The same geometry imported into SolidWorks and rebuilt.

Building on the fly: sketching outside the box

The two previous chapters focused on creating forms through the intersection of individual views and sectional sketches. We have now broken free of the flat sketch plane to develop ideas quickly with 3D sketches. In the progressively more challenging tutorials that follow the case study of compound curvature and an overlaid gridded mesh – Mario Bellini's TCV 250 video display terminal for Olivetti, p. 108 – the process will begin, in every case, with a set of orthographic views. This allows quick exploration of critical issues such as proportion and scale before moving into the more challenging process of building a good perspective sketch. The orthographic top view will be skewed into perspective to work like a footprint and help situate and centre the concept. The footprint metaphor is heavily relied upon in the final tutorial – for a trainer – which starts with the sole (footprint) and moves systematically to the upper, building the design quickly through compound curves, sectional development, 3D sketches and a series of interior contours. The trainer is an ideal product for such an exercise because there are literally no flat surfaces. The tutorials should be repeated with other designs until a level of comfort with the process is achieved.

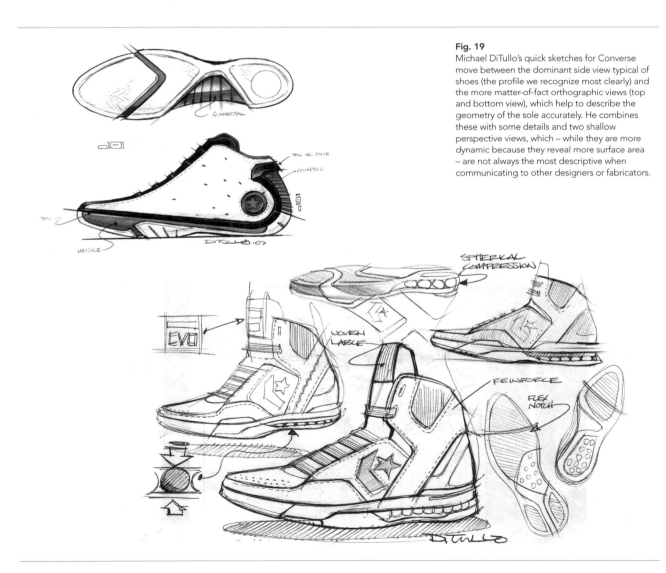

Fig. 19
Michael DiTullo's quick sketches for Converse move between the dominant side view typical of shoes (the profile we recognize most clearly) and the more matter-of-fact orthographic views (top and bottom view), which help to describe the geometry of the sole accurately. He combines these with some details and two shallow perspective views, which – while they are more dynamic because they reveal more surface area – are not always the most descriptive when communicating to other designers or fabricators.

Case Study

TCV Display for Olivetti

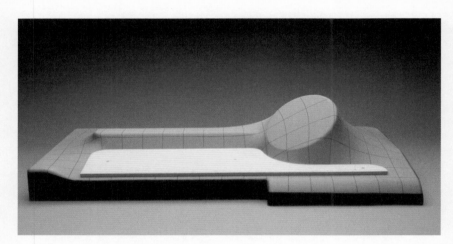

Mario Bellini's TCV 250 video display terminal for the Italian manufacturer Olivetti represents a classic example of compound curved surfaces. The vacuum-form 'buck' used to cast the top surface of the terminal takes on the appearance of a 'stretched membrane' and works successfully to unify the overall design into a more organic whole, thus making it look less technical. The product, designed in 1966, consists of sheet steel and vacuum-cast ABS plastic.

The grid superimposed over the form bears a similarity to Bertoia's wire mesh seat for his Diamond chair. Here, however, the grid is used to help the mould-maker to create the pattern that will form the top mould. The images illustrate stretching a flexible material over a set of hard objects to create a transitional form. Bellini employed such an approach for the development of many products manufactured by Olivetti, including the Divisumma 18 calculator. This is considered a design classic, with its rubber membrane surface and generous fillets on the

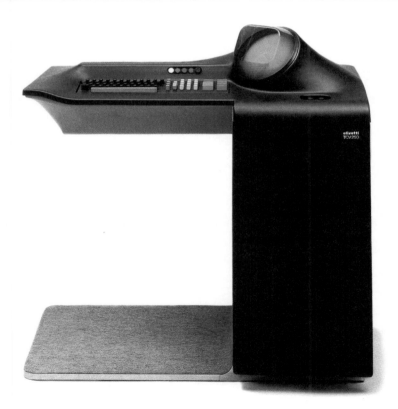

The thermo-formed skin of the TCV console unifies the control panel into a smooth and continuous landscape-like form. The detailing on the monitor and the angle of tilt and orientation provide a sense of beauty and ergonomics – viewing the monitor involves less bending and straining. These details were used by Bellini in other products designed for Olivetti.

base of the buttons to create a unified quality between the interface and the product's surface. (For more detailed information see chapter 8.)

Bellini's stretched membrane has been re-created (top right) in Adobe Illustrator to better see the gridded overlay, which in this case acts very much like a uniform set of contour lines, thus helping the eye/brain understand the surface undulations. The rendering below it was done in Photoshop using the same Illustrator file (with the gridded surface turned off). This rendering has no outlines, contours or edges of any kind but is instead an image based entirely on colour (referencing the original photograph). These two illustrations demonstrate the power of line and the power of colour, shade and shadow. Communicating form relies on strong sketching or a strong sense of light (shade and shadow). Often the best sketches combine both in amounts appropriate to the fidelity required for communication (see chapter 9).

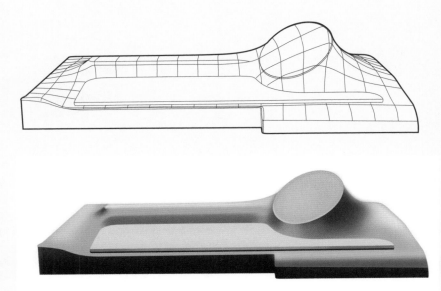

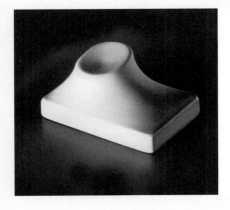

Imagining sophisticated forms sometimes requires imagining the transformation process and then sketching it. The button study shows the transitional surfaces (from circle to square) as well as the concave indentation for the finger.

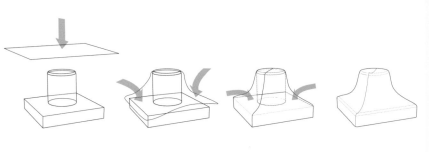

Tutorial

Sketching a contoured bar of soap

Note how different the sketch above looks from the tutorial on the following page. This is because the vantage point is different. In the sketch above, the vantage point is much lower, making the object appear rounder. Choosing a good orientation is essential to a successful sketch.

The step-by-step tutorial opposite focuses on the creation of what are commonly referred to as compound curves – curves that bend in two opposing directions. An easy way to accurately sketch compound curves is to use points plotted on the centrelines of varying planes within a volume. A compound curve often defines the boundary of a compound curved surface (a surface that bends in two opposing directions like the soap bar above). This is also known as a double curved surface. Contemporary products often have compound curvature. Sketching such products can be a challenge for a student, but once the process is clearly understood and practised it should become second nature.

Understanding the orthographic view of such an object is essential for sketching it in perspective. The curve that defines the side profile slowly doubles back on itself. The drama of the compound curve is more noticeable from the front view.

1. Begin by sketching a base plane on which the top view (ellipse) is placed. Pay attention to the symmetrical placement of the ellipse: the major and minor axes will correspond to the centrelines of the plane. Sketch in the ellipse. This will be used as a reference sketch throughout.

2. Box-in to create a top plane for accurately sketching a second ellipse. This represents the orthographic top view redrawn in perspective on the top plane. These flat ellipses are necessary references for the beginner to sketch the compound curve.

3. Sketch a third ellipse just below the top plane. This too will serve as a reference for sketching the compound curve. Having multiple sets of centrelines is essential and will serve as contacts for the compound curve as it swoops from one plane down to the next and back up to the first.

 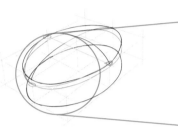 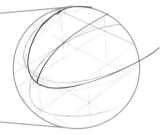

4. Sketch a set of arcs that correspond with the centrelines and the major and minor axes on the top plane. These arcs will become contour lines later on but will serve for now to indicate that the top surface is a compound curved surface.

5. The small circles in red indicate the nodal points that the compound curved path must take. Start at any one of these and sketch an arc that curves in two directions: one that follows the path of the ellipse while also moving down to the lower ellipse to connect with the nodal point there.

6. This compound curve should be as smooth and fluid as possible. Begin by sketching only one half of the full curve. Over time the full compound curve can be sketched without the aid of the lower ellipse, as the student will start to 'feel' the curve as it moves in both directions.

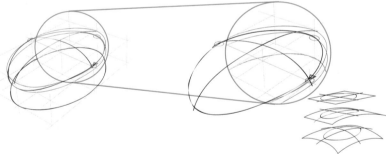 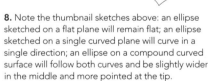

7. Sketching the second half of the compound curve is identical to the first half. Select a nodal point on a centreline and sketch the curve, simultaneously following the elliptical path while also moving downwards in space to connect to the nodal point on the lower ellipse. Transition the second sketch into the first.

8. Note the thumbnail sketches above: an ellipse sketched on a flat plane will remain flat; an ellipse sketched on a single curved plane will curve in a single direction; an ellipse on a compound curved surface will follow both curves and be slightly wider in the middle and more pointed at the tip.

9. For the lower compound curve I've eliminated the extra reference ellipse and sketched the curve in one smooth continuous motion. This is the desired method because it is faster and more intuitive. Learning to feel the movement of an elliptical path as it traverses a compound curve enables minimal scaffolding and greater speed.

10. The final step is to differentiate the various line weights. Sketch a continuous outline merging the outer edges into one continuous curve. Use a heavy line weight to help hold the object together so that it can be read as a single object. Use a slightly thinner line for any distinct edges. Finally, use a very thin line (or a light grey line) for any contours. In this case the top surface will not be read as convex without contour lines. A drop shadow and cool grey can be added to suggest a light source.

Sketching the Pringle potato crisp

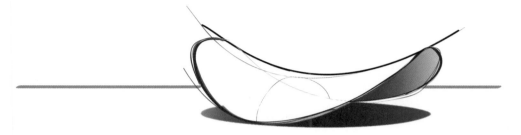

The Pringle potato crisp is a compound curved surface often referred to as a 'saddle' because of its resemblance to the riding accessory. It is very difficult to draw this form in perspective without understanding the dominant arcs that drive its shape as seen in the orthographic view (below). These provide critical centre points and end points, which define the limits of the surface's boundaries. Such an example clearly illustrates again the importance and power of understanding form in orthographic view before proceeding to sketch it in the more challenging perspective view. The compound curved surface is defined by a continuous compound curve much like an old-fashioned roller coaster. The biggest challenge with a surface like this is to sketch the compound curve in one fluid stroke. Another way to think about this surface is as series of sections that are connected by a continuous compound curve (see illustration left). On the following page are two examples of how to approach such a form.

A compound curved surface like a saddle sliced at even intervals will result in a series of simple arcs aligned along a curving spine.

1. Box-in the basic envelope – the cubic volume the full object occupies in space. Sketch the top view ellipse on the bottom plane, being careful to position the ellipse so the centrelines pass symmetrically through it. This serves as a reference.

2. Repeat and sketch the same top view ellipse on the uppermost plane of the product envelope, again ensuring that the ellipse is symmetrical to the two axes. These two ellipses are the upper and lower reference points for the compound curve.

3. Sketch two arcs: one that runs parallel to the major axis and one parallel to the minor axis of the ellipse. These are direct translations of the side and front view – see orthographic drawing on p. 112. Note that one is concave, one is convex.

4. This step is not strictly necessary but is useful for beginners. Sketch a series of small arcs to help define the direction of the compound curve at the end points on the two previous arcs. As the compound curve is sketched, these references help direct the process.

5. While a compound curve should be sketched in one fluid motion if possible, it's been broken down into two steps here for clarity. This is the hardest part of the process and requires the student to literally 'feel' the curving line ride along the ellipse while also moving up and down.

6. A single fluid motion isn't absolutely necessary but often results in a more convincing curve. The earlier scaffolding was created so the compound curve could be sketched with confidence. Feeling the shape of the object while sketching can also build confidence.

7. A single darkened outline can help make the object pop out in space. As the resulting surface is a compound curved surface, the addition of contours to reinforce the curvature are very helpful. The contour lines are the previously sketched arcs.

8. All objects have thickness that can be conveyed through a second edge. Rather than sketch the entire compound curve again, lightly sketch just a partial second sketch that follows the first edge and disappears naturally out of sight.

9. Use the original elliptical sketch as a reference for casting a shadow. While this is not completely accurate, it helps to situate the compound curved surface in relation to the ground plane. Hatch marks and a blast of cool grey marker will suffice.

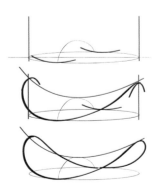

10. The sequence above is more or less identical to the previous one. The main difference is the vantage point (the angle from which the object is viewed). By lowering the vantage point, the nature of the compound curved surface becomes more

apparent. When the object is drawn from above, the contours flatten out, making the compound curve that defines the perimeter of the surface less extreme. The choice of orientation when sketching an object can play a big role in how easily the

object is understood. Note that the 'envelope' has been intentionally eliminated. The arcs and ellipse suffice as references for quick sketching. Also, the original reference ellipse defines the projected shadow.

Tutorial

Sketching a trainer

One of the simplest metaphors for rapid sketching is to think of the product's 'footprint', as the starting point for sketching. It makes sense then to practise by sketching a trainer. This tutorial begins with the footprint of the product and proceeds to build the upper and the internal detailing through sections. Finally all the various sketches are united by a single compound curve outline. Many product sketches begin this way as it helps to first establish the overall shape of the object on the base plane (footprint) before building up the necessary sectional sketches (or ribs) to give the form dimensionality. The compound curve (also known as a 3D sketch) when combined with interior contour lines creates the illusion of a compound curved surface or skin.

This tutorial is about speed rather than a high degree of detail. The perspective sketch process should not take longer than 15 or 20 minutes when done correctly. Critical to the success of this approach is working out the approximate design in orthographic view before translating it into perspective. The focus should be on the quick proliferation of ideas rather than on a high degree of finish or detail.

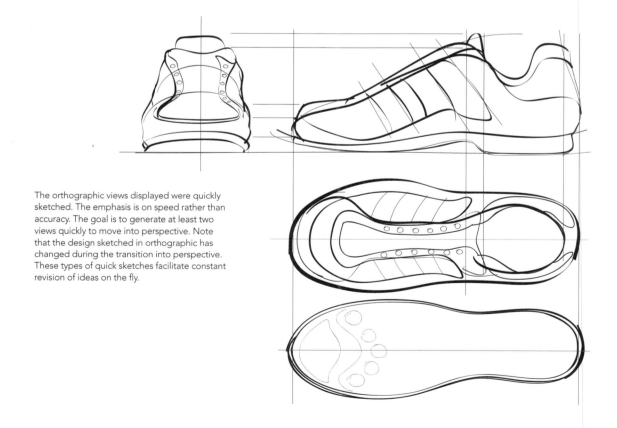

The orthographic views displayed were quickly sketched. The emphasis is on speed rather than accuracy. The goal is to generate at least two views quickly to move into perspective. Note that the design sketched in orthographic has changed during the transition into perspective. These types of quick sketches facilitate constant revision of ideas on the fly.

Bottom view

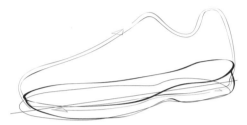

1. Begin by sketching the footprint in perspective. Here it is literally the print the trainer might leave. Sketch a centreline to help in positioning the symmetrical sketch (the front half of the drawing will be larger due to the foreshortening). This sketch represents the orthographic bottom view of the design and will help to position the compound curves that will reference it. The centreline will also be used to position the side profile of the trainer.

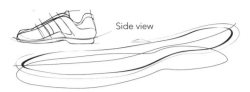

Side view

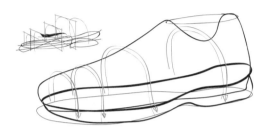

2. The next sketched surface floats just above the footprint and represents the top of the rubber sole. This sketch is a compound curve that simultaneously follows both the footprint and the side-view profile of the sole (see detail). It is helpful to sketch a centreline that mimics the curving side-view profile. Just like a flat centreline, a curving centreline suggests the plane on which the compound sketch sits.

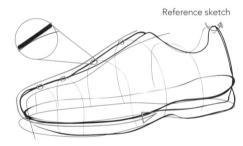

3. Referencing the side view, sketch that profile in perspective on the centre plane (the plane is not actually there but the centreline that references it is). With this profile in place, the trainer now begins to emerge as a 3D reality even though there are few sketches present. The next step is to add in sectional sketches from the front view orthographic to help build out the upper. Note there is not a single flat surface present.

4. Sketch a series of sections (ribs) along the length of the trainer as if they were placed on a series of parallel planes (see detail). The centre point of each sectional sketch should touch the top side of the side profile. While this process is aimed more at speed, it is still important to strive for accuracy. An additional section has been lightly sketched where the foot enters the trainer as a reference point for the compound curves.

Reference sketch

5. With the sectional sketches (ribs) in place a partial outline can be sketched. The outline should touch tangent to the sections (circled in red) creating a single compound curve that joins them into one nearly cohesive form. The outline is only partially sketched at this point to provide clarity for the remainder of the sketch. The full outline will be completed when more geometry is placed. Sketching often proceeds in small incremental steps.

6. With the trainer slowly taking shape, sketch the back geometry where the heel tab and heel collar meet the front of the shoe. The geometry for the tab and collar are a compound curve somewhat similar to the Pringle crisp. When sketching it think about the oval opening (top view) combined with the side profile. Finally, with the trainer outline complete, sketch on the compound curved surface of the upper as if it is 3D to add in the details.

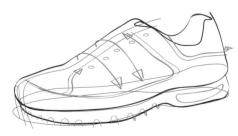

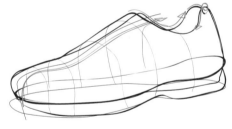

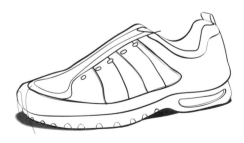

7. The remainder of the process is detailing. With the 3D form fully developed, the sketching process involves lightly sketching on top of it and acknowledging the compound curved surfaces. Once a detail is correct, it can be darkened. It is very important to feel the form of the product while sketching. While the sheet of paper or computer screen is flat, the object is not and all internal contours must reflect this reality.

8. This sketch represents a quick 20 minute concept based on orthographic sketches that might have taken an additional 10 minutes to sketch. It could be completed to a much higher degree of detail including material finishes, colour, shade and shadow, but that's not the point. The idea here is to show that even a quick sketch can communicate form very quickly so others can view and give their input before moving on.

LINE

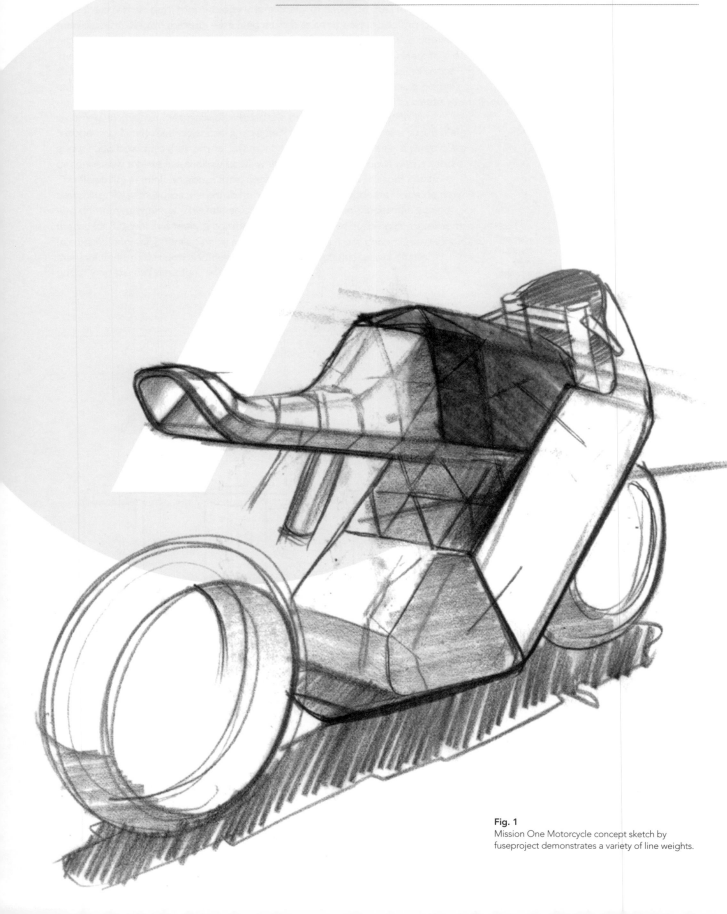

Fig. 1
Mission One Motorcycle concept sketch by
fuseproject demonstrates a variety of line weights.

Fig. 2
Line-weight differentiation is the result of varying
the pressure on a pen or pencil. With practice it's
possible to get five distinct line weights with just a
normal ballpoint pen. Practising applying different
pressure is useful in creating line modulation. Most
tablets have pressure-sensitive pens that simulate
that same effect digitally.

Story line

As demonstrated in chapter 1, few, if any, objects have lines; they have edges.
Yet designers must rely on line to tell the story of the development of a product's
final form. There are the faint ghost lines that provide the necessary scaffolding
for good sketching; the otherwise invisible contour lines that tell the eye (actually
trick it into believing) there is a soft recess or protrusion on the surface of an
object; the strong outlines that help make a three-dimensional object pop; and
the parting lines that serve the more technical purpose of indicating where parts
from different moulds meet – for example, the two halves of a hand drill. There
are also hatch lines, shadow lines and, finally, vignettes. Seven different types of
line will be examined in this chapter.

In addition to different line weights there is also line-weight modulation or
the varying of the line weight within one stroke to convey depth or even emotion.
An outline, for example, is often heaviest at the bottom of the object where it
contacts the surface it is sitting on. Thinking of line as merely the 'mule' that
transports meaning through accurate placement of geometry misses its real
power. Accurate sketching requires a steady and practised hand as well as an
ability to make quick decisions about the appropriate type of line.

Clarifying meaning through line weight

Let's look at the example of a sphere (fig. 3). To the eye, the outline of a circle (2D)
and the outline of a sphere (3D) are identical unless the viewer moves around the
object to detect the depth of the sphere. In sketching, a circle is transformed into
a sphere with the simple addition of an ellipse passing through its centre. Merely
by modulating the line of the circle (varying the thickness) so that it is weighted
more at the bottom than the top, the circle instantly becomes more three-
dimensional. The weighted line suggests both heaviness and a hint of shadow.

While this is an illusion it is important to be able to control the illusion
carefully to create the right effect and thus avoid bad ambiguity. The image on
the opposite page (fig. 1) is an early sketch iteration from fuseproject's design
for Mission Motors. While seemingly simple, it reveals the power of line to convey
the look and feel of the motorcycle. The sketch contains nearly every type of line
possible, from ghost lines to heavier outlines, contours and cross hatching to
indicate shade and cast shadows. The quickness and brevity of the marks helps
to convey emotion and a sense of power and speed. The contour lines on the seat
create a sense of sculpted form more sensuous than the stealthy flat geometry of
the shroud. Let's look more closely at the various lines and how they can be used
in sketching to define three-dimensional form.

Fig. 3
Sketch lines do more than just outline form. They
leave traces of how an object took shape. Each line
weight tells a different story and helps the brain to
comprehend the object quickly.

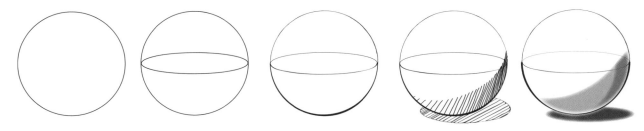

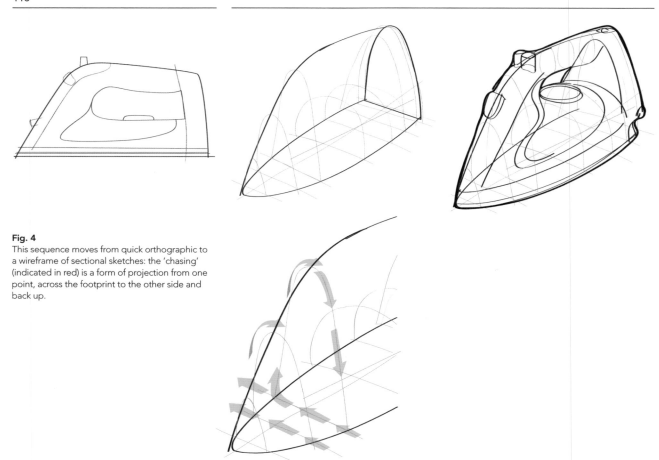

Fig. 4
This sequence moves from quick orthographic to a wireframe of sectional sketches: the 'chasing' (indicated in red) is a form of projection from one point, across the footprint to the other side and back up.

Line 1: Chasing the ghost lines

Good sketching begins with an initial set of lines laid down so lightly that they are barely visible. These lines (which I refer to as ghost lines) allow for a lot of experimentation in order to get things right. They establish the basic footprint and structure (or wireframe) of a product when necessary, and are drawn so lightly that they will disappear visually once the final darker lines are sketched over them. Ghost lines are similar in a sense to hidden lines – the term used in CAD to describe the thin but visible grey lines of a 3D model that would otherwise be obscured by the surfaces in front of them. Hidden lines are necessary for the designer to understand the model on screen as it is rotated in Cartesian space and relate directly to the idea of occlusion discussed in chapter 2. The sketched-in ghost lines work to provide the reference scaffolding, but also add depth and dimensionality to a final drawing. With the iron (fig. 4) the ghost lines were instrumental in defining the shape of the handle and its location on the body. In some instances, a ghost line will simply be darkened to create a final outline or to position a contour line.

Ghost lines are not restricted to sectional sketches but can include diagonals, centrelines, quick planar sketches and even contours. They can serve as the temporary scaffolding for additive and subtractive sketching, or as an underlay for accurately sketching in the radius corner of an object or centring critical geometry. Ghost lines are reference geometry and are created through projection, often with a reference back to centrelines. Through practice the whole process will become quick and intuitive, facilitating faster and more efficient design exploration.

Line 2: The boldness of the outline

The outline is a continuous and connected line that defines the outer boundaries of an object; it unifies edges that are close to the viewer, as well as edges that are further away. The outline, in terms of line weight, is the boldest line of all but is usually established soon after the ghost lines have been sketched in. After a sketch is fully defined the outline can be darkened further, but it helps to establish it early on to get a sense of the overall size and shape of the object.

Fig. 5
The sketch below (SolidWorks model above) shows the power of the unifying outline to help define a product in the early sketching stages – much like a silhouette. Modulating the outline (varying the thickness) adds life to the line. Orientation is also important here as the handle, spout and body can all be viewed from this vantage point.

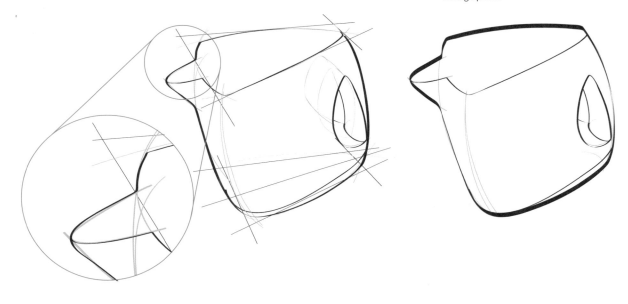

Fig. 6
This step-by-step sequence shows the process of defining an outline that will traverse the three primary planes of a radiused cube, as well as any transitional geometry such as the radiused edges (fillets).

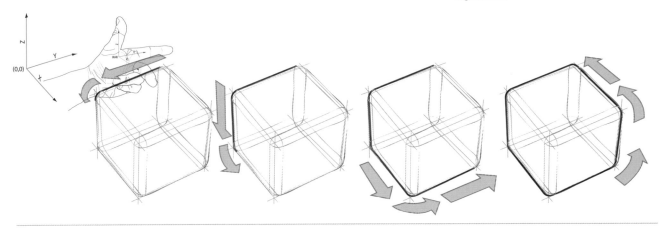

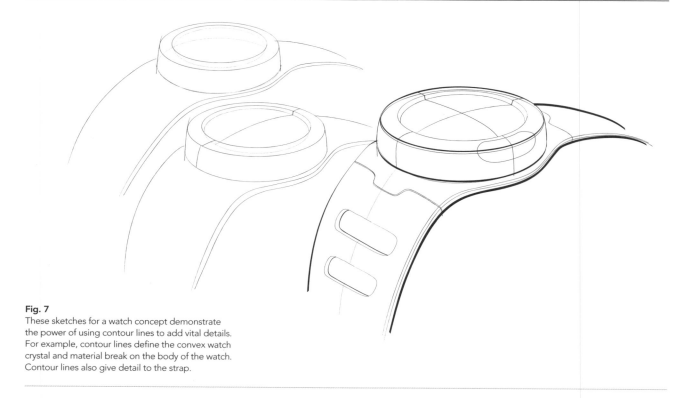

Fig. 7
These sketches for a watch concept demonstrate
the power of using contour lines to add vital details.
For example, contour lines define the convex watch
crystal and material break on the body of the watch.
Contour lines also give detail to the strap.

Line 3: The functional beauty of the contour

The contour line is an artificial line – a drawing convention to help explain and
visualize form. It rarely exists on real objects although material and colour breaks
can create physical contours. Depending on how a CAD model is built, contour
lines can emerge in the form of other types of edges. In sketching, contour lines
are especially useful in visually describing compound curvature and organic forms,
which have few or no internal edges. In the illustration above (fig. 7) a series of
ellipses have been transformed into a watch face: the contour lines help define
the geometry of the lens. Without the contours it is difficult to 'read' the form
three-dimensionally. It is easy to see just how descriptive contour lines can be in
conveying changes in complex surfaces. Contour lines need to be kept light to
suggest form without suggesting actual geometry.

Fig. 8
This sketch for the Argus 'Bean' digital camera
(TEAMS Design, Chicago) uses contour lines to
define actual material breaks, parting lines and
compound curvature.

Lens

Clip

Line 4: The technical line (parting and cut line)

The parting line, as previously mentioned, refers to the boundary edge where the two halves of a mould come together (see fig. 10, below).

The parting line also refers to the visible seam on an assembled plastic housing where two separately moulded parts are joined. It is different from a contour line because it is an actual edge as opposed to geometry added to make the sketch more readable.

Slots in plastic parts for venting or other types of openings (for example, where the buttons protrude on a mobile phone – fig. 9) would also be represented as real edges and therefore darker lines in a sketch.

The plastic housings on many products are split symmetrically but they do not have to be. The parting line can curve or deviate in order to accommodate the various buttons or other openings on a device or tool, and can also be used for expressive detailing. Openings for buttons in a plastic part (such as the computer mouse, fig. 11) often have a secondary level of detailing like a fillet, chamfer or bevel. These lines add critical technical and aesthetic information about an object.

Fig. 9
Two types of line that represent real edges in a sketch are parting lines and internal cuts to accommodate buttons and other controls.

Fig. 10
This sketch shows an exploded view of a hand-held grinder concept. The two halves have been split at the parting line, thus revealing some of the internal components. Separate parts like buttons, insert panels or electronic components can be revealed in this way.

Fig. 11
Sketches for the Microsoft Arc mouse, designed by One and Company (San Francisco), utilize heavier line weight to describe articulating parts.

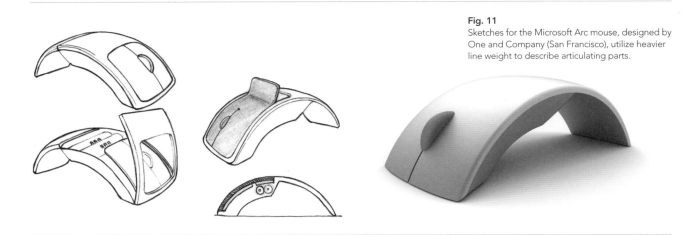

Line 5: Deep space – the vignette

The vignette can be thought of as a partial frame intended to set off a sketch on a sheet of paper or computer screen and create a greater illusion of depth. It works in a manner similar to the 'ground' in the classic 'figure and ground' relationship defined by the Gestaltists by providing a distinct background against which the object can 'pop'. The lines of the vignette are often as thick as the outline even though it appears to be further away. There are just two things to remember when creating a vignette: for the illusion of depth to occur the vignette should be interrupted by the object; and the frame lines of the vignette should never touch tangent to any outside edge of the object as this will flatten the sketch (see fig. 12, third image).

1. The vignette is incorrectly used as a frame
2. The vignette incorrectly coincides with the top and right sides of the objects
3. The vignette incorrectly coincides with the bottom edge of the object
4. The vignette correctly intersects with the object
5. The vignette with shading added

The shape and fill of a vignette can vary from quickly sketched and intersecting lines that create a framing effect to a carefully radiused rectangle; the inside can remain empty or be filled with a wash, or slug, of colour (fig. 12, image 5). On a page full of very small sketches multiple vignettes might only confuse the spatial issue. Use the device sparingly or to isolate ideas from one another (fig. 14).

Fig. 12
The horizontal or vertical edges of a vignette shouldn't coincide with any edges on the sketch (examples 2 and 3) but should intersect with one of more edge to establish depth (see detail).

Fig. 13
A vignette is used in the sketch to help locate the hand mixer in space. It not only frames the object but also provides a stopping point for the eye.

Decaf Rim

Fig. 14
(Right) Astro Studio (San Francisco) uses radiused corners to soften the vignettes. The individual vignettes create a cell-like effect similar to animated sketches.

Line 6: The emotional line

Controlling line weight for expressive purposes is essential to good sketching. Correctly modulated lines can help ground an object, and suggest volume or depth. Lines sketched with speed and ease can also add expressiveness. In other words, lines that might be laid down to establish a dominant direction or curve can also provide expression and urgency. This is referred to as sketching past the object. For example, a car designer might lay down very large gestural lines to set the mood of the design. Such large gestures should be fast and unencumbered. The sketch is often built around these types of gesture because they provide a sense of speed and elegance, which is hard to achieve when working on a very small scale and with tight gestures. Feeling the power to convey ideas expressively also makes the sketching process more enjoyable and engaging, which ultimately leads to longer ideation periods. Tentative marks often feel less assertive or certain and can translate into less confident presentations.

The emotional line comes once the designer has internalized many of the earlier lessons: how to build the necessary scaffold for assured and accurate marks; how to sketch a circle in perspective properly; how to create compound curves and compound curved surfaces. Emotional lines and marks require that the designer has internalized all the necessary steps and can mentally see the way to building the concept; thereby he or she makes efficient use of every mark and relies on the minimum of marks to express an idea or develop a form.

Fig. 15
The initial sketching process involves quick gestural ghost lines to flesh out the basic geometry while maintaining a sense of immediacy. Refining such a sketch requires darkening outlines and defining secondary and tertiary details. Adding some cool grey to help define the geometry will assist the eye in reading the form (TEAMS Design, Chicago).

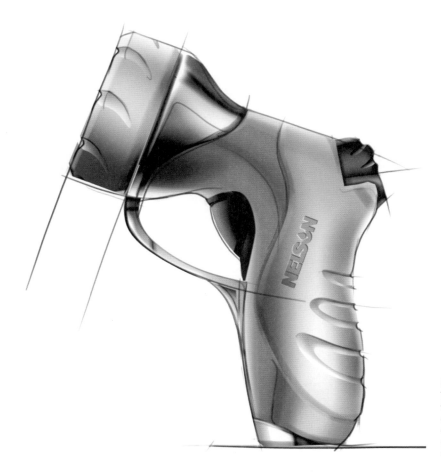

Fig. 16
This rendered sketch (TEAMS Design, Chicago) is for a Nelson multi-pattern spray nozzle. The sketch clearly demonstrates the power of the gestural or emotional line to help reinforce the form's overall geometry while keeping even a middle-fidelity rendering feeling fresh and immediate.

Line 7: Reinforcing depth through straight hatch lines

Hatch lines can be a series of lines indicating shade cast on an object or the shadow an object casts. They suggest modulation in light on a surface when it is not possible to add colour with a marker or digitally. Hatch lines are generally used to convey quick initial ideas and hatching generally uses straight lines for purposes of speed, regardless of an object's shape, but can also be drawn to reflect its surface identity. The more tightly packed the hatch lines are, the darker the resulting surface will read. As the lines move further apart the illusion of shade cast on the object fades. Hatch marks can be applied loosely and expressively to reinforce the freshness of the sketch.

Fig. 17
Scott Wilson's quick sketch for the Nike Presto digital bracelet uses hatching to create volume and depth while also suggesting material changes.

Fig. 18
These sketches by Matthew Boudreau for Reebok's V12 trainer demonstrate the simple but effective use of hatch lines to suggest form while differentiating surfaces. The designer has to meld high performance into an aesthetically pleasing final product, which requires a lot of quick sketches from a variety of vantage points.

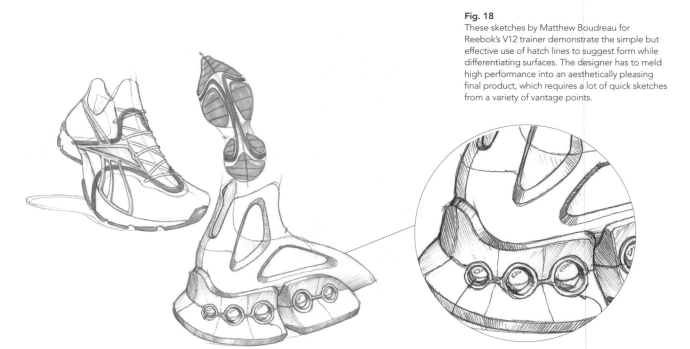

Projecting shadow lines

Lines are essential for both projecting and shaping the shade and shadow on objects. The series of cubes below (fig. 19) shows the connection between projection lines and the outlines of the actual shadows. The light source is positioned where the lines converge, creating a 'triangular wedge' effect that moves as the height of the light source changes and the rotation around the object is altered. It is convenient to think of the shortest edge of the triangle as being the pivot point (red arrow in the diagrams). As the light swivels the shadow swivels with it. The actual shadows are the direct result of two sets of projection lines in alignment along a vertical axis. Projection, like everything discussed so far, is essential to the creation of shade and shadow.

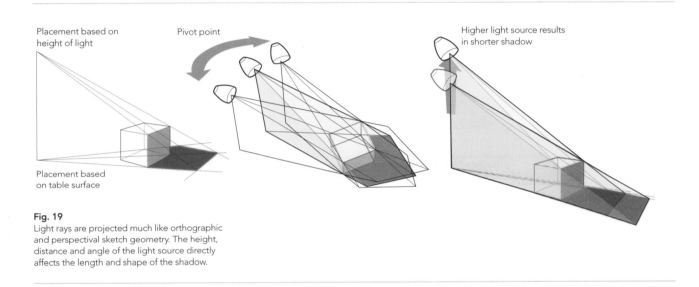

Placement based on height of light

Pivot point

Higher light source results in shorter shadow

Placement based on table surface

Fig. 19
Light rays are projected much like orthographic and perspectival sketch geometry. The height, distance and angle of the light source directly affects the length and shape of the shadow.

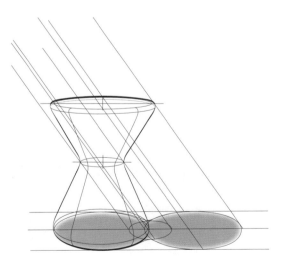

Fig. 20
The carafe sketch above shows how light rays intersect with the sketch geometry as it is projected on to the flat ground plane to create the outline of a believable shadow.

Fig. 21
The pen concept sketches by Omer Haciomeroglu employ light hatch lines to suggest volume, shade and shadow. The absence of hatching can effectively suggest a highlight.

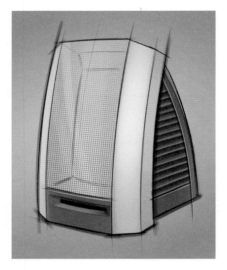

Fig. 22
In this perspective sketch the arcs extend beyond
the form as part of the dynamic sketching process
but also as a way to emphasize the dominant
curves that define the form. (TEAMS Design,
Chicago.)

Letting the line reinforce the story

This entire chapter has been devoted to the richness and variety of line, which
remains the most powerful element of sketching. It can be a tool for registering
objects accurately in space or an expressive mark suggestive of volume and
weight, but it can also be laid down in a tentative and provisional way to simply
start the thinking process. Designers sometimes need to mull over the marks they
make, responding to their potential. Orthographic sketching, discussed in chapter
3, is way of giving form without resorting to perspective. This remains one of the
fastest ways to get ideas out because the focus is on one or two views only,
allowing the designer to develop a rapid succession of thumbnail sketches that
can be translated later into perspective. This also relates directly back to the
earlier discussion about dominant views and the psychology of sketching in
chapter 2 – the fact that we recognize and retain idealized forms of objects more
easily (which tend to be orthographic). Here we will explore the generation and
refinement of form through repetition and revision.

Repetition and revision

The dominant view is a great place to begin the ideation process, laying down
broad strokes to establish the primary geometry of the product as well as the
overall proportions. Large gestural marks help establish the underlying look and
feel of a design. Line weight is crucial at this stage: the underlying gestural marks
should be the lightest, the outline of the product the darkest and the interior
details somewhere in the middle range.

'Sketching through' the object in perspective view is critical for placing
accurate geometry; sketching past the 'envelope' of the product in orthographic
view adds flair and feeling while not constraining the designer at the early stages
of concept iteration. Lightly sketched lines or arcs help to quickly capture the

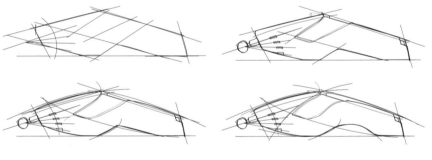

Fig. 23
This series of sketches for a hand-held rotary
grinder begins with the basic massing of form
through very light lines and arcs, to help establish
the general layout and possible aesthetic of the
product. The subsequent sketches add detail and
variation while remaining consistent with the
original massing.

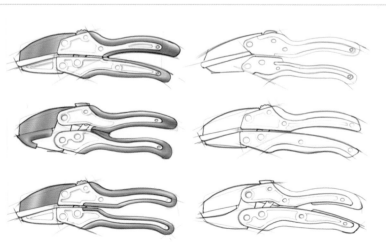

Fig. 24
These sketches show a typical exploration of
a hand tool (secateurs). Notice how the designer
has laid down a series of arcs and lines to help
establish the look and feel of the product. While
the differences may seem subtle, explorations like
these are essential in creating products that are
not only highly functional (correct layout of
mechanical components) but are also aesthetically
pleasing. Sketches by Daniel Lipscomb for Fiskars.

essence of an idea and require little time commitment, thus allowing the designer to move on if he or she is not satisfied with their work. Once a successful layout is established, the designer can tighten up proportional relationships and begin a higher level of detailing or move on quickly to another variation. These initial marks are like the regulating lines some architects use to help generate form. They are not to be confused with 'ghost lines', which are more tentative in nature and structural; instead they are suggestive of the essence of the design.

Open-endedness is as important as speed. Early in the design process it is vital to get ideas out quickly and in quantity, for review as well as refinement. These sketches need to convey the essential nature of the design idea to a range of collaborators including other designers, project managers, engineers, marketers and so on. Quick sketches often capture the feeling and spirit of an idea better than refined ones, and the speed and ease with which they are created give them a kind of magical quality. Because a concept will go through multiple filters of refinement, including physical models and prototypes, it is crucial to keep the expressiveness high in early conceptualizations. Up until now the focus has been on accurately transforming orthographic sketches into perspective sketches by carefully building them section by section. Once the ability to do this is internalized, the designer needs to sketch without the safety net of underlying ghost lines and carefully constructed sections in order to create more expressive sketches focused on the overall form of the object.

While no single line defines a three-dimensional object, the brain is still greatly influenced by the power of outlines. Dominant orientations – like side views for cars – are crucial to any iconic profile being recognized. The loose sketches below and right show how Philippe Starck's Masters series for Kartel merges three mid-twentieth-century modern chairs into one hybrid or mash-up chair. The main difference between his chair and the three referenced chairs is that the latter are all volumetric masses while Starck's design is completely linear except for the seat pan. Whether or not his chair can be seen in the other three chairs can only be answered by the individual viewer. For those familiar with the classic chairs shown, it would be hard not to see the references; they just might need to take a second glance.

Fig. 25
Philippe Starck's Masters chair for Kartel is particularly interesting in terms of line. It is as though the shadows of three of the most recognized chairs have been merged. Starck said: 'The Masters chair brings to mind the lines of three great masters and three great masterpieces. Putting them all together, they create a new product, a new project, a reflection of our new society.'

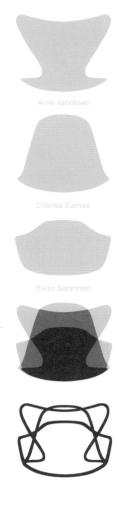

Fig. 26
Starck's Masters chair is based on the outlines of three classic mid-twentieth-century modern icons: the Series 7 from Arne Jacobsen; Charles and Ray Eames' Eiffel chair; and the Tulip armchair from Eero Saarinen.

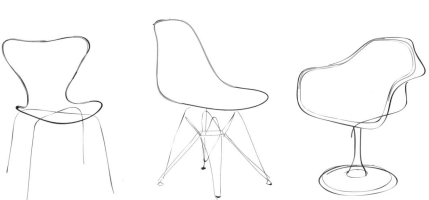

Case Study

DC25 Vacuum Cleaner

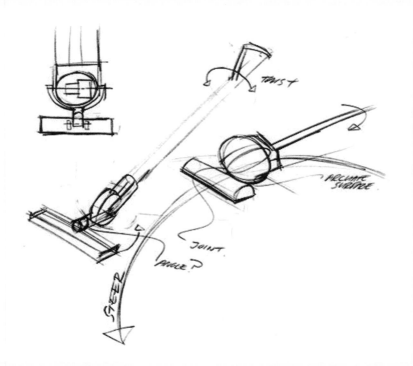

James Dyson's name is synonymous with the 'bagless' vacuum cleaner and the dual cyclone technology that makes it function. And while his approach to design is prototype intensive – he worked for 15 years through more than 5,000 prototypes to refine his bagless vacuum technology – he has also relied heavily on sketching. In his autobiography *Against the Odds*, he recounts his trip out to a sawmill where a cyclone dust collector was installed. He 'made some sketches by moonlight and climbed all over it to determine exactly how it worked, what the proportions were, and what it was made of.'

The DC25 is an example of Dyson's relentless search to improve a product that remained dormant in terms of technological development for decades until he came along. The DC25 and its 'ball' technology allows for far greater control of the vacuum cleaner, especially in the many tight spots encountered in living spaces. Commentators have noted some similarities between the DC25 and Dyson's first attempts at developing his own products. What makes Dyson a great designer is his attention to detail and his ability to ask simple questions like: Why does this work and can it be applied to this other problem? Today, Dyson is a global manufacturer of a range of household products from vacuum cleaners and washers and dryers to his most recent product innovation: the bladeless fan.

(Above) Early concept sketches for the ball vacuum, and (right) the finished product.

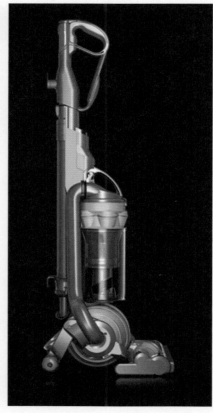

Case Study

Vessel Ideation

Vessel Ideation is a boutique design studio, based in Chicago, which specializes in the creation of high-impact ideas that inspire emotional connections between global brands and their consumers. This translates most commonly into structural packaging that supports company brand messages. The montage of images represents Vessel Ideation's entry for the 2009 World Kitchen Tea Off (which they won). The process begins with a range of quick conceptual sketches, followed by tighter orthographic drawings to work out overall proportions and functionality, another round of form-giving, model-making, computer-aided design and, finally, rapid prototypes.

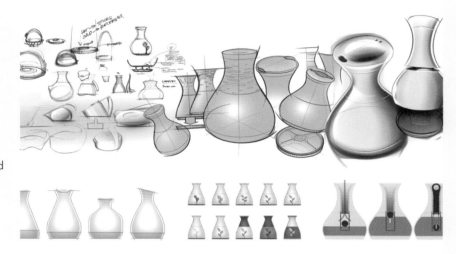

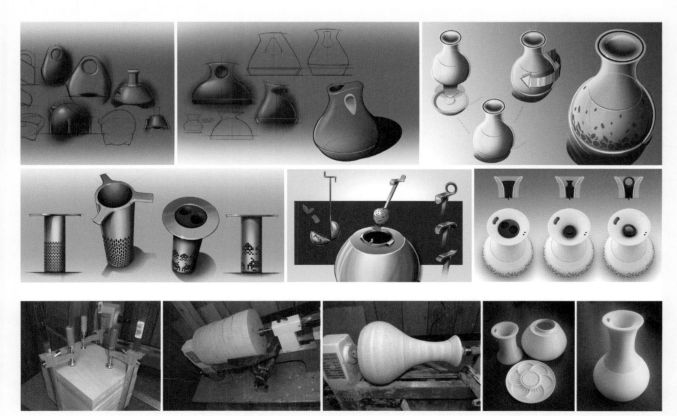

Tutorial

Putting line and orientation together

Developing concepts orthographically is quick and allows easy comparison across a range of concepts. Details can be quickly sketched in 3D if necessary (below).

Using the example of a shampoo bottle, we will combine line and orientation in order to understand the design's geometry. The quickest and simplest approach is through a series of front- and side-view orthographic sketches that require the designer to focus on only one view at a time (front, side or top view). Moving from left to right, making either small or large changes is easy and fast and permits broad experimentation combined with the ability to review concepts side by side. Isolating a single component (like the cap) and moving between orthographic and perspective can also be effective.

In this sequence, the approximate bottle shape is quickly and lightly boxed in to establish the overall footprint of the form, followed by the most essential curves from the two orthographic views. Details are then added to the basic wireframe. A tight sketch like this can be rendered in Photoshop in less than ten minutes to provide a higher level of fidelity.

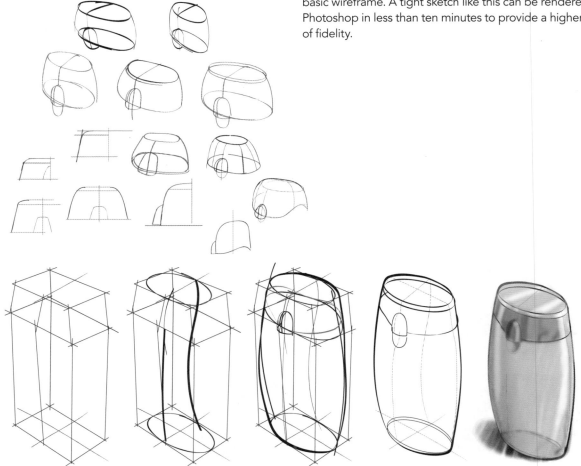

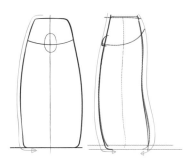

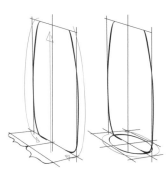

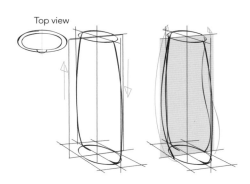

1. Determine which geometry would be most helpful in getting the sketch started. In this tutorial, the box will be eliminated in favour of simple lightly sketched planes. This method makes it faster and less confusing. The seasoned designer needs no scaffolding to sketch.

2. Sketch only what is needed – speed is essential. The two primary outlines are sketched on a plane with a centreline for symmetrical placement. The orthographic sketch is truly symmetrical. The back half of the perspective sketch that is further from the viewer is foreshortened. Sketch an ellipse to represent the bottom.

3. Now is a good time to sketch the top view to work out the geometry. Transfer this section (ellipse) into the perspective sketch as a reference for the profile that passes through the centre plane. Using the top section, sketch the profile so that it connects top and bottom sections. The same must be done for the back profile.

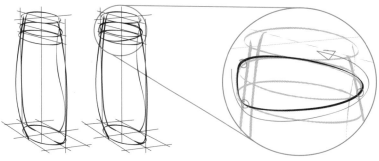

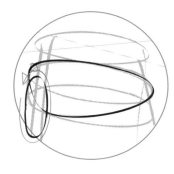

4. With the top section in place, add two additional sections placed accordingly to help place the compound curve that defines the top. These two references will greatly assist in sketching the curve by supplying points of contact at the centreline and side profile curves – much like the compound curve of the Pringle.

5. With the close-up it's easier to see how the compound curve touches the three points of contact formed by the ellipses as it winds its way around, curving in two directions at once like a roller coaster. Try to sketch this lightly as one continuous curve to achieve a smooth compound curve that does not look choppy.

6. Using the centre profile, sketch a quick ellipse (the major axis is vertical). This is just a reference sketch for placing the convex surface that will form the grip for opening the top as well as the concave surface (affordance) for placing the thumb or finger while opening. Make the reference sketch as light as possible.

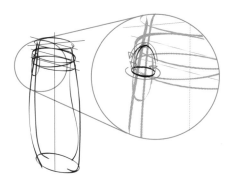

7. Construct the convex surface with three simple sketches: an ellipse that forms the bottom, a centre arc to define the depth and a compound curve that pulls it all together. Keeping these sketches light makes it less likely to get confused when sketching the final compound curve.

8. Sketch the outline in a bolder line weight, careful to touch the various elliptical sections at tangent points. The outline is one large compound curve that creates a boundary which unites all the earlier sketches. Using a lighter line weight add in contour lines to help define the radiused top and bottom and grip.

9. Retrace if necessary to eliminate any unwanted lines and to differentiate the line weight even more. Ghost lines can add volume to a sketch if they are very light otherwise they can confuse the viewer depending on the complexity of the sketch and the amount of scaffolding required to create it. A simple line can add depth.

EXPLORING FORMS IN SPACE

Geometry creation: from analogue to digital

Chapter 6 touched briefly on the connection between sketching and computer-aided design as well as some of the standard CAD processes. This chapter explores much more deeply the interconnection between the form languages of computer-aided design and freehand sketching. The argument is very simple: building forms in the computer still requires sketching – computer-based sketching. A firm knowledge of geometry creation will not only strengthen the analogue skills of sketching but also the digital skills of computer modelling. When sketching on paper it is not possible to extrude an object's thickness, revolve a sectional sketch or loft a series of sketches at the click of a mouse button. But a good sketch is built very similarly to a computer model: the bowl below has a profile that defines and orients the various ellipses correctly.

I have included examples of several classic as well as contemporary products to demonstrate this connection. These designs were specifically chosen because of their forms (geometry) and their close association with surface-model typologies known as primitives and standard CAD operations such as extruding, lofting and sweeping. While many of the products were designed in an era that predates the computer they are used to demonstrate methods or strategies for computer-modelling techniques that map well to freehand sketching. I have built CAD models in SolidWorks and Rhino using product images found in design books or online. They are not to be confused with the original designer's drawings or the way a designer might model the object. Computer modelling, like sketching, is all about selecting appropriate strategies since there are multiple ways to build and sketch any object. Some of the CAD models presented might not represent the best ways for sketching. However, they present general ways of thinking about geometry creation. Note the similarities between many of the CAD models and the geon approach to object identification and breakdown.

The following pages more closely examine the processes involved in sketching and computer modelling using examples of classic product designs, beginning with the most basic process: extrusion.

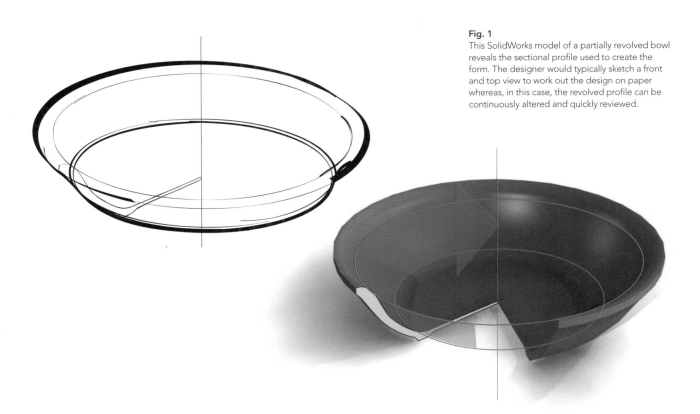

Fig. 1
This SolidWorks model of a partially revolved bowl reveals the sectional profile used to create the form. The designer would typically sketch a front and top view to work out the design on paper whereas, in this case, the revolved profile can be continuously altered and quickly reviewed.

Fig. 2
The extruded form created in a 3D program
is very similar to the analogue sketching process:
establish the sectional sketch in perspective (think
of this as the footprint of the object), 'chase' the
sketch lines up along the z axis (to establish the
object's height) and then connect the various lines.
Doing this on the computer is simply far faster and
more flexible than sketching.

Extrusion

Maarten Van Severen Chaise (Vitra)

The Belgian designer Maarten Van Severen trained originally as an architect but
worked primarily as a furniture designer and interior architect during his tragically
short life (1956–2005). Van Severen's work is often referred to as minimalist, but
Rolf Fehlbaum, CEO of the furniture manufacturer Vitra, described him instead
as 'an essentialist'. Van Severen's furniture nonetheless lends itself to simple
processes of sketching, as many of the forms are profiles extruded into three-
dimensional space.

Marteen van Severen's chairs (opposite) and chaise (below), both for Vitra,
are forms that derive largely from side profiles extended into space. While the
seat-back on the chair has some compound curvature the overall appearance is
very simple. Van Severen was a materialist concerned with the touch and feeling
of his work.

Fig. 3
Van Severen's MVS chaise for Swiss furniture
producer Vitra is an example of a simple profile
extruded into a three-dimensional form.

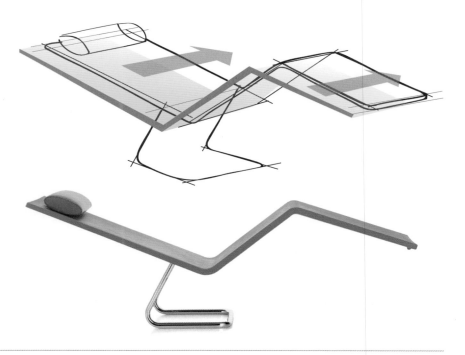

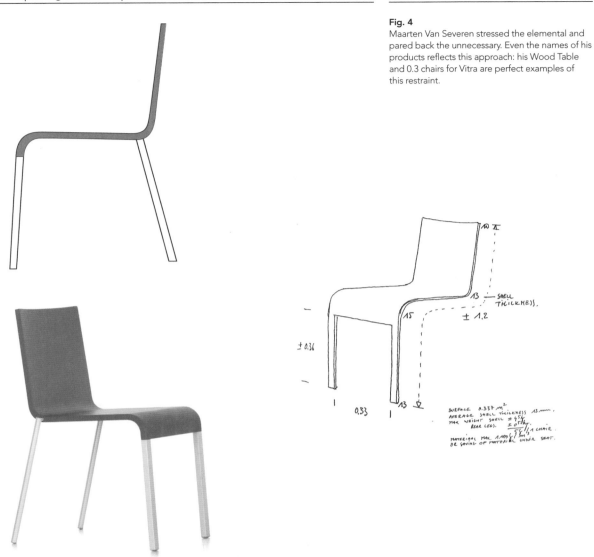

Fig. 4
Maarten Van Severen stressed the elemental and pared back the unnecessary. Even the names of his products reflects this approach: his Wood Table and 0.3 chairs for Vitra are perfect examples of this restraint.

Jonathan Ive: Senior Vice President of Industrial Design

Jonathan Ive is justifiably famous for defining the form language of Apple Inc.'s most iconic products, starting with the 'candy coloured' iMacs and continuing through to the iPod, iPhone, iPad and the ongoing series of laptops and desktop computers. The form language of the first generation iPod mini consisted of simple extrusions and cut extrusions (fig. 5). The current form language relies on far more sophisticated complex transitions between flat and curved surfaces.

Apple computer's 'cube' is a simple example of an extruded square with filleted (radiused) edges. Drawing such a shape involves understanding the top view (sectional profile) and the height of the extrusion (fig. 7).

The process of creating such a form in the computer (fig. 6) involves extruding the square then filleting the edges or extruding a 'softened' square. Sketching the object manually involves creating the footprint (sectional profile) including the radiused edges on the base plane, determining the height and orientation of the top plane, and then sketching the top profile and connecting all the edges at their tangent point (figs. 6 and 7). Sketching the geometry of the top face requires laying out the appropriate centrelines, sketching in a series of circles in perspective and connecting them to create the elongated openings.

Fig. 5
The form language of the original iPod mini was a straight extrusion, as seen in this sectional profile.

Fig. 6
Whether sketched or extruded in CAD, the vertical edges need to meet tangent to the curve (fillet) of the top profile. While the software takes care of this issue in CAD, in sketching special attention should be paid to connecting vertical edges to their appropriate tangent point on arcs (filleted edges).

Fig. 7
The orthographics of the Apple Cube were re-created from photographs to assist in creating the sketch sequence and CAD models. This orientation is not aligned and is therefore atypical. The two views would normally be stacked vertically.

Fig. 8
This sequence extrudes a 'softened square'. However, it could just as easily have started with a square extrusion and the filleted corners could have been added later.

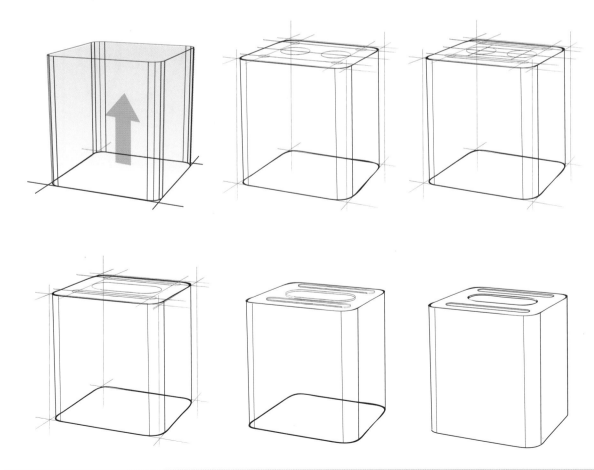

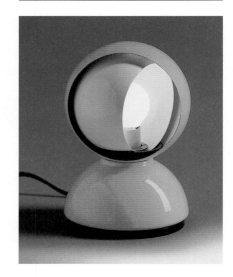

Sphere

Vico Magistretti's Eclisse Luminaire

Vicco Magistretti's Eclisse light for Artemide is a great example of a 'revolved' shape. The form consists of a semi-spherical base upon which another partial spherical 'diffuser' is placed. Nested inside the diffuser is yet another partial spherical form which rotates within the diffuser to create the 'eclipse-like' effect of the luminaire. As the inner housing is rotated around a vertical axis, more or less light is emitted giving the overall appearance of the moon in its various phases.

Building the model in the computer involves revolving a series of profiles around the same centreline, then cutting them at various points on the perimeter of the sphere. To sketch the form, a centreline is established around which a series of spheres are sketched and then cut. The base sphere is a great example of the circle in perspective (ellipse). It is created by revolving a full circle which is then cut in half and a base is added at the bottom and a collar at the top. The two diffusers are also partial spheres but they are cut beyond the midpoint of the sphere, leaving approximately 60 per cent of the sphere remaining.

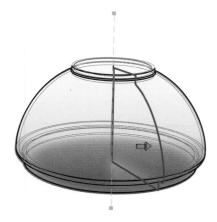

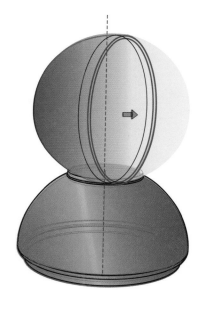

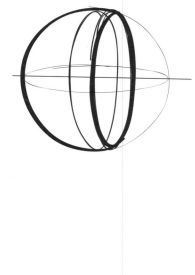

Fig. 9
The revolve is the result of a half profile and a centre axis around which it is 'revolved'. This can be done to up to 360 degrees.

Fig. 10
Once the base has been revolved, the outside diffuser is revolved around the same centre axis. Because of the nature of the geometry, the outside diffuser is revolved 360 degrees creating a full sphere, which is then cut to create a partial sphere beyond the centreline.

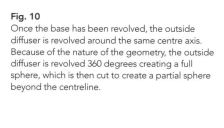

1. The Eclisse lamp is comprised of a series of partial spheres – some nested inside others. Begin with a base plane upon which an ellipse is quickly sketched. Note that the ellipse in this case has its major and minor axes aligned with the vertical and horizontal axes. The minor axis is extended to help centre the other sketches.

2. Sketch another set of intersecting axes to help subdivide the circular base (ellipse) into equal quadrants. These lines will help position the product so that it is turned slightly away. The end points of these axes will serve as references for projecting the arcs that will define the partial sphere of the base.

3. Sketch a series of centred ellipses positioned at the top of the projected arcs as references for the neck or collar between the base and the light diffuser. These ellipses are smaller but also flatter (more closed) because of the effects of perspective (see detail drawing).

4. Sketch a circle that is symmetrical with the centreline and the same diameter as the base. The circle will intersect with the neck that was previously sketched (refer to orthographic). Sketch an ellipse that passes through the centre of the circle to create the illusion of a sphere. The base and top are now positioned accurately.

5. Sketch an outline that will unify the base and the collar into one solid surface. This outline must touch tangent to the ellipses. The projected arcs now appear as seams or contour lines and will help the viewer read the form as semi-spherical. These arcs were placed at that angle for this purpose. Sketch an interior circle for the nested sphere.

6. The inner nested sphere must be cut or sliced in such a way to create the opening (see the section cut in the orthographic view). A plane has been sketched to provide a reference for the cut (see detail). The resulting ellipse becomes the opening of the internal sphere. Using the collar as a reference sketch in the socket for the bulb.

7. Referencing the ellipses that form the socket, sketch the bulb. This is also a perfect circle. Next is perhaps the most difficult part to understand conceptually. The outer sphere, like the inner sphere, is also cut or sliced. This slice will be at an angle different to the other sphere for clarity. Sketch a circle that is slightly offset from the large circle.

8. Sketch another ellipse that passes through the largest circle – this will serve as a contour line to help differentiate the inner and outer sphere. Sketch a final ellipse beneath the base – this will help define the foot. With this sketch in now draw a final outline that cleanly connects the base and outline of the outer diffuser (sphere). This outline helps unify everything.

9. Remove unnecessary lines (construction lines) by retracing the drawing and eliminating those arcs that would be hidden. While the geometry was essential in building the sketch, they are now redundant and confusing to the viewer. With all occluded edges removed, the outlines darkened, and the contour lines sketched lightly, the light fixture is readable.

Fig. 11
Bending the torch into an L-configuration means it can be carried easily and, ergonomically speaking, it is more comfortable to the hand and wrist in such a position.

Fig. 12
Sketching the Polyphemus torch represents a unique challenge. Not only is the cylindrical body based on an elliptical profile (section) but the head rotates along a central pivot point, creating possible positions that range from 0 to 360 degrees. The angle between the head and body is 45 degrees. With this information the sketching process becomes easier.

Cylinder

Polyphemus torch

Designed in 1985 by the Argentinian Emilio Ambasz, this light is based on sectioning an elliptical cylinder at a 45-degree angle to create a circle on which a rotating torch head turns. Built from separate male and female parts and then snapped together, the torch can stand or lie on any surface while its light beam is aimed in any direction. Additionally, the torch holds a magnet inside so that it can be attached to a metal surface. The unique shape of the torch utilizes a patented topological principle.

Cylinders are generally thought of as extruded circles but can also be extruded ovals or ellipses as in this torch, which can be fiendishly difficult to sketch despite its relatively simple geometry. While the basic cylindrical form is not difficult, accurately capturing the geometry as the head swivels requires a real ability to imagine, plan and carefully execute. The renderings shown here were built in SolidWorks from approximate dimensions, and involved extruding an oval form the height of the product and cutting that form on a 45-degree angle. The form that results from this cut becomes the head of the light.

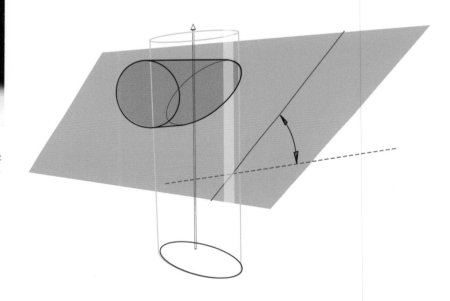

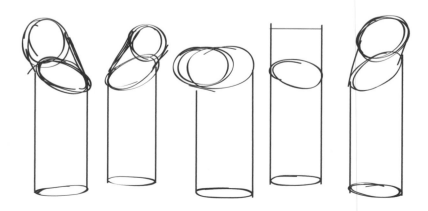

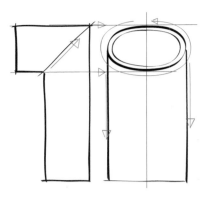

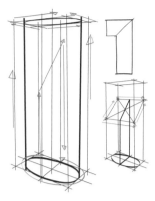

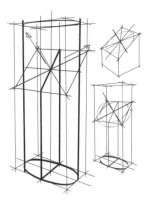

1. Sketch the orthographic front and side views so that they are aligned. Referencing a centreline, sketch the elliptical lens on the front view. While this sketch is simple it will help with the placement of all subsequent geometry and should be referenced throughout the process.

2. Box-in the basic shape of the torch. On the bottom and top faces sketch in elliptical sections and connect to create an extruded cylinder. Along the centre plane sketch the side profile for reference to accurately place the plane angled at 45 degrees for the swivelling lens.

3. On this newly created plane sketch in diagonals to determine the centre point. From here sketch a line that projects at a 90-degree angle from the centre: this represents the axel around which the ellipse will be centred and is approximate.

4. From this same centre point project a line forwards at 90 degrees from the main vertical axis. This line will help locate the plane on which the lens sits. Because the horizon line nearly cuts the centre of this plane, the ellipses' major and minor axes will be close to vertical and horizontal.

5. With the plane in place the projected line now serves as the axle of the ellipse (the minor axis). Sketch the ellipse to fit the plane (remember the lens is elliptical which makes it seem more distorted than usual). The rest of the extruded cylinder can be ignored from here on out.

6. This product is a great example for using the original sketch as an underlay. Trace over using a light table or tracing paper. Sketch the outline of the product to unify what has been drawn. It is fine to leave a few of the ghost lines in place as they might be useful later on.

7. Sketch the lens and the bulb. In order to understand the geometry make a thumbnail sketch of a section cut right through the lens housing. Sketch four contour lines at 3, 6, 9 and 12 o'clock and follow the concavity of the housing. The bulb is sketched around the ellipse axle.

8. The three quick circular sketches that represent the bulb, the stem and the base need to be unified with one strong outline. The set back on the lens needs some clarification. As it stands right now it is defined by several additional ellipses which will need to be cleaned up.

9. Using an ellipse template redraw the lens and set back. With a circle template the bulb can be cleaned up and finally the outline can be made more exact with a straight edge if desired. A simple vignette can help a product stand apart from the background.

Cone/Truncated cone

Konstantin Grcic, KGID Authentics and Flos

Konstantin Grcic's work is often characterized as reductive or minimal in its form language. Born in Germany, his design education began at the School for Craftsmen in Wood at Parnham (England) under John Makepeace. He obtained a master's degree in product design at the Royal College of Art in London and worked for Jasper Morrison in London, then returned to Germany to set up his own design firm, KGID, in Munich. Grcic's deep knowledge of furniture and product design history is clearly evident in his attention to detail and proportion, and his desire to push manufacturing as far as he can. KGID is known for a hybrid approach to design development that combines hands-on manipulation of prosaic materials (paper, cardboard, wire, fabric, etc.) with computer modelling and rapid prototyping. His Mayday light for Flos may take its name from the naval distress signal, but the form language is pure Grcic – direct and eminently functional. The form is the very essence of projected light with the practical coat-hanger-like addition for wrapping the cord and hanging the light. It is a piece that Jasper Morrison and Naoto Fukasawa might refer to as 'super normal'.

Fig. 13
Modelling the Mayday lamp in a CAD program involves revolving a half profile (half of the cross section) 360 degrees around a central axis. The process of sketching the same form, while not identical, is similar – every sketched ellipse involves a revolution around a centre point and in relation to a major and minor axis.

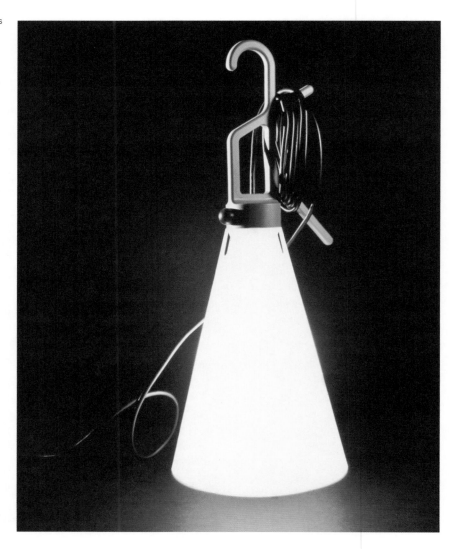

Fig. 14
The diffuser on the Mayday light for Flos is a simple truncated cone. Here the sectional profile has been revolved around a central axis to give an immediate sense of the form.

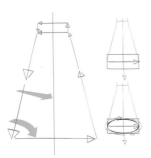

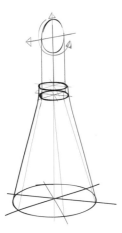

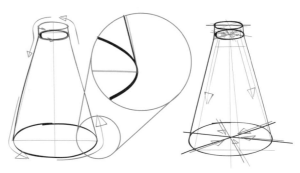

1. Sketch in the full profile (front view) of the product with a centreline. Sketch in the bottom ellipse – an oval perfectly centred on the intersection of the centreline and bottom edge. This serves as the ellipse's major and minor axes.

2. Sketch in three ellipses – one for the base and two for the top. Drawn an outline that touches tangent to the outer edges of all the ellipses. This creates a fluid transition (see detail).

3. Subdivide the bottom and middle ellipses into six even slices. Project sloping lines along the outside of the product connecting the slices into wedges. This is a reference for the vents.

4. Extend the centreline upwards as a reference for the hook. Sketch a line perpendicular to the centreline for the minor axis. This ellipse does not slant left or right because it is at eye level (on the horizon line). Quickly sketch the ellipse.

5. Using the ellipse as a reference, sketch in the hook. Sketch in a line just below the hook and angled slightly downwards (review the orthographic sketch for accuracy). Connect the hook and this line into one fluid sketch.

6. Using the completed sketches, double up (offset) the geometry to give the hook dimensionality. Begin adding more details from the orthographic side view to finish the upper assembly of the lamp.

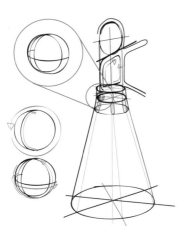

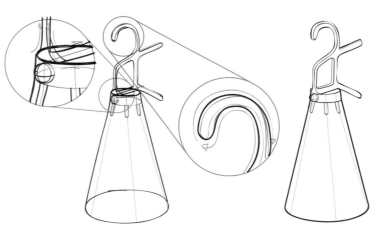

7. Using the existing sketched geometry create the opening. Connect the various sketches to solidify the handle (hook). Using the earlier reference lines, sketch in the vents.

8. Determine which face to unfold first and sketch a quick set of arcs to determine approximately where the face would land when folded down to the ground plane (red).

9. The finished sketch, with line-weight differentiation.

Fig. 15
A close-up detail of the elliptical sections machined and slotted out of aluminium sheet.

Ellipsoid

Alberto Meda's Titania light fixture

The Titania light fixture, designed by Alberto Meda with Paolo Rizzatto, Luceplan (1984), is a great example of how intersecting planes or sections can create volume. Titania is an example of an early product designed with the aid of computer software. The sections, machined from a single sheet of aluminium, are ovals that are slotted to accept the intersecting pieces that make up the overall form. The blade structure eliminates glare while allowing heat from the lamp to escape. A housing made of polycarbonate encloses the lamp and accepts various coloured filters, which in turn alter the projected light coming from the centre of the fixture onto the ribs.

The ellipsoid poses sketching challenges because the side and top profiles are ellipses and all of the intersecting ribs are ellipses. It is hard to accurately place the geometry without getting lost in a sea of ellipses. The wireframe (fig. 17) was modelled in Rhino. The two profiles are indicated in red for clarity.

Fig. 16
The final constructed light fixture is reminiscent of the elaborate wooden bucks used in the automotive industry for clay modelling.

Fig. 17
(Above) Using the CAD software Rhino, an ellipsoid primitive can be generated based on the intersection of only two orthographic profiles. In this case the top view and side view were used.

Fig. 18
(Right) Technical drawings for the Titania light fixture, including top, middle and side view (images courtesy of Alberto Meda).

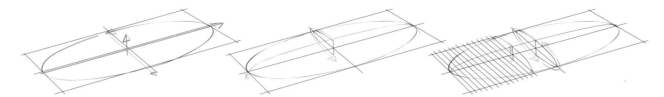

1. Sketch the basic footprint for the top view of the ellipsoid, making sure to add in centrelines. From the centre sketch a line to define the depth (z axis) of the ellipsoid. No centre plane will be created but this axis serves as a kind of proxy for the plane and will help orient the sketch.

2. Sketch the ellipse that will define the front view (middle section) of the ellipsoid. In this example only half of it has been drawn but it is always best when possible to sketch one continuous ellipse. Ghost in the longitudinal section (only the top half has been sketched).

3. There are 13 ribs on either side of the main central housing where the bulbs reside. In order to sketch the elliptical sections, lines have been quickly laid down as references for the various sections. Note: the middle elliptical section has been re-sketched.

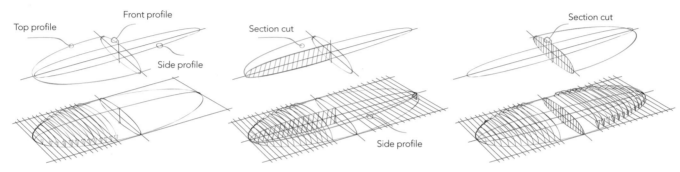

4. For this particular example, given the vantage point, only the top halves of the elliptical sections will be initially sketched. Full ellipses will be sketched over these partial sections using them as a reference. The ellipse is a good example of just how crucial the vantage point is for workflow.

5. Sketch the bottom half of the side profile ellipse (in red). Sketch reference lines for the other half of the ellipsoid trying to ensure even spacing in the perspective view. These lines combined with the side profile will serve as guides for sketching the other set of ribs.

6. This type of sketching can be difficult. Reference lines are close together and multiple ellipses are parallel to each other. Thinking in terms of section cuts can be very helpful. Here the various sections have been filled in with hatch lines to better define the surfaces.

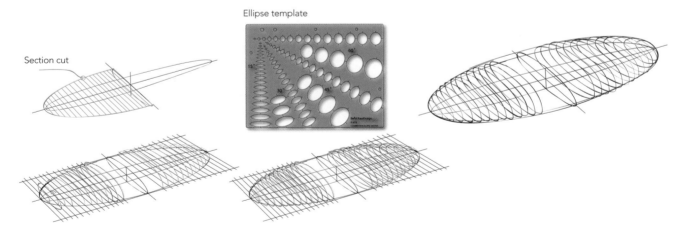

7. Using the earlier half ellipses as a reference, sketch full ellipses over all of them. This process is highly repetitive. Developing a rhythm can help speed things along and ensure accuracy over the length of the light.

8. Do the same for the back half of the light fixture. With so many ellipses in sequence it is advisable to do the final sketch using an ellipse template. While sketching ellipses is great practice, getting so many aligned can be difficult.

9. With the ellipses sketched, the ghost lines removed and some adjustments made to a few of the ellipses, the sketch is complete. Not an easy process using pen and paper or even with a tablet but with Rhino this model is built in minutes.

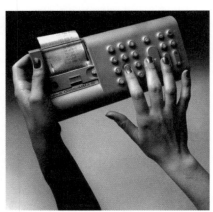

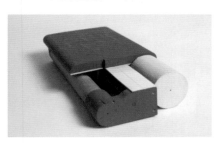

Fig. 19
(Above right) Orthographic front, side and top view sketches, recreated by the author.
(Above) Product shots and early form study model courtesy of Mario Bellini.

Fig. 20
Whether sketched or extruded in CAD, the vertical edges need to meet tangent. The fillet at the base of the buttons creates a fluid 'skin' or membrane feeling to the surface of the machine.

Tube/extrude

Mario Bellini's Divisumma 18 calculator

Mario Bellini, like many of his Italian contemporaries, trained as an architect but worked primarily as a designer of furniture and products. Among his initial clients was Olivetti, the Italian manufacturer of business machines, for whom he designed many products including the Divisumma 18 calculator. Bellini added a 'soft touch' long before such a concept was commonly employed, through the use of rubber, which served to integrate the controls in a more sensuous and sculptural way.

The 'skin' that forms the primary surface of the product, along with the colour and minimal layout, makes this calculator stand out from more traditional business products. Bellini's design created a membrane as opposed to a button, resulting in a more unified control panel. His experiments with 'stretched membranes' are also essential to understanding compound curvature.

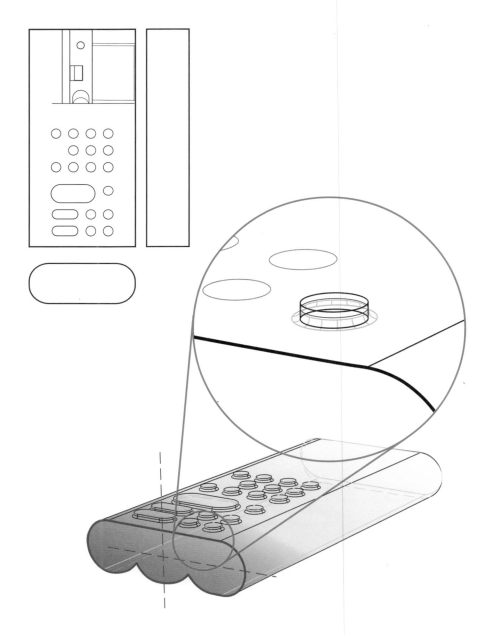

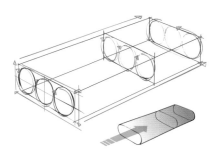

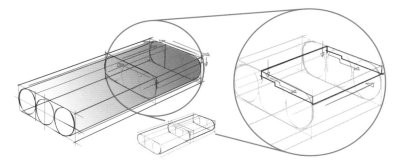

1. Sketch in a cubic form (box) the size of the product. Sketch three sets of ellipses for reference as illustrated above. These ellipses define the lozenge shape of the extrusion (see detail) while providing additional reference for the secondary detailing, which is a cut extrusion.

2. With the cubic form still visible sketch in the reference lines that will be used for the subtractive process of detailing the display. 'Sketching through' the cubic form can be difficult, which is why it's so important to sketch lightly and darken the lines later. At this stage a clearly defined boundary should be established.

3. With the first set of reference lines placed and the boundary defined, begin cutting downwards into the surface of the extrusion to define the display panel. Note the presence of a step and sketch accordingly. This sketch has been darkened for clarity. In reality it would also have been sketched very lightly.

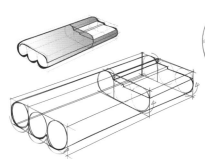

4. Cut through to reveal part of the tubular extrusion that forms the housing for the paper roll in the calculator (see detail in blue). Sketch over part of the original ellipses that defined the tubular form of the product as well as the cut extrusion at the base.

5. With the display panel cut away, begin the detailing process of the on/off switch and the small light. I've sketched in another control but as this cannot be seen from this perspective it won't be detailed. The cavity for the switch and the elliptical cylinder of the light are simple sketches.

6. Reference the orthographic front view in order to lay out guide lines for the buttons, which are rubberized for a 'soft touch' effect. Use the guide lines as major and minor axes to sketch rough ellipses that appear to sit on top of the surface of the product.

7. Sketch a nearly identical ellipse slightly above the first one to indicate height. To create the soft touch button sketch an additional ellipse which will be larger (offset) from the original sketch. This creates the reference geometry to sketch the filleted transition.

8. The remainder of the process involves line-weight definition. With a product as complex as this (the button placement, for example, needs very accurate spacing) it is best to use the original sketch as an underlay and go back in with tools (straight edge, ellipses templates, etc.) to refine

the sketch. The sketch can also be scanned and the linework recreated in Illustrator or another vector-based software. In this case the lightest lines represent fillets or contours on the buttons or edges of the product while the darkest and boldest line weight is reserved for the outline.

Fig. 21
The Toot-a-Loop radio could be closed to make a form that fitted around the consumer's wrist. The radio combined portability, fashion and mobility in a unique product.

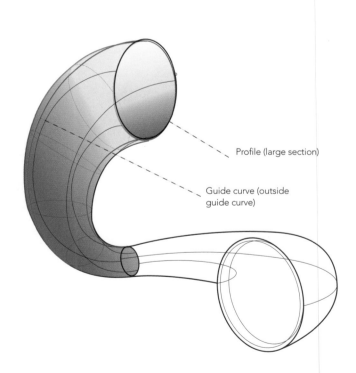

Pipe/Loft

Matsushita Model R-72 Wrist Radio, Toot-a-Loop

The Toot-a-Loop R72 radio from Panasonic was the second in a series of small transistorized radios that emphasized both play and fashion. Its predecessor – the R70) – was spherical and originally designed as a commemorative product to be exhibited at the Japan World Exposition in Osaka, in 1970.

The R70's primary design cues came courtesy of the *Apollo 11* spacecraft (1969) while the R72's futuristic styling, although clearly 'space age', was also a statement of pop culture's desire for greater mobility. The ring shape allowed the end-user to carry the product wrapped around their wrist like a giant piece of jewellery – the tuner controls were accessed by twisting the radio. This innovative series sent a clear message to Japanese product designers of the day, who had previously focused exclusively on rational functionality, that playfulness and fun are also important factors in design.

The Toot-a-Loop radio is an excellent object to sketch in order to master complex curving form creation. The two symmetrical halves can be thought of as horns defined by a large radius on one end and a small radius on the other end. The path is not a simple circle but an ellipse. Note that the product's opening is off-centre. To sketch a product like this, designed before CAD software was commonly used, in perspective the designer must understand the various orthographic views and how the large circular interface (radio dial) connects to the smaller circular section where the product pivots. This is an articulating product that forms a large S when opened and is a slightly eccentric 3D loop when closed (hence its name). In the computer this form would be created through a sweep operation with the two sections and the central guide curve that connects them.

Profile (large section)

Guide curve (outside guide curve)

Fig. 22
This orthographic sketch was done to work out the guide curves precisely. Once one half of the object is modelled the second half can be mirrored.

Fig. 23
It is useful to think of a circular ring as a clock face, and sketch elliptical sections at o'clock positions.

Fig. 24
This object was modelled in Rhino using a sweep operation that involved two sections as well as some guide curves.

Inner ring

Centre ring

Outer ring

1. The radio is an articulating set of horns that swivel at the centre. Each horn is made of a series of diminishing circular sections aligned along the centre ring and touching the inner and outer rings. The first step is to establish a plane parallel to the ground to sketch the nested rings in perspective.

2. Rather than sketch the plane, I have sketched two axes to represent the plane and oriented the nested rings to pass approximately through the centre of the smallest ring. NB: the rings are not concentric (sharing the same centre) but eccentric. This creates the asymmetry of the product.

3. Referencing the centreline and all three rings, sketch two ellipses – one for the larger diameter and one for the smaller diameter. The major axes of both ellipses will lean towards the left vanishing point because they are below the horizon line. Additional elliptical sections are required to sketch the outlines accurately.

4. A third elliptical section can be sketched at the 3 o'clock position. Note that the major axis of this ring leans towards the right vanishing point because it is oriented 90 degrees away from the other two faces. One more sectional ellipse needs to be placed for accuracy.

5. The fourth ellipse will be sketched near the 4:30 position. Note that the major axis of this ellipse leans in the same direction as the first two, and the minor axis is larger because it's almost parallel to the picture plane. An ellipse becomes more circular as its plane rotates parallel to the picture plane. The sketch can now be closed.

6. The outlines are sketched quickly to ensure a smooth arc. Be sure to touch the ellipses at the various tangent points. The outline connects the ellipses into a form that resembles a horn. The challenge in sketching and reading such forms is the lack of clear edges. The outline helps to hold the form together.

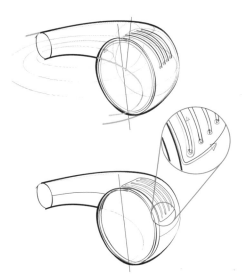

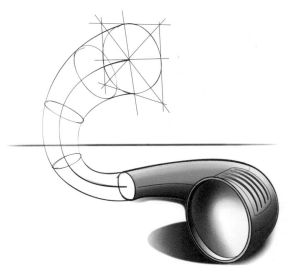

7. For secondary details like vent holes, parting lines and thickness, various methods can be used. Sketch light arcs (shown in red) that follow the contour of the body for the speaker vents. These are partial ellipses and can be sketched referencing what's already there rather than sketching a full ellipse. Double up the arcs and cap them.

8. Forms that are difficult to read due to a lack of clear edges can benefit greatly from the addition of colour, shade and a cast shadow. In this case the sketch was brought into Photoshop and colour was added along with highlights. The shadow was created as a path, feathered and filled with a black to no colour gradient. The edges of the shadow

were lightened with a low-opacity eraser to add depth. The sketching process informs the rendering process, making it easier to know where to add the colour, shade and highlights. Finally the second half of the product has been lightly sketched in based on what is already there.

Tutorial

Panton chair

The Panton chair is justifiably famous as the first manufactured single-form injection-moulded chair. Long before the ubiquitous white plastic chair arrived, Panton was trying to solve a similar problem: how to use form and material to make a plastic (polypropylene) chair that was not only strong enough to support the required weight but was also stackable.

In some ways the Panton chair resembles an earlier radical experiment in furniture design: the Zig Zag chair by Gerrit Rietveld. But whereas Rietveld made his out of planar wood material mechanically fastened with screws, the Panton chair is far more expressive and conforms more closely to the contours of the human body.

Given the complexity of the Panton chair's form, building it in the computer should be done as a surface operation. Just as with sketching, the computer model is built through a series of sections that match the chair's side-view profile. With a centre-plane profile and an outside profile joined by a set of connecting guide rails, half the form can be created and then mirrored. This provides only the approximate shape of the chair (seat pan, back and concave leg). The final front-view profile must be cut into that surface. The wrap-around edge or profile that runs around the chair, thus providing much of its stability, is created through a series of sectional profiles sketched at strategic points on the chair and then lofted. (This is, of course, only one of many ways to build and sketch the chair.)

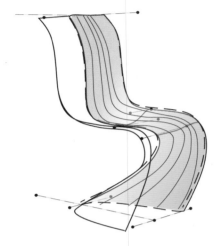

Panton chair by Verner Panton, courtesy of Vitra.

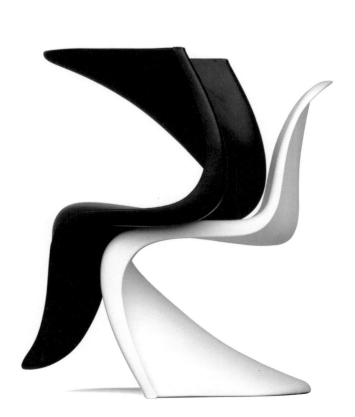

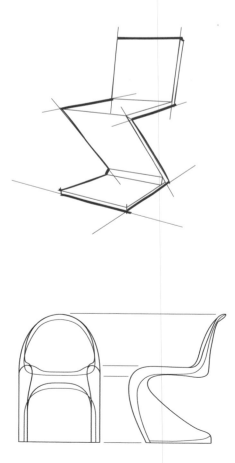

Footprint sketch

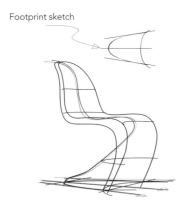

Sketch planes

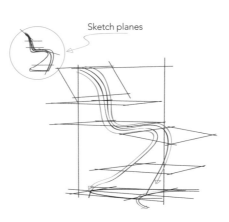

Skeletal sketch

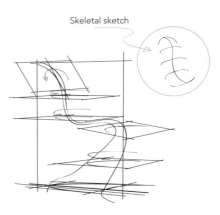

1. Darkened outlines are used to define the perimeter while sectional sketches help define interior contours. The bottom plane that defined the base of the chair has been left along with the plane that defines the rear profile. There's enough here to connect the dots to build the chair.

2. With the 'footprint' of the object sketched out on the bottom plane, side profiles can be sketched. Reference planes parallel to the bottom plane can be lightly sketched in to help situate the various sectional sketches accurately in space for interior contours. Angled planes can be added.

3. With practice reference planes are no longer necessary. Designers can picture the plane and accurately place the sketch symmetrically along the side profile like a skeletal spine (in red circle). Centring the sectional sketches is crucial. The endpoints become guides for the compound curve (outline) that closes the shape.

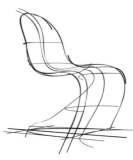

4. Another approach is to use the sectional sketches to help lightly 'box-in' the basic form. This way the chair can be better visualized. The skeletal box should touch the end points (vertices) of the sectional sketches. Think of this as a test run for sketching the actual compound curves.

5. Rather than trying to sketch one quick and continuous compound curve, sketch smaller key sections to serve as guides for a final continuous compound curve. Sketching this way allows you to focus on specific aspects of the form such as seat pan or back without having to see the whole design.

6. Continue to connect smaller curves with larger expressive curves that extend beyond the object to capture the compound curvature. With such a sculptural chair you might keep sketching lightly over the sections until the form is correct, then use this sketch as an underlay to redraw the final form.

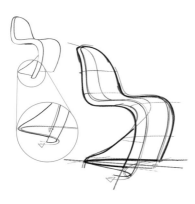

Concave surface

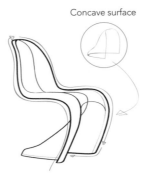

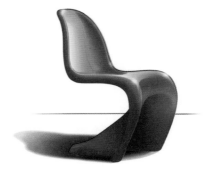

7. The last step is to sketch the fold at the outer edges of the chair. This fold (or rolled-over surface) is a structural element that adds stiffness to the form, like a large fillet on a plastic container or bottle. The footprint sketch didn't include this extra fold as it might have confused matters. It is now added before the final bold outline is sketched.

8. The original sketch has been used here as an underlay for a new sketch. Unnecessary geometry has been removed. The bold outline merges the final compound curve to define the compound curved surfaces of seat, back, sides and bottom support. Light contour lines are added for clarity. The sketch is rendered for maximum readability.

9. Compound curvature is difficult to truly read with lines only. Here the Panton chair has been quickly rendered in Photoshop to add a base colour along with highlights, shade and cast shadows. Shadows and a horizon line help to ground the chair while the crisp highlights and gradients communicate a gloss plastic finish.

Tutorial

Vållö watering can

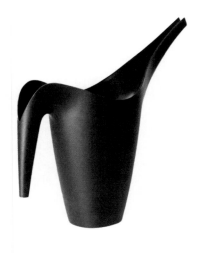

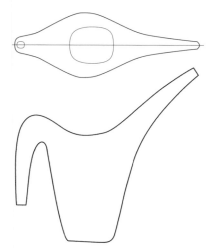

The Vållö watering can by Monika Mulder for IKEA is an ideal form for advanced sketching as it represents a series of compound curved surfaces that flow seamlessly into each other. This thin-walled plastic watering can is rigid enough to carry water while still stackable. According to Mulder, transporting 'air' is taboo at IKEA. Indeed, Mulder noted that she 'would never have thought of that shape if it were not for being forced to make it affordable in transport.' The result, as Phil Patton, automotive critic for the *New York Times*, says, it 'resembles a flower itself, blossoming upward. The cleverness of its single shape—proven in its stackability—is as impressive as the Verner Panton plastic chair or (even more to the point) William

Sawaya's Calla chair for Heller. The upward sweep of the spout, like a heron or bittern in an Audubon print, or a coyote baying at the moon, contrasts with the plunging arc of the handle, shaped like the high heel of a woman's shoe.'

This quick and very approximate SolidWorks model shows one strategy for lofting the spout on the Vållö. Surface models are built oversized along non-critical dimensions and then trimmed with profile sketches to get the desired geometry. In the case of the Vållö, the profile (sketch 2) is an intersection curve to help ensure tangency between the spout and the body of the product. With CAD, as with sketching, there are always multiple ways to get any form built.

Understanding the subtle geometry of the Vållö begins with orthographic sketches which can be translated into perspective sketches or computer models. Here the front and side views have been juxtaposed. Above the front and side views have been quickly sketched for translation into a SolidWorks surface model.

Profile (sketch 4)

Profile (sketch 3)

Profile (sketch 2)

Profile (sketch 1)

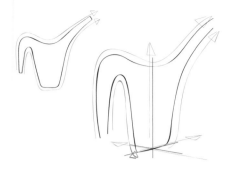

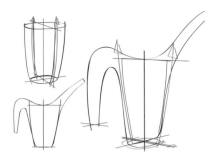

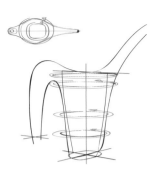

1. Establish a vertical centreline to help sketch the side profile. Sketch an axis for the base of the product. The sketch does not need to be complete, just enough to help place other critical geometry. In this example no planes will be created, only centrelines and axes, which will define the space of planes without the extra lines.

2. With the side profile in place, sketch a partial section to define the volume of the product. The axis and centreline are needed to place the geometry accurately. Sketch the base section of the product touching the various profile sketches already in place. Three profiles are now in place to help place additional sections.

3. Sketch a top-view orthographic to be sure of the geometry. Working off of the centreline, the axis and the various profiles, add in a few more sections to help define the outline of the watering can body. The section that defines the base of the product is more rectilinear than the upper sections.

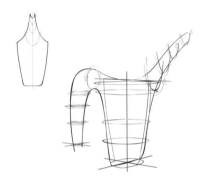

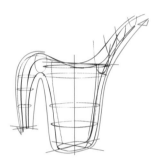

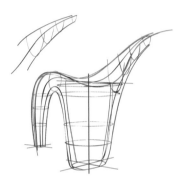

4. Referencing the earlier profile of the handle, quickly sketch in some elliptical sections to define the 3D volume of the handle. This will require imagining where the various horizontal planes are placed to determine the exact shape of the various ellipses. Do the same thing for the spout.

5. In order to accurately sketch the handle or spout, it is advisable to roughly sketch the overall outline of the product. This will provide much needed reference points for the more complex compound curves that define the top of the spout. The surface connecting the handle and body of the product is a good start.

6. With both the outline and sectional sketches approximately in place along the profile, sketch in the first compound curve to define the upper edge of the spout continuing back to the handle. The uppermost sectional sketch that defines the body of the product can assist with the placement of the compound curve.

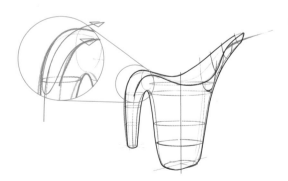

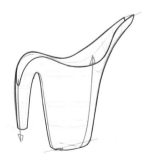

7. With all of the sectional geometry in place, sketch a new centreline down the back handle to help place the compound curve that defines the opening there. Centrelines for perspective sketches are essential as they help establish the symmetrical nature of the geometry. Note the back half of the sketch is smaller.

8. A sketch with so many sections should be retraced for clarity if the ghost lines are too dark. For a product with this number of compound curved surfaces, a few contour lines can really help to define the geometry. A light parting line is added at the back of the product along with one contour along the centre.

9. Assess the results and lighten (highlight) or darken (shade) where necessary. Here, the value of the core shadow has been intensified while the area closest to the light and directly opposite the shadow has been lightened. The back edge of the cylinder has been lightened to add greater contrast to the core shadow.

Tutorial

Sketching tools

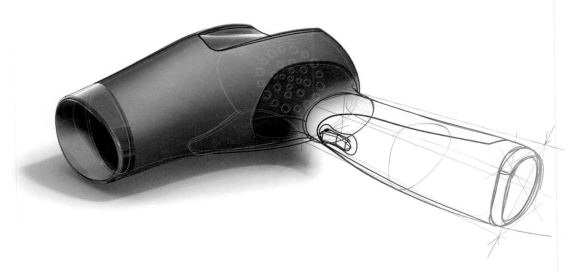

The blow dryer concept (above) began as a loose freehand sketch developed first orthographically and then perspectivally. This process clarified greatly the strategy used in building the CAD model in SolidWorks. The most difficult part of that process is creating a smooth transition between the handle of the product and the body where the fan motor resides. This is similar to sketching/building many hand tools such as drills, sanders and sabre saws. Spending the time to work out the proportional details in orthographic and developing the concept perspectivally through sections provides great insight into building the final model. In the above example the rendering has been manipulated in Photoshop to sync up with the wireframe drawing and a free-hand sketch using a Wacom tablet. This mash-up provides the tightness of a photorealistic rendering with the looseness of a sketch.

(Right) Rough orthographic front and side profile sketches.

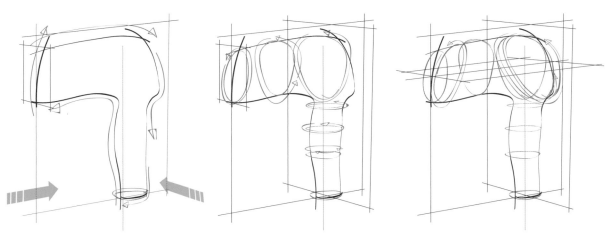

1. Quickly sketch the dominant side view in perspective (sketch planes if necessary). Sketch an arcing centreline to help position the opening which, in this case, is not circular but elliptical. Sketch a sectional reference at the base.

2. Sketch front, middle and back sections for the body of the product. Add a few horizontal sections for the handle. With only a few sketches in place the wireframe takes shape and the product's basic geometry is established.

3. Sketch the sections that are tilted out of vertical or horizontal orientations: the front chrome collar and the back face of the product. Reference other sections to help position these sketches. The next step involves outlining the product.

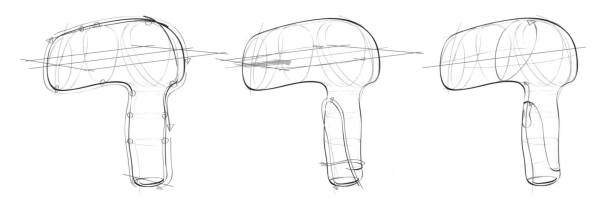

4. The outline should touch tangent to the various sketched sections (circled in red). A heavier line will help differentiate the outline from the sections. Modulating the outline (varying the thickness) will help increase its impact.

5. Now begin sketching secondary details like the overmoulded handle. Sketch on it as though it's three-dimensional and follow the contours as they wrap around the handle. Finally sketch arcs on the middle plane to suggest the outer edges.

6. Sketch the parting line on the handle to help accurately place the power switch. Sketch a section at the correct angle to position the concavity on the product's upper housing. Sketch the peanut-shaped button directly over the parting line.

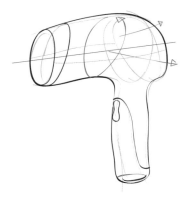
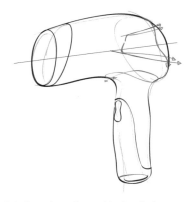

7. Sketch the lower and upper edges of the concavity by referencing the new section. Sketch these arcs as though they are on a 3D surface rather than a sheet of paper. Add the necessary detail to the power switch

8. Refer to the orthographic views before sketching in the back section to define the concave detail. Using a subtractive approach cut away the required surface. Sketch in a compound curve to achieve the transition between handle and body.

9. Use a template to tighten up the ellipses. Re-trace the sketch leaving out any construction lines to achieve a clean look or leave light construction lines and darken the outline, parting line, and any cut lines for vents or openings.

EXPLAINING FORMS IN SPACE

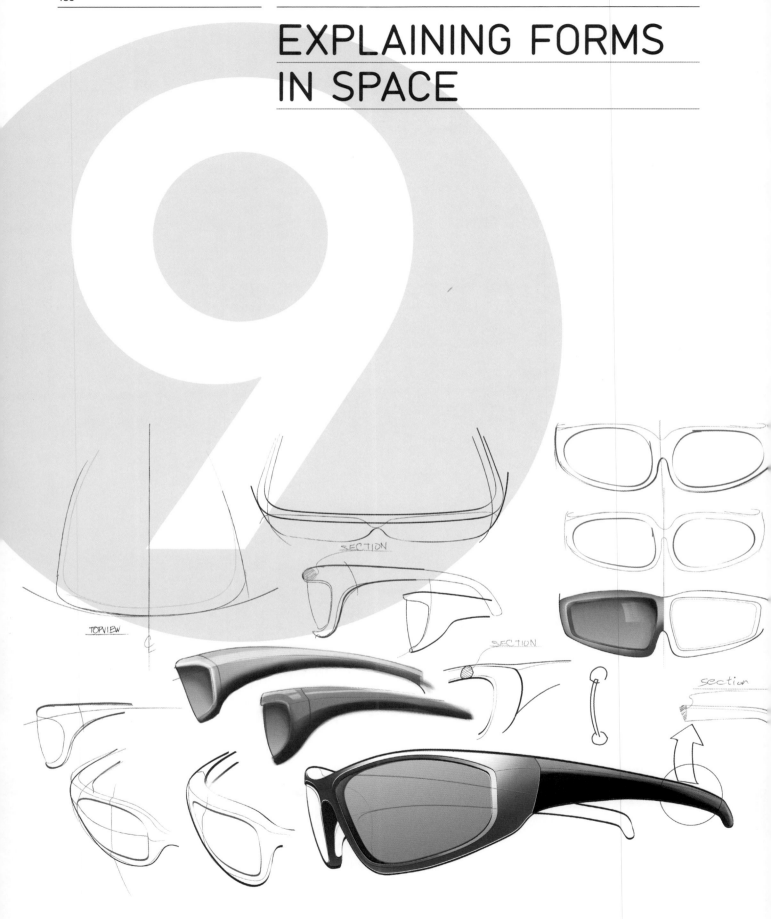

Grounding a sketch

This chapter explores the many ways in which a sketch can explain and locate a three-dimensional concept clearly in space. Early ideation sketches often float freely in paper space as the designer attempts to get ideas out quickly and in profusion, unconstrained by space, gravity or context. The phase that follows typically grounds or contextualizes the concept for greater clarity. The most common grounding method is through rendering, which will not only increase the fidelity of the concept sketch but also positions the product on a surface by indicating cast shadows, highlights and even materiality. A second method is to provide contextual cues as to the product's scale by situating it in a larger composition next to an easily recognized and appropriate object (a chair, for example, might include a sketch of someone sitting on it). For certain concepts (small consumer products, for example) the addition of a hand provides the best context. We begin by looking at colour and its ability to increase the emotional quality of the sketch while providing depth cues and suggestions of materiality.

The power of colour

Rendered high-gloss red plastic has a very different impact than moss green rubber. But when and where should a designer add colour in the initial ideation phase? Note, for example, what happens on a page full of quick sketches when even a small amount of colour is applied to a few of the concepts (see fig. 1).

Likewise, when a designer is struggling with a product's form, rendering the sketch adds a level of detail that can help in making decisions as to the correct direction. Even at the preliminary sketching stage a little bit of colour can help communicate form and materiality without slowing down the process. Increasingly, designers are beginning the sketching process on the computer with digital tablets and graphic software. Scanning a paper sketch takes only a few minutes and adding even a suggestion of colour can have a big impact.

Rendering has been an essential part of design communication from the very beginning of the profession, when the typical media included gouache, pastel, marker, coloured pencil and eventually the airbrush. While today's digital tools can speed up the process and increase the level of realism, the conceptual approach remains essentially the same. Rendering a sketch requires three fundamental elements (in addition to colour): light source, highlights, shade and shadow. These three components assist the brain in locating the product in space, understanding its material properties and reading the form more precisely. However, rendering is not a matter of simple technique; like sketching it requires an understanding of how the human brain interprets colour in multiple contexts and under varying light conditions. And like sketching it requires moving beyond the constraints of a two-dimensional surface to understand how light impacts colour and form in three-dimensional space. Let's look at some of the key issues that might trip up a novice designer thinking about applying colour, highlights, shade and shadow.

Fig. 2
Emiliano Godoy is a product designer who specializes in sustainable products, which he often self-produces. In these light fixtures designed for a hotel in Mexico City, the sketches have colour and luminosity added for greater fidelity. Godoy adds a SolidWorks rendering to the page for even greater fidelity as well as contextual illustrations to better understand scale and the context of use.

Fig. 1
The eye is immediately drawn to the sketches where colour has been applied. The colour provides clues as to the product's materiality and gives weight to the form.

Fig. 3
(Right) Daniel Lipscomb's sketch renderings for Fiskars demonstrate colour's power to visualize the product. Because Fiskars has a specific brand colour-palette (common for most tool manufacturers), adding in colour helps the designer make brand-related and category decisions about the design.

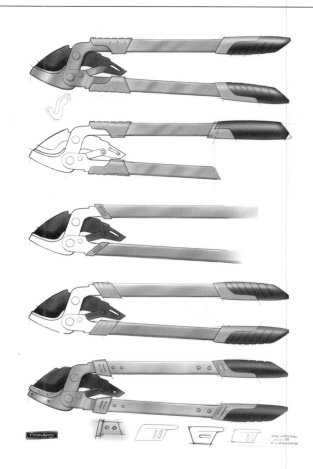

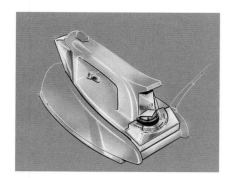

Fig. 4
(Above) Chuck Harrison's rendering for Casco demonstrates how colour can transform a sketch: the bright highlights suggest the reflective metal base and the 'hot spots' on the plastic handle.

The psychology of colour and light perception

It is only in the presence of light that we are able to perceive three-dimensional forms in space or recognize their colour, which we generally become aware of even before their outlines or general forms. Nevertheless, the brain struggles with certain ambiguities related to light and colour much as it does with overlapping lines or figure–ground relationships. For example, a banana sitting on a table in the shadow cast by a nearby object is still perceived as a yellow banana despite the actual hue that hits the retina of the eye – a phenomenon called colour constancy. This is yet another example of the brain's need to categorize for greater efficiency because of its limited cognitive resources, as discussed in chapter 2. Vision relies greatly on context and colour is no exception.

Fig. 5
While these photographs of the same banana clearly reveal different yellows because of shade, the brain perceives them as the same yellow by adjusting for the shade.

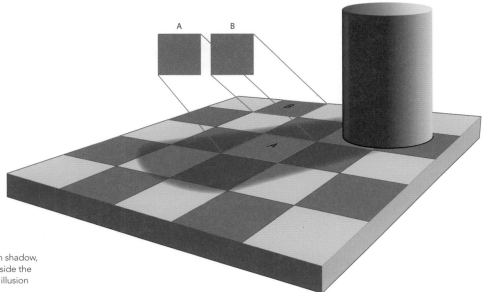

Fig. 6
The brain perceives square A, which is in shadow, to be lighter than square B, which is outside the shadow. In fact, as this Edward Adelson illusion reveals, they are identical.

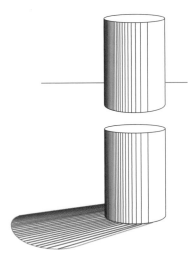

Fig. 7
The brain needs very little convincing that a source of light exists. This cylinder has been re-created using lines and hatches to create the illusion of light, shade and shadow.

In Edward Adelson's chequer shadow illusion a green cylinder atop a chequerboard casts a long shadow. The light squares (tiles) within the cast shadow turn out to be the same hue as the dark squares (tiles) outside the shadow. However, the brain is challenged to perceive this similarity naturally because of context: we assume that the light tile, despite being in the cast shadow, can't possibly be identical to the dark tile outside the shadow. This contextual effect is further reinforced by the darker tiles that surround the lighter tile within the cast shadow and the darker tiles that surround the lighter tiles outside the shadow. The brain simply needs to generalize things. Adelson, an MIT professor of brain science, explains the ambiguous effect shadows create this way: 'The visual system tends to ignore gradual changes in light level, so that it can determine the color of the surfaces without being misled by shadows.'

The effect that shadows produce may be visually deceptive but they are essential to understanding forms in space because their very existence suggests a multitude of other effects. Their presence indicates that a plane or surface exists beneath the object, the direction of the light source, the absence of light (shade) due to the object blocking it and finally the shadow cast by the object. Shadows, far from being flat, are instead rich and varied. Highlights, on the other hand, are indications that certain surface geometry is situated to pick up light more directly than others. So rendering should not be viewed as simply adding the right colour to a sketch, but rather as adding depth to a sketch. Let's review what is involved in this process.

Let there be light: direction and materiality

The position of the light is crucial when rendering a sketch. One light is sufficient. The light source is commonly thought of as positioned behind the left or right shoulder of the designer at an angle of 30 to 45 degrees off a vertical axis. (This can, of course, be changed to achieve more or less dramatic results.)

This orientation creates a subtle shadow in front of the object while lighting the primary surfaces or faces (top, front and side). The second crucial issue is the materiality of the product: is it shiny plastic, matt rubber, brushed stainless steel or some other material or combination of materials? Light hitting a high-gloss object will have crisp well-defined highlights; light hitting a matt surface will be duller and dispersed. I have created a simple rendering of the sunglasses on page 165 to demonstrate the light source and the resulting highlight, shade, and shadow. Note the complexity of the cast shadow and how the light bounces off the ground plane and hits the underside of the object.

Fig. 8
Note the difference between these sketched and fully rendered versions of the same subject: in the left-hand image the sunglasses appear to be flying, due to the lack of a cast shadow.

Fig. 9
The drawing below shows a typical set-up for thinking about light sources – a task lamp placed slightly in front of the object, to the right or left, will project light onto the top, front and side surfaces while creating a very small drop shadow in front of the product. On the right are side and top views of the same light source and object.

Fig. 10
Highlights on a shiny surface, such as the sunglasses above, are crispy and sharp. Highlights on a matt surface, such as this powder-coated steel pencil case, are diffused and more generalized.

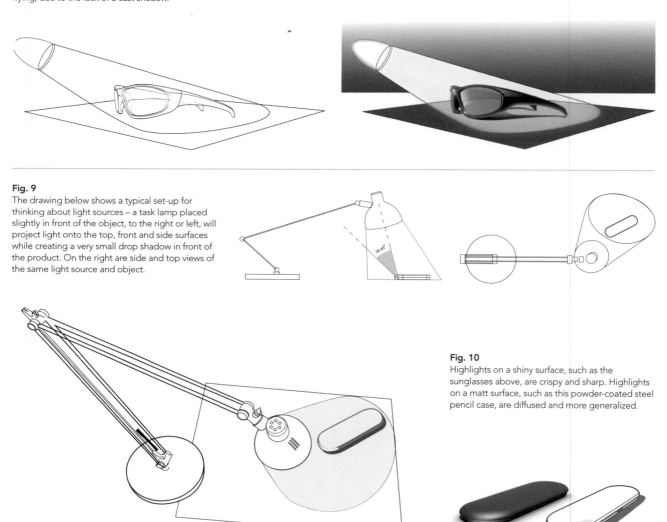

Light's impact on form: value change and geometry

The impact light has on an object depends on the object's geometry; for example, when it is projected onto a flat wall the result is a flat circle of light whereas when it is projected onto a curved surface (such as a cylinder) the result is a subtle gradation between light and dark. The surfaces closest to the light source will be the brightest while those further away will get progressively darker. I use the term gradation to describe this for two reasons: first, it connects to J.J. Gibson's concept of the texture gradient (see chapter 2) and, second, the term is applied to a commonly used feature in both Adobe Photoshop and Illustrator for creating subtle gradations between two or more colours.

There are, however, more subtle effects with light than can be simulated through the application of colour gradients. A fundamental one is the 'core shadow', which results from the object casting a shadow on itself at the point where the light rays hit tangent to the object's outside edges. In the illustrations 12 and 13 the arrows represent parallel light rays while the red plane represents the centre of the cylinder perpendicular to those rays. It's at this point that the surface of the cylinder curves out of sight resulting in the tangent edge casting a subtle shadow onto itself. The core shadow effect can occur with any three-dimensional form where primary surfaces curve away from the light source. The designer needs to understand the direction of the light source and envision the plane cutting through the object perpendicular to the light rays. Figure 14 is a cylindrical form with light rays from the left; the centre plane is in red.

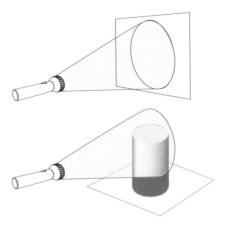

Fig. 11
Light conforms to the shape of the surface it is projected onto. This results in a range of luminance from very 'hot' to 'cooler' at the edges furthest away from the source.

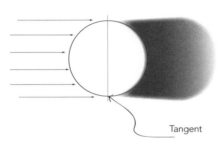

Tangent

Fig. 12
The core shadow is best understood in top view: the surface beginning where the light rays hit tangent to the cylinder doubles back on itself creating a subtle shadow.

Fig. 14
The core shadow occurs at the centre of the object and moves down regardless of the light-source angle. The core shadow, highlight, shaded section of the object and the cast shadow should all be in harmony based on the angle of the light.

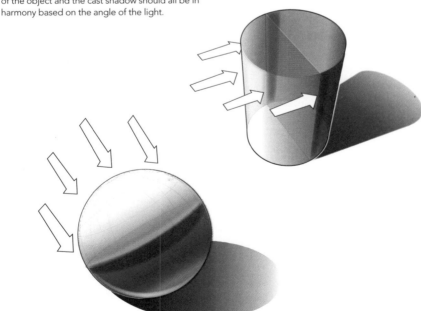

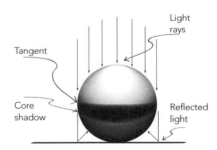

Fig. 13
On a sphere with light directly overhead, the core shadow begins at the centre and dissipates as it moves downwards. These same light rays will hit the surface on which the sphere is sitting and bounce up to reflect on the sphere's underside.

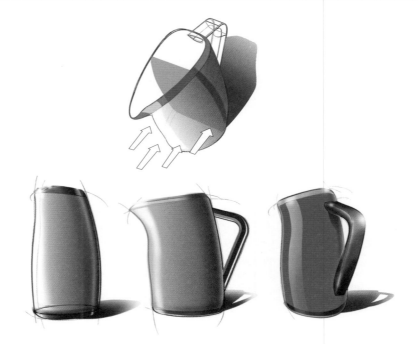

Fig. 15
The light source hits the brushed stainless-steel jug at the front of the product and produces a highlight in line with the spout. The core shadow therefore happens just beyond the centre plane and conforms to the geometry of the product. On stainless steel the highlight is diffused; on gloss plastic (blue) the highlight is crisp.

Understanding reflectivity

The jugs, above, have at their centres a highlight or 'hot spot', where the light is most intense. This highlight may be crisp or diffused depending on the nature of the surface's finish. High-gloss plastic results from a highly polished mould (all tooling marks and scratches removed) while matt surfaces are the result of an etched texture or pattern in the mould, which will reflect light more diffusely. A brushed surface like stainless steel has been intentionally abraded (scratched) to give it a uniform texture. Scratches, whether in wood, plastic or metal, diffuse light whereas polished surfaces like those on a silver ring reflect light, resulting in crisp well-defined highlights and shaded areas.

Objects like cylinders and spheres have predictable highlights, given the uniformity of their geometry. When an object is made up of multiple compound curved surfaces the rendering becomes more complicated.

Shade and highlights follow the underlying geometry of a product, which means the designer must rely once again on a knowledge of sketching to determine the geometry that defines these areas. The creation of accurate shadows relies on quick sketch projection. Ultimately, the designer has to determine the level of fidelity appropriate to what the client or design team need to make a decision and render the concept accordingly.

Fig. 16
The vacuum cleaner has two very different material surfaces: the orange high-gloss body and the matt-grey handle. Both are lit by the same natural light source to the left, creating a distinct crisp window-shaped highlight (body) and a diffused and dull highlight (handle).

Fig. 17
Cars and heavy equipment are typically rendered to reflect the landscape they are situated in. The windows and body panels tend to reflect the ground and sky, beginning just above the belt line of the car.

Rendering: digital versus analogue

Product design concepts are increasingly rendered in the computer for reasons of speed, accuracy and flexibility. Many of the digital rendering techniques derive from earlier analogue approaches using airbrush, marker and coloured pencil; however, rendering manually was unforgiving, as mistakes were hard to correct. In the digital age many of the analogue strategies have a digital counterpart, with instant masking capabilities, layering, opacity settings, customizable brush shapes and so on. What could once take half a day can now be completed in an hour or two.

The sunglasses on this page were sketched and scanned before being cleaned up in Adobe Illustrator and then exported as a jpeg to Photoshop (fig. 18). The rendering process took approximately an hour and allows for a range of colour and material surface treatments. This type of rendering is considered 'photoreal' and requires very accurate sketching. The rendering involves creating separate layers for everything from base colours to shade to highlights. Paths were created for most of the highlights to suggest a high-gloss surface, especially on the lens. All that is missing is a drop shadow, which was not added. This is because the context required to understand and validate this concept would be a human face rather than a flat table surface upon which a shadow could be cast (see contextualized rendering page 167).

The lenses were rendered with a simple two-colour gradient, which was easily changed for each of the colour studies. The light source is pointed directly at the front of the glasses creating a 'window-like' highlight. The shade (absence of light) occurs at the bottom of the frames. Otherwise, all the required elements are in the rendering as annotated in the illustration.

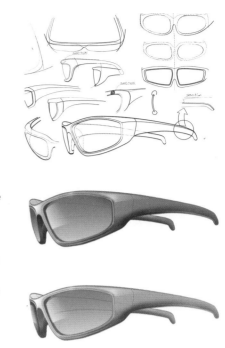

Fig. 18
This sequence moves from loose sketches to a single concept to be rendered in multiple ways.

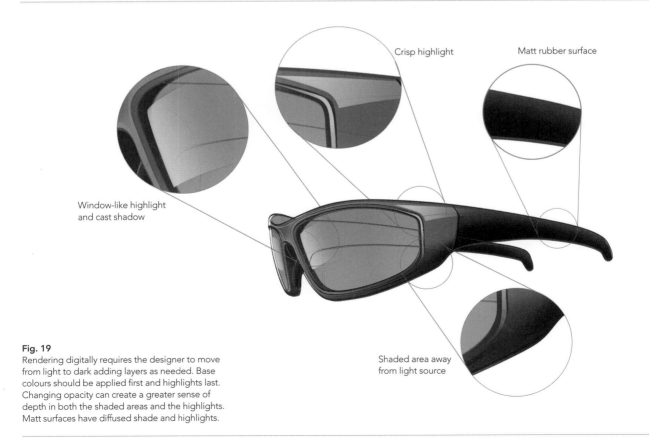

Crisp highlight

Matt rubber surface

Window-like highlight
and cast shadow

Shaded area away
from light source

Fig. 19
Rendering digitally requires the designer to move from light to dark adding layers as needed. Base colours should be applied first and highlights last. Changing opacity can create a greater sense of depth in both the shaded areas and the highlights. Matt surfaces have diffused shade and highlights.

Fig. 20
These renderings from Radius Design (Chicago) demonstrate a photorealistic approach combined with the accuracy of orthographic.

Rendering is a quick and effective tool for refining a concept but needs to be weighed against the time required to make a physical mock-up or build a computer model that can easily be rapid prototyped. If ergonomic input is required, a rendering will not help as it won't allow the designer or the team to handle the product physically; however, rendering does communicate design intent at an early stage. Rendering can also be used to show aspects of the product including details, size or context of use, and even packaging ideas as seen in Thomas Maguire's rendering in Alias Sketchbook Pro, above.

Fig. 21
This rendering was done natively in the computer using the program Painter, and demonstrates a clear sense of the light source and material finishes. The added call-outs increase the level of communication or further clarify materials and finishes. (TEAMS Design, Chicago.)

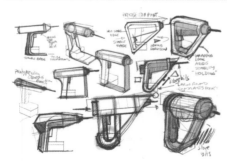

Fig. 22
This sequence by Thomas Maguire demonstrates the workflow from sketch to final rendering. Working in greyscale simplifies the process while still communicating form. The light source is above and slightly in front of the object, creating the necessary highlights and shaded areas.

Fig. 23
These trainer-concept renderings by Michael DiTullo for Converse are scaled identically and placed side by side for easy comparison. They are done in side elevation for speed and to avoid ambiguity common in even well-done perspective sketches. The figure has been sketched to show the trainers in context with the wearer.

Referencing the body: the power of context

While rendering increases the fidelity and brings the concept closer to a photographic image, adding references to the body provides greater context for understanding the scale and potential use of the product. No functional object exists that does not get handled in some way, so even adding a disembodied set of hands provides an immediate sense of how to operate the product, as well as its size. When the product's main function or purpose involves another part of the body (a bag, a pair of glasses, a bicycle) it is necessary to include the appropriate context in the sketch or rendering.

While there is an infinite number of positions in which the hand can be formed there are finite sets of common grips: grasping, cupping, cradling, steering, picking and so on. Choosing the right shape for the hand in relation to the product's function is vital for clear communication. Manipulating an iron is similar to manipulating a small garden tool or screwdriver. For professionals who use hand tools for extended periods of time, exerting great pressure on the handle, it is essential to create the optimum ergonomic feel. In fig. 25, taken from a Bosch ergonomic manual, the designers have mapped the hand with respect to the contact, pressure and counterpressure surfaces, and colour-coded them. The top-view sketches were created to convey the ideal handle geometry to maximize ergonomic fit; note that the illustrations are displayed in section and coloured black for maximum clarity. The addition of arrows helps to explain visually how the energy is transferred from handle to tool.

Fig. 24
This illustration show sunglasses in context. Low-fidelity context sketches like these ensure that attention is paid to the showcased product rather than the sketch of the individual.

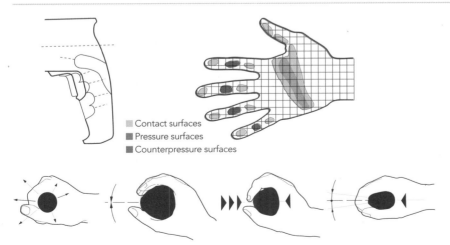

■ Contact surfaces
■ Pressure surfaces
■ Counterpressure surfaces

Fig. 25
A global manufacturer, Bosch is responsible for producing everything from car parts to heavy machinery and hand tools. The illustration visually demonstrates the transfer of power from four different handle geometries. The ultimate shape is elliptical.

Fig. 26
(Right) This sketch rendering shows the Pogo pen being opened by pulling. The hands in conjunction with the arrow confirm the motion required to use it. The unrendered pen sketch is oriented along its dominant view, as we might view it atop a table. (Morrow Design, Chicago.)

Fig. 27
(Far right) This sketch uses a hand and a flexed lid to show interaction and the ideal way to open the container with the first and second fingers in front of the thumb. (Astro Studios, San Francisco.)

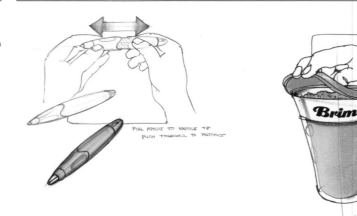

Fig. 28
Three superimposed photographs show the various positions a hand assumes as it moves from fully opened to what is more like the 'pistol grip' common when holding hand tools. Notice that the thumb moves in concert with the fingers when grasping. The thumb's ability to pivot not only adds strength to the grip but also changes what the hand looks like.

Sketching the hand remains one of the biggest challenges for the designer because of its complexity. With 27 bones and a large number of joints it can assume a huge range of different positions or configurations. Drawing a hand well requires understanding of its anatomy and proportions. The fingers in conjunction with the opposable thumb allow the hand to form both the power grip (hand and fingers together) to grasp tools, and the precision grip (fingertips and thumb together) for fine motor skills such as writing.

Sketching accurate hands requires practising the most common positions and understanding where the bones lie underneath the skin. Thinking about the hand as a wireframe with articulating joints can help the process of imagining the positions appropriate to the product in question. Taking photographs of as many hand positions as possible is a great reference for sketching; outlining these in a vector program like Illustrator can greatly speed up the workflow.

Fig. 29
Keeping in mind the underlying bone structure allows for quick sketching and reasonably accurate joints.

Fig. 30
A simple technique for creating reference material is to photograph the hand alone and then with a product. Adjust the transparency on both photographs to see through the product.

Sketching objects held in a hand requires a process very similar to sketching products: begin with the object that is being held (general form only) and ghost in lines to approximate the main anatomy of the hand. Keep the initial sketch simplified to a wireframe with each finger divided by joints. Work until the overall proportions are reasonably accurate and focus on the hand's gesture. Sketch the 'skin' over the wireframe. Adjust the line weight to differentiate the hand's overall outline from interior details like the fingernails or the outlines of the object. Line weight helps to define a hand much as it does a product.

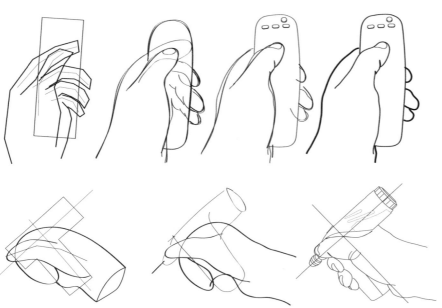

Fig. 31
Begin the sketch with a rough approximation of the form being held. Follow this with a simple wireframe sketch of the hand to capture the gesture and volume. Continue to refine the sketch with greater fidelity.

Fig. 32
Use a set of directional axes to define the handle and barrel of the tool. Sketch a mitten or gloved hand around these axes, taking into consideration the required bending of the various fingers around the object. Continue to refine the sketch with greater fidelity.

When sketching a hand that is using a tool it is smart to create some directional axes for the tool and the hand. These should be sketched quickly and very lightly so that darker lines will more or less mask them in the final drawing.

Another technique is to imagine the hand clad in a heavy leather mitten that conceals the detail of the digits. Sketching out such a 'gloved' hand is a quick way to capture its overall massing along with some of its gestural qualities without getting caught up in the more complex details.

For some products it is not enough to show isolated parts of the body to provide the necessary context. Furniture is a great example as its use/interaction with the end-user is complex and varied, and changes over time. Designers often need to manipulate scale and point-of-view to convey the functional aspects of the design combining human figures for scale and context as well as arrows to indicate articulating parts.

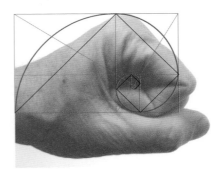

Fig. 33
This illustration demonstrates the way the digits of the fingers diminish in size as they wrap around themselves like a spiral. The digits change from softened cubic to wedge-like forms as they assume the power grip. Understanding that this transformation occurs is helpful when sketching the hand.

Fig. 34
This sketch combines perspective, top-view orthographic and a section cut to reveal the heating element, along with annotations to help communicate the idea. (Radius Design, Chicago.)

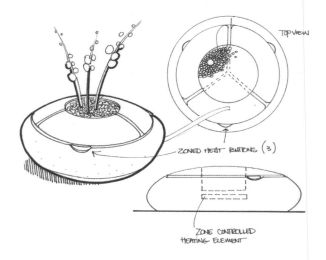

TOP VIEW

ZONED HEAT BUTTONS (3)

ZONE CONTROLLED
HEATING ELEMENT

Section, partial section and details

The final issue to explore in a chapter that explains forms in space is the section cut. This time, however, the discussion is not about the power of the section to help build perspective sketches, but rather the true intention of the section cut as a way to magically reveal what lies beneath the skin of the product. Because so much of what is in a product today lies hidden underneath the surface, the section can help identify components that are otherwise invisible, and help explain what makes the product work in the first place. Section cuts are increasingly easy to create in CAD, but in freehand sketching they remain an important tool for imagining the inner structure of the product or the ways components nest inside or connect.

The section can run along the length of the object or space like the torch (fig. 35) or it can cut across the product at any point, much as a knife slices bread. A section does not have to cut all the way through an object but can be a partial cut in two directions (length and width) that reveals something important while still allowing the viewer to imagine most of the housing or outer layer still in place.

Fig. 35
These two section cuts of the same torch differ only in the use of colour and degree of detail. The top section shows the internal battery and the blue anodized metal housing.

Fig. 36
Sketch showing a partial section for an external hard drive. This type of sketch can demonstrate the wall thickness of the plastic cover along with internal components, and still communicate the concept's overall aesthetic.

Outside housing
(top)

Outside housing
(bottom)

Printed circuit board

Ghosting, or changing the opacity of the product's housing – which is not to be confused with the lightest, most provisional lines laid down when sketching – is another way to reveal internal components. Technical illustrators used this convention to reveal the engine inside cars.

The sectioned drawing can also reveal wall thicknesses or other internal structures like ribs and bosses. For products without internal components, such as ceramic ware or trainers, sections help explain technical issues; how a particular wall thickness varies over its length, for example, or the particular make-up of composite materials in the sole of a shoe.

Fig. 37
These drills for Bosch use the technique of 'ghosting' by reducing the transparency of one image to overlay a second drawing (section), thus revealing internal components such as the motor or gearing. (Ignite USA, Chicago.)

Fig. 38
Trainers are created out of many hidden layers in order to achieve the desired comfort and performance. These section cuts display precise technical data about the geometry and dimensions of the layers within this complex sandwich, as well as some of the more visible elements that determine the product's aesthetic appearance. (Michael DiTullo, Converse.)

Fig. 39
This trainer concept for Converse shows a top view sectioned in eight places that correspond to the various section cuts above. Sections are an ideal way to understand geometry at a particular point in space.

Tutorial

Fundamentals of rendering

Rendering digitally is quickly becoming the norm for product designers. Proficiency comes with practice and having a clear goal in mind. Over time designers develop a personal 'workflow' that fits their needs. Designers familiar with marker rendering often simulate their traditional approach with digital tools while younger 'digital natives' often learn the software with little or no knowledge of the past. The main goal, as with sketching, is to develop fluency and speed. Rendering should fit into the larger design process as naturally as possible. The following short list will be helpful for rendering (in Photoshop in particular).

1. Renderings are only as good as the drawing being rendered. (Good sketches = good line art!)
2. Always work with layers (which can be deleted or easily moved around) and name them!
3. Move from light to dark creating value in direct relation to the object's form.
4. Work fast and never apply colour at full opacity.
5. Use gradients sparingly as they can overwhelm a form and appear gimmicky.
6. Use paths to control light, shade and shadow.
7. Learn the short cuts (hot keys) to speed up the workflow.
8. Learn to customize the workspace to your method of working.
9. Highlight, shade and shadow should come last.
10. Photograph a wide array of objects to study their surfaces and use those resources to practise rendering.

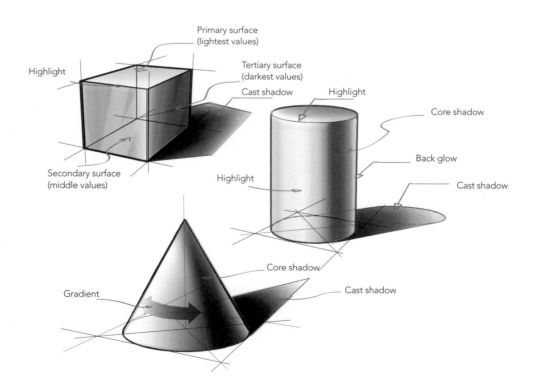

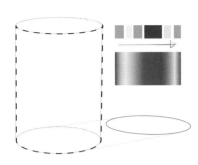

1. Sketch a cylinder using vector-based software like Adobe Illustrator or using a pen and paper and then scan it. Carefully sketch the shadow of the cylinder to help establish where the light source is coming from. This will determine everything that follows. Using the magic wand tool in Photoshop select the front surface only.

2. The selection will be highlighted with a pattern of 'marching ants', the term used to describe a dashed-line marquee. Next apply a multi-colour gradient to the selection. A colour gradient, like a texture gradient, is a perfectly smooth transition between two or more colours on a surface and will reinforce the effect of light.

3. Another approach is to apply a series of quick vertical brushstrokes using the airbrush tool set to a low opacity (20-30 per cent) and a large diameter. With the opacity low and diameter large, gradient effects can be achieved with repeated passes to build up darker values. The variation in value reinforces the illusion.

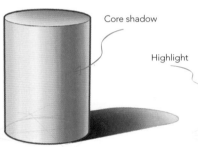

Core shadow

Highlight

4. Using the magic wand, select the top surface only and apply either another gradient or a series of large-diameter and low-opacity airbrush strokes that move from left to right to build up the desired value. In this case the front of the cylinder top should be lighter and the back darker, given the location of the light.

5. Using the magic wand again, select the shadow area. With a large diameter airbrush set to a low opacity (10 per cent) brush in the shadow. Begin with the area closest to the object and work outwards. Make large quick passes. If necessary use an eraser tool (10 per cent opacity) to soften the outer edges.

6. Assess the results and lighten (highlight) or darken (shade) where necessary. Here, the value of the core shadow has been intensified and the area closest to the light and directly opposite the shadow has been lightened (highlight). The back edge of the cylinder has been lightened to add greater contrast to the core shadow.

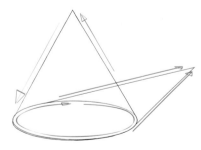

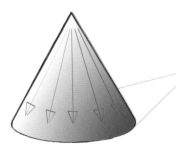

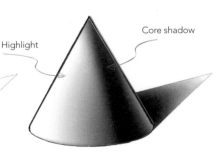

Highlight

Core shadow

7. Sketch the cone either on paper with a pen and scan it or in the computer using a vector-based software program like Adobe Illustrator. Be sure to sketch the shadow because this sets up much of the dynamic for the remainder of the rendering process. The shadow is in direct line with the light source: move that and the shadow moves with it.

8. Just as the airbrushed strokes on the cylinder involved large vertical gestures, the airbrushed stokes on the cone should taper outwards in order to follow the direction of its surface. Even though the drawing is on a flat two-dimensional surface, the addition of colour can easily add the necessary value required for the eye to see the drawing as a

3D volume. The core shadow and highlights must also follow the taper of the cone in order to complete the illusion. All that remains is to add a shadow, which will help ground the object and reinforce the direction of the light source. Softening the shadow's tip helps give it depth.

Tutorial

Rendering simple forms

Rendering even the simplest of forms requires practice and planning. As with all rendering there are three things to think about: the light source (location and direction), geometry and the materiality of the object. Once the direction of the light is understood (in this case it is coming from above and left), the designer knows where the highlights will be along with the resulting shade and shadow, based on geometry. Materiality determines whether the highlights and shading are sharp or diffused.

The shapes below were sketched in Adobe Illustrator and taken into Photoshop for a quick render. I sketched not only the outlines of the various forms but also some quick contours to help communicate the form. For the purposes of this tutorial I sketched in the diagonals for the first two rectilinear forms, and after that used only a centreline and some basic contours. A competent renderer can simply look at the form and colour it up without the aid of the contours. Note that even without colour the sketches, below left, are easy to read because of the contours. Adding them helps determine where the highs and lows will be. The shadow does far more than indicate a ground plane; it reinforces the form's shape as well as the direction/location of the light source.

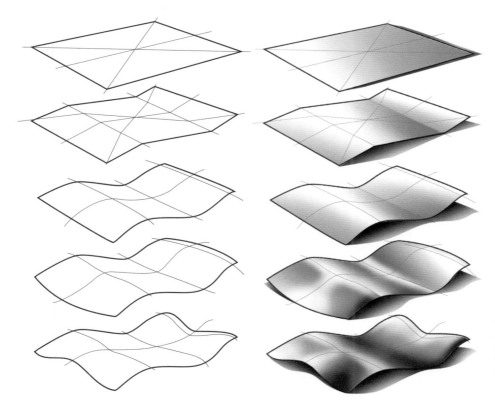

These forms have all been rendered with an airbrush tool in a cool blue at about 40 per cent opacity. The highlights are not added in white but are merely erased from the blue to reveal the white background.

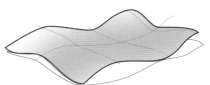

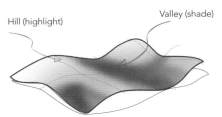

Hill (highlight) Valley (shade)

1. Sketch the product with a vector-based program like Adobe Illustrator or with pen and paper and scan it. Open it up in Adobe Photoshop or another raster-based program. Be sure to include contour lines to help determine where the 'hills and valleys' are as well as a cast shadow to determine where the light source is.

2. A gradient fill is not advisable given the undulating compound curvature of the surface. Gradients are reserved for smooth continuous surfaces like the previous tutorial. Using a large airbrush at a low opacity (between 10–15 per cent) lay down a light colour. Even at this point it is possible to suggest highlights.

3. Change the opacity of the brush but keep the size the same. Changing the opacity has the effect of increasing the value, hence darkening the colour. Relying on the contour sketches, add value to those areas that are lower and out of direct contact with the light source. Above is a clear hill and valley effect.

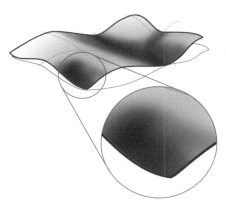

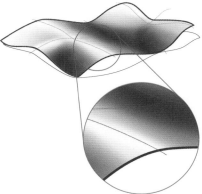

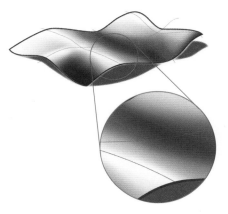

4. Continue to increase the value by raising the opacity of the airbrush. The goal is to slowly build up the surfaces to reflect the product's geometry. In the detail above, note that the surface has a gradient-like effect, blending seamlessly between the lighter and darker values.

5. Using a large diameter airbrush tool set at a low opacity, brush in highlights where needed – on the tops of the hills or highest points on the product. The light source is coming from behind on a slight angle, based on the placement of the shadow. Shade, shadow and highlights must sync.

6. The shadow not only suggests the ground plane the product is sitting on, but also creates a strong contrast with the product's surface. In this case the shadow, created in Photoshop, suggests the edge of the product, which can give the illusion of thickness very simply and quickly.

7. The finishing touches involve pushing the highlights, shade and shadow to the point where the surfaces become truly easy to understand. The shadow has been further darkened and softened to give it greater complexity. A shadow is never composed of a single value but should, like surfaces, have variety. Finally the edge has been given more surface area. Such a rendering should not take more than 20–30 minutes.

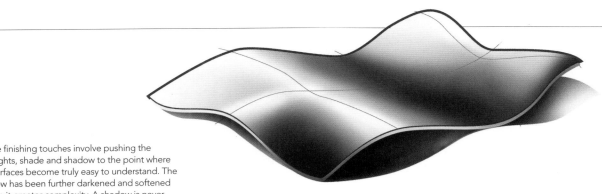

Tutorial

Rendering complex forms

This tutorial goes through some very simple and abbreviated strategies for rendering more complex forms. I've chosen not to render in perspective because the level of complexity is increased greatly. Rendering orthographics is a great way to get started and to develop some confidence with the tools and the techniques (all of which can be applied to perspective rendering). The renderings here were done over sketches cleaned up in Adobe Illustrator. The linework was intentionally left to suggest a rendered sketch and not a 'photorealistic' image (CAD rendering). It is impossible to compete with CAD rendering, but that's not the point: the goal here is to simply raise the fidelity enough so that a more focused conversation can take place about possible changes or modifications. In the end if a rendering takes more than an hour it might not be time well spent when a computer model could be started using some of that time. Renderings of this level are often created to communicate to those stakeholders unaccustomed to interpreting technical drawings or loose sketches.

Writing in *Scientific American,* neuroscientist V.S. Ramachandran claims that the brain has a strong bias towards 'top-lit' surfaces because our brains assume the light source to be the sun. As a result, circles with shading on the bottom half will be perceived as convex while those shaded on the top half will be perceived as concave.

Use a pen and paper to sketch the product and scan it or use a vector-based software like Adobe Illustrator to create the linework. Bring this into Adobe Photoshop or similar software (Sketchbook Pro, Painter, etc.) and place the sketch as the first (lowest) layer and lock it down so that it cannot be manipulated. This is the selection layer.

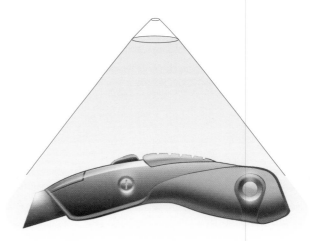

This light source here is positioned directly above the product, creating highlights on the top surface and shade below. The light source in rendering determines everything from the placement of highlights, shade and shadow to the appearance of specific materials. Highly reflective surfaces with no applied texture will have crisp highlights (the die-cast body for example). Thermoplastic elastomers (TPE overmoulded surfaces) will have softer and less crisp highlights and shading (such as the handle above).

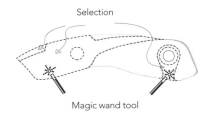

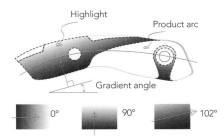

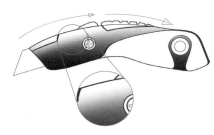

1. Using the magic wand in Photoshop, select the primary surface of the die-cast metal housing. The section, defined by the 'marching ants' marquee, will allow the direct application of a gradient. The gradient is a fast way to apply a continuous tonal range. In this case it will be black to no fill set at an opacity of 30–40 per cent.

2. A colour gradient, like a texture gradient, is a perfectly smooth transition between two or more colours. Gradients reinforce the effect of light falling evenly over an object. The default angle of a gradient is 0 degrees, moving from left to right. A 90-degree gradient moves from bottom to top. The gradient here is 102 degrees.

3. Another approach is to utilize a large airbrush (set to a low opacity of 20–30 per cent) and paint in large strokes along the product's arc. In both cases, an eraser tool (at a low opacity) can be used to remove value at the top of the product to suggest a stronger highlight. Rendering can be done in multiple ways.

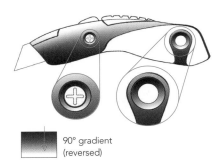

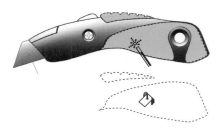

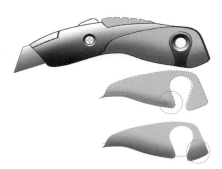

4. Use the magic wand tool to select the two bevelled surfaces on the die-casting. These are ideal surfaces for a 90-degree gradient. The direction, however, will be reversed, moving downwards from dark to light. The concave geometry of the bevel catches light (highlight) at the bottom while shading the top.

5. Select the overmoulded handle (layer 1) with the magic wand tool. Create a new layer and name it. Apply a fill colour from the edit menu or use the paint bucket. The fill colour is solid but darker colours will be added on separate layers. Select the blade with the wand and on a new layer brush on grey to suggest a metal finish.

6. Add new layers. With the magic wand select the overmoulded handle again and airbrush a darker colour (dark blue or black) at a low opacity (20–30 per cent) following the geometry of the handle to suggest the shaded underside of the product. Multiple layers can be added and darker values added until the effect is achieved.

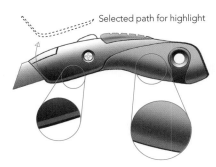

7. Light commonly bounces off floors and ceilings and back on to objects. In this case, a subtle reflected highlight has been added to both the overmoulded surface and the metal surface. The main difference is in the definition. On metal the highlight is crisp and well defined and created using a path.

8. The detail for the cross-head screw is accomplished using many of the same techniques. Select the white space of the screw head with the magic wand, and add a gradient fill. Using the magic wand select the interior of the screw (cross). Use a very small airbrush tool at low opacity to whisk in grey for the drop shadow.

9. Add a new layer as usual and name it. The final touch is to add some 'hot spots'. Like the starburst of light in photographs with direct exposure to the sun, a hot spot is a diffused burst of light seen on the edges or corners of objects. Using a large low-opacity white airbrush, slowly apply colour to edges and corners.

Case Study

Fiskars garden barrow

The range of exploration undertaken by Daniel Lipscomb, senior product designer with Fiskars USA, in the design of a garden cart is a great example of the depth and breadth of skill a designer needs to take an idea from the quickest sketches straight through to rapid-prototyped parts. The earliest sketches are simple but direct explorations in orthographic side view to determine the overall geometry and orientation of the handle, which doubles as a rest. The cart is a multi-purpose piece of garden equipment designed to carry tools, a 20-litre (5-gallon) bucket, soil, grass clippings and other commonly transported garden material.

The first set of renderings shows the application of traditional marker to add detail to the handle grips, wheel covers and tool trays while still in orthographic side view. Arrows are used to suggest motion (push/pull) while the faintest ground line provides context for the resting position.

The sketch renderings that follow are progressively more detailed and realistic. Vantage points are changed to allow a look inside the cart to better understand the overall geometry, lip detail, connection between the metal handles and the plastic body, and the internal cavities for tools and the bucket. The final image is a SolidWorks rendering which is identical to both the one-eighth-scale model and the half-scale model.

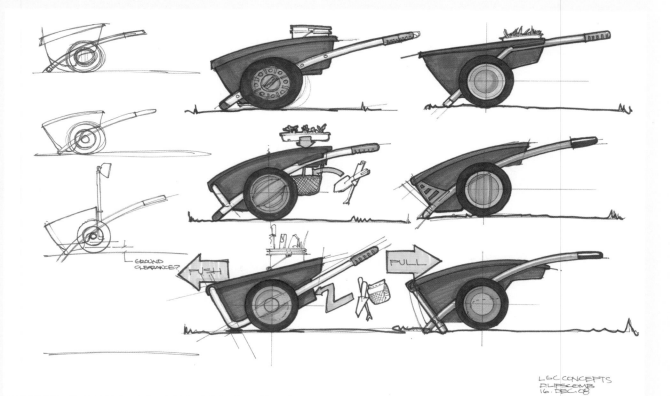

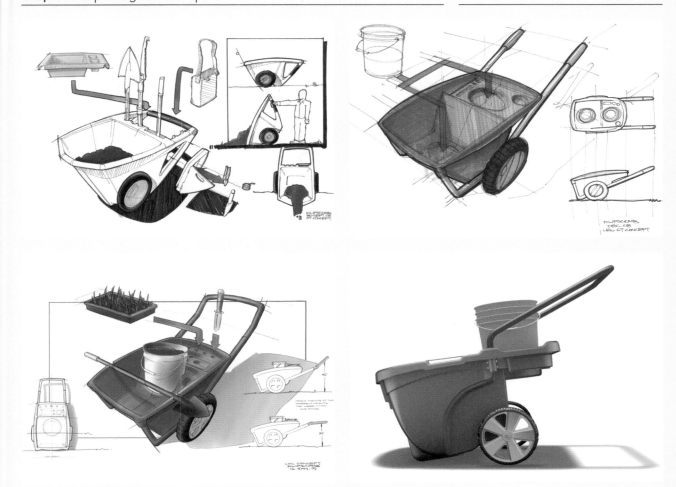

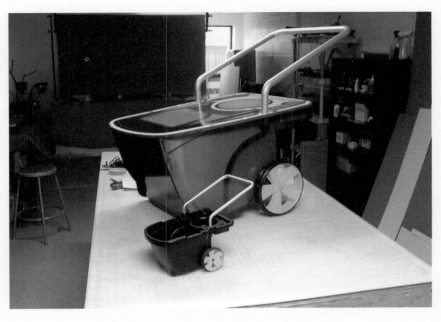

EXPLORING FORMS IN TIME

Articulation

Exploring forms that morph and change over time requires a designer to think not only in 3D but also in 4D (time). Designers have been using visualization techniques to demonstrate how a product articulates – opens, closes and transforms – from the very beginnings of the profession, and have devised conventions to show change using directional arrows and ghosted images. Niels Diffrient and Alvin Tilley mapped out the human body and its range of articulations while interacting with controls of all sorts, resulting in detailed measured anthropometric drawings. Their work became the measure of man and woman, the first ergonomic reference for designers. This data continues to be expanded and refined, and remains critical to the design of everything from furniture to tools. The latest challenge facing designers has less to do with strictly physical products (such as tools) and more with smart products like mobile phones that are manipulated haptically but rely on screen navigation, nested menus, and other time-based interactions.

This chapter looks more closely at the full range of products that move in space and time, and explores the way designers leverage visualization techniques to both explore and explain product interactions. It begins with one of the most basic conventions – the exploded view – and moves on to that workhorse the arrow; then on to scenario-based storyboarding; wireframing; and finally the all-encompassing information graphic. As designers are called upon to imagine ever-more complex interactions they are turning towards methods traditionally used outside the profession, including filmic storyboarding, comic books, graphic novels, web interfaces and diagrams of every description.

The C2 Climate Control is designed to raise or lower the temperature in a person's workspace (30 degrees warmer and 7 degrees cooler) to maximize comfort. The product, which weighs approximately 500 grams, has a touch-sensitive control strip (beneath the Herman Miller logo) for adjusting fan speed, toggling between hot and cold, and powering on/off. The head tilts for finer adjustment. The product also serves as an air filter that is Greenguard certified and can be cleaned and reused. The manufacturer claims that the C2 is 90 per cent more efficient than a typical space heater. The sketches on the right demonstrate the ability of a static sketch to 'explain' products in both space and time. Arrows are used to help explain everything from rotation and expansion of the product to the movement of liquid or other media through the product. The range and flexibility of the arrow is quite remarkable while its universality makes it an ideal symbol of motion.

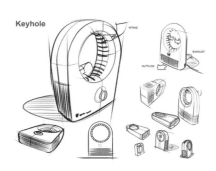

Fig. 1
It is easy to take in the range of ideas shown here because the main concept is the largest image and the formatting remains consistent.

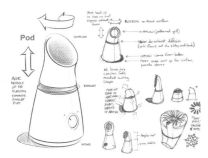

Fig. 2
This is the final concept selected by Herman Miller for the design of the C2 climate control device, which is to be used in offices and interacted with through simple touch controls.

Fig. 3
(Above) The exploded view of Dyson's DC 25 'ball' vacuum cleaner.

Fig. 4
(Right) This sketch from Astro Studios (San Francisco) for the Herman Miller Intersect Work Island uses exploded views in sketch form combined with details, call-outs and sections to explain the product.

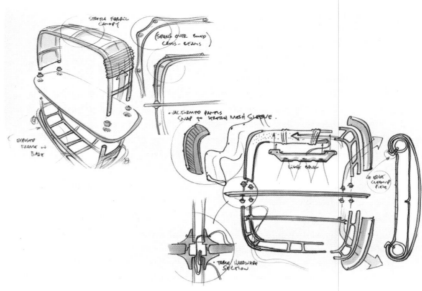

The anatomy and logic of the exploded view

The exploded view is exactly as it sounds – an assembly with all its components exploded apart. The main difference is that the explosion is controlled along one or more of the Cartesian axes depending on how the product comes together or apart. The static image of a product exploded in space suggests that a specific sequence or set of stages is required to disassemble it. Such a time-based sequence often involves unscrewing the two halves of a tool that hold the motor assembly in place or a face plate that hides the internal components. Once these pieces are removed there is typically a series of nested parts mechanically fastened together. The designers of repair manuals understand the need to show every component in an assembly in the exact order that it goes together and comes apart. The image of Dyson's DC 25 vacuum assembly (fig. 3) is a case in point. With the advent of computer-aided design the process of exploding complex assemblies is easier than ever, and the views are not restricted to line drawing; they can instead be photorealistic renderings with colour to help differentiate the various parts. Nevertheless, a designer has to be able to sketch an exploded view early in the process (fig. 5) or use variations of the concept to pull facings away to reveal hidden fasteners (rendering fig. 6).

Fig. 5
The torch sketch represents a quick view exploded along a single axis while the CAD rendering uses photorealism to show the assembly including the battery. (TEAMS Design, Chicago.)

Fig. 6
This product rendering represents the product 'pulled apart' to reveal how the two parts go together.

What is articulation?

Articulating products have moving parts that allow them to be transformed. These include something as simple as a handle on a door, the sliding mechanism on a mobile phone, or the living hinge on a plastic container. Sketching articulating products requires the designer to show the object in multiple states, either through ghosting the open state over the closed state or by creating arrows to indicate the path or direction. Figure 8 shows a concept from Astro Studios (San Francisco) for a coffee-storage container with a sliding lid, which also houses a nested serving spoon inside. The designer has sketched and rendered a sliding version of the lid in both its open and closed states, and relied on the arrow to help communicate.

Figures 7 and 9 represent a food container with a living hinge and a mobile phone with a sliding mechanism that reveals the keypad. In both instances the arrow is crucial to the communication. Let's explore this highly flexible symbol of motion in greater depth.

Fig. 7
This rendered sketch of a food container with a living hinge shows the main view in perspective, but the articulated view is in the less ambiguous orthographic side view where the lid is ghosted in; note the importance of the arrow in both views.

Fig. 8
The sliding motion of the lid is cleverly expressed using an arrow to show the direction of travel while also pointing to the top-view orthographic.

Arrows

A flexible tool for direction and articulation

The arrow is one of the first true symbols indicating movement and direction. This is largely because of its history as the first dominant hunting tool. Everyone from graphic and information designers to architects and product designers relies on it to show movement whether in articulation, sequencing (flowcharts) or plain old directional guidance (indications of an exit). It is the most ubiquitous symbol in sketching because of its flexibility: it can indicate up and down, side to side, in and out, around and up, and can even bend around corners, disappear and reappear. It is the obvious choice for indicating anything that pivots or swings on a hinge but it can also show the path a lid takes as it moves up along a helical thread.

Fig. 9
The articulation required to access the keypad of many mobile phones requires a clear indication of both the motion (hand gesture) and the axis of movement (arrows). Note that a gradient is applied to the arrows to also suggest speed.

Fig. 10
(Above) The grid as defined by the Cartesian coordinate system is critical for sketching arrows. They may bend and flex but they tend to follow one of the three primary directions: left to right, up and down, and forwards and backwards. As with compound curvature, the arrow can move through all three axes at the same time, as it does in the helical arrow.

Fig. 11
(Right) Arrows are created with the same care and precision as objects but, given their relative simplicity, they can be sketched much faster. In thinking about the arrow it is important to sketch it so that it maximizes impact. While most arrows follow the Cartesian axes the primary exceptions are those that revolve around an axis or move along very specific types of paths, like the helix.

Fig. 12
Products with screw tops open and close along a helical path. The threads that facilitate this motion can be fast (few threads) or slow (many); they can also be a combination of unscrewing and pulling. Demonstrating this with one or more arrows is a clear way to communicate complex interactions.

Fig. 13
In this chart the arrow has been taken through a series of manipulations while remaining an indicator of motion. In the third row it has been reduced to its fletching, which still communicates motion and direction. The recycling symbol utilizes a complex arrow rotated around a central axis.

The taxonomy of the arrow

Let's break the arrow down into its constituent parts. The traditional hunting arrow is composed of five parts: the point (tip); the insert (where the point attaches to the shaft); the shaft; the fletching (the vane type mechanism for guiding it); and the nock (slot to accommodate the bow).

Of course, in graphics the components are reduced to the point and shaft although the fletching occurs in more traditional graphic arrows. While hunters rely on the straightest arrows possible the designer needs a symbol that can be twisted, turned and otherwise tweaked to suggest a range of motion. As with every other aspect of sketching, the arrow adheres to the Cartesian axes for its major orientation.

While the most basic stencil-type arrows, like those on traffic signs and packing crates, suggest simple directions or orientation, the graphic arrow can move in all three directions. For example, unscrewing the top of a travel mug requires a helical arrow (fig. 12). The arrow can lead the viewer's eye through both time and space while suggesting causality.

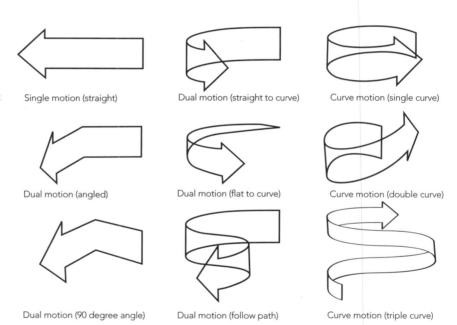

Single motion (straight) Dual motion (straight to curve) Curve motion (single curve)

Dual motion (angled) Dual motion (flat to curve) Curve motion (double curve)

Dual motion (90 degree angle) Dual motion (follow path) Curve motion (triple curve)

Sequencing time in flat space: cause and effect

Let's look at a few examples of the arrow in action. In figure 14 the section cut for a pair of Converse trainers reveals small spheres underneath the sole, which are designed to take the downwards impact of the wearer's weight. In the sketch the arrow is used to indicate the axis of the downwards motion but what actually happens is not clear from a single view. The designer, Michael DiTullo, has added a second detail sketch to show the actual compression of the spheres (a before and after set of orthographic sketches).

Product designer Dan Lipscomb uses a variety of different arrow types in multiple perspectives of the same product (in various open and shut states). By combining arrows, scaling and multiple locations, the use scenario for the lawn-care product (fig. 15) becomes very apparent. This rendering hovers between a short storyboard and an information graphic.

Products that open, shut, swivel and expand need to have those functions shown early in the process so others can understand the concept. Articulations may take place in a specific sequence or may happen over a longer period of time: multiple arrows are often required to tell the story (see fig. 16).

Fig. 14
This orthographic of a trainer uses an arrow to indicate the impact of the wearer's weight, and an additional detail sketch reveals the compression of the spheres in the sole.

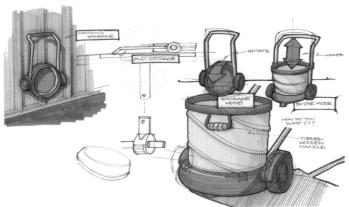
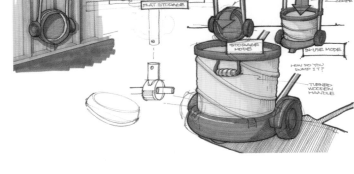

Fig. 15
(Left) In this rendered sketch the eye travels from left to right, moving with the product as it hangs on the wall, is rotated into place, is extended to its full height (articulated) and finally, in the last, and largest image, is ready for use.

Sequencing of process in flat space: the information graphic

There are many times when the addition of arrows to a sketch is simply not enough to explain a multi-phase activity such as interacting with a product, assembling a product or describing a process. Information guru Edward Tufte writes that humans, 'thrive in information-thick worlds' and lists 60 different verbs commonly associated with this activity including: structure, highlight, synthesize, condense, categorize, scan, filter, chunk, outline and glean. While that's a lot of verbs to describe the parsing of information required to make sense of the world, Tufte's list repeats some of the key concepts of Gestalt psychology, vision and cognition in general. To categorize, filter, outline and synthesize are all essential skills for sketching as well as for presenting information, which is why information graphics have become essential to the design process.

Information graphics rely heavily on the use of sequential images (what Tufte calls the 'small multiple') to show subtle changes over time. While sequences can be created by traditional sketching, using underlays and computer modelling programs have made the process easier; data can be exported, laid out and better organized in graphic programs such as Adobe Illustrator or Photoshop. The designer can create what is essentially a simple animation or storyboard that clearly controls the follow of the viewer's eye through the information.

Fig. 16
Showing images in a sequence demonstrates the various states of a product. The arrows must clearly show direction and motion and often require multiple arrows to tell the story.

Fig. 17
(Right) This information graphic explains the process of slip casting a single vessel. It combines many conventions including perspective, orthographic, arrows, sectional details, call-outs and layer opacity.

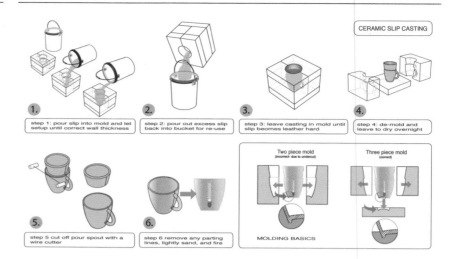

CERAMIC SLIP CASTING

1. step 1: pour slip into mold and let setup until correct wall thickness

2. step 2: pour out excess slip back into bucket for re-use

3. step 3: leave casting in mold until slip beomes leather hard

4. step 4: de-mold and leave to dry overnight

5. step 5 cut off pour spout with a wire cutter

6. step 6 remove any parting lines, lightly sand, and fire

Two piece mold (incorrect - due to undercut)

Three piece mold (correct)

MOLDING BASICS

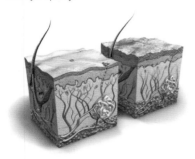

Fig. 18
(Above) This information graphic from Golden Section shows a close-up section of the epidermis. It was created using various modelling techniques.

The storyboard

The final form of time-based visualization we will consider is the storyboard. While storyboards have traditionally been used for advertising, film-making, animation, video and now computer game design, they are increasingly used by designers to visualize scenarios for products and services. Because the process of developing a new product or service often begins with research, the designer needs to communicate that information visually. This may be through a well-designed diagram or a set of photographs with annotations, or both. Taking the deliverables and creating user-scenarios that can be shared as visual stories (even if the appearance of the actual product is not known) is a powerful communication tool.

The process often begins by determining the problems that users of a service face or the needs and desires they have, and creating a story around possible situations. The first visualization phase can be sketched out on paper, using traditional cells and adding stick figures accompanied by captions and voice bubbles (see fig. 19). For designers who are good at comic-book sketching, this process is natural and often follows the conventions established by the genre, including manipulation of camera angle and perspective, establishing shots and close-ups, voice bubbles and annotations and so on. For those less skilled at

Fig. 19
(Above and right) Gravity Tank's storyboards begin with basic line drawings made with cool grey markers, and are often accompanied by text bubbles and captions or notes like a filmic storyboard. Final presentations might include photographs, music and animation edited in a program like Adobe After Effects. While not cinematic, the results can be very compelling in helping a client visualize the possibilities for a new product or service.

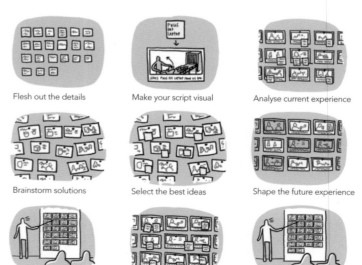

Flesh out the details

Make your script visual

Analyse current experience

Brainstorm solutions

Select the best ideas

Shape the future experience

Pitch the story

Critique the experience

Re-work and repeat

Fig. 20
Cooper (San Francisco) uses a mixture of digital photography, illustration, voice over and sound to create a scenario about a combination service and device for frequent flyers (Stratus Air). The final concept is a video lasting approximately five minutes.

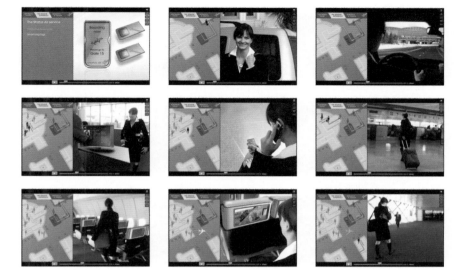

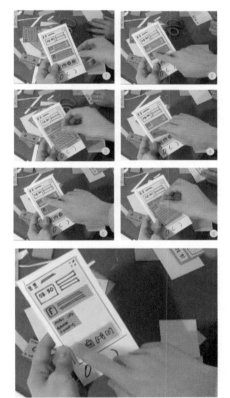

Fig. 21
This sequence is taken from a Nokia video. Rather than sketch out each frame of interaction, this 4D sketch mode (over-the-shoulder video) captures the look and feel of the mobile phone experience. Low-fidelity sketches and storyboards such as this are ideal early in the development phase.

comic-book style sketching, using a digital camera to photograph colleagues or models in the situations shown in the stick-figure sketches allows the quick assembly of a photo-storyboard.

The true power of the storyboard lies in its compression and its requirement for the viewer/reader to interact with what is being shown, as well as what's omitted, to complete the story. The storyboard designer, like the journalist, has to fit a lot of story into a very small space for it to be effective. These are not movie-length productions and, as with initial ideation sketches, clients should feel welcome to participate, edit and otherwise shape the ideas expressed. Economy is at the very heart of good storyboards much as it is in the best comics. In fact, we are for the most part comfortable with the storyboard format because of a general exposure to comic books and strips. Of central importance to both these genres is the frame. Scott McCloud calls this the most important icon of comics: 'The panel acts as a sort of general indicator that time or space is being divided.' This space is where the reader/viewer can stop and catch a breath or contemplate what is happening; it is, more importantly, where the artist or designer can alter the direction of the story, change the viewer's perspective or slow down the pace of the story altogether. A good dense sketch page that is composed to flow much as we read, and which combines critical renderings, details and annotations can engage the viewer in a similar way.

Interacting with products (whether traditional objects or virtual 'smart' devices) involves experiences that unfold over time. Sketching time-based interactions is an essential part of communicating a product's value. When the focus is on the haptic interaction with the screen, the physical look and feel of the device is irrelevant (it is sometimes referred to as the 'black box'). An interaction designer from Nokia used Post-it notes stuck to a piece of foam board (mobile phone surrogate) to explore possible scenarios. Each task was assigned a different-coloured Post-it, which could be quickly added or removed to simulate the interaction with the phone. This can be considered both a low-fidelity physical sketch and a scenario: the recorded video acts as a 4D storyboard.

Case Study

Dyson DC 25 user's manual

The contemporary user manual represents a bridge between product design and visual communication. While many of the conventions, including details and call-outs, are common in technical drawings the graphic (or product) designer needs to present what is often a sequential process in clear and unambiguous visuals for ease of use. With product and graphic designers now sharing data across various softwares it is easier than ever to create compelling manuals that are truly innovative.

This user manual relies on standard orthographic views (CAD data) combined with interesting call-outs modelled after voice bubbles from comic strips and cartoons. Numbering, altering opacity, contextual use of the hand and minimal use of colour for maximum effect are all commonly used strategies.

Case Study

Golden Section
information graphics

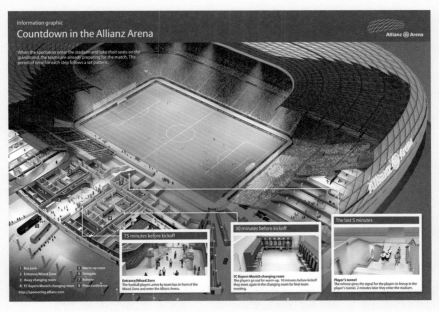

The information graphic, top left, was created by Berlin-based Golden Section and maps the migration of the German language around the world. It is easy to compare the density of German words in predominantly English-speaking North America with the extent to which they occur in South America, Africa or China. Such mapping conventions are now commonly used in data clouds to suggest frequency through size or scale. Many of these conventions continue to migrate back and forth between the various design disciplines.

Golden Section's information graphic for the Allianz Arena in Munich, Germany (below), is an excellent example of an effective graphic visualization. The image was created with an array of digital tools shared by architects, product designers, videographers and graphic designers to help convey clear and concise information. The designers have used a partial section very effectively while creating a bird's-eye point of view.

CEO and infographics artist Jan Schwochow combines architectural drawing, mapping, section cuts and call-outs to present condensed but rich information which is often shown sequentially. His goal is to concentrate the graphic on one subject if possible, while paying attention to its environment, and understanding who the reader is and the media format in which the graphic will be viewed (whether print or screen). The amount of space allotted for the graphic is also a critical constraint. Schwochow believes that ultimately his role is to tell clear concise stories to the viewer/reader.

Tutorial

Creating a storyboard

As with product sketching, orientation and vantage point are important in storyboard sketching. The first low-fidelity sketch, below, was used to visualize a scenario exploring the challenges faced by parents calling their university-aged son on his mobile phone. The son is playing video games while wearing headphones to listen to loud music. The sketch focuses on the locations and characters and, while it is rudimentary, it manages to communicate the essence of the problem without excessive detail.

The first storyboard served as a sketch to flesh out the scenario. Revisions were made (university-aged son is now high-school daughter). This was used as a shooting script for the photos. This second iteration helps to clarify the focus of the story and also provides good images for re-tracing in Adobe Illustrator for the final storyboard. This is done to minimize the detail and engage the viewer in completing the story, much like a comic book or graphic novel. The tutorial on the next page uses three frames to illustrate this process.

(Left) A simple icon like a wall clock can help convey the passage of time. As with cartoons, the point of view is crucial in capturing the attention of the viewer.

(Below) After shooting the frames, filters in Photoshop were used to reduce the fidelity so that the viewer's attention is drawn to specific objects like the mobile phone and 'smart technology' embedded in the car rather than the make of the car or the driver's clothes.

1. Photos are often taken without consideration of background 'noise' or composition so can be visually rich yet information poor. This makes it difficult to extract the 'gist' of the scene without getting hung up on extraneous details like the colour or texture of clothing.

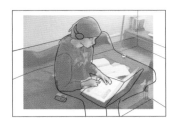

2. Place the photograph in a vector-based program like Adobe Illustrator and drop the opacity (40–50 per cent). Use the pencil or brush tool to trace only those contours that are crucial to the frame. One approach is to select people, places, objects and things that convey time.

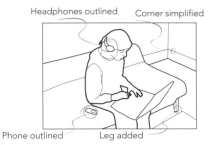

Headphones outlined · Corner simplified · Phone outlined · Leg added

3. Turn off the photo layer to reveal the line art. Because it's a tracing rather than a freehand drawing the image is easily recognizable. Varying the line weight will help to define the image. The young girl and the mobile phone have the heaviest outline to help focus the viewer's attention.

4. The photos have all been run through an Adobe Photoshop filter to lower the fidelity, thus simplifying the scene. The mobile phone has been highlighted (circled in white) and a simple icon has been added to suggest an urgent audio signal emitting from the speaker.

5. The photo's opacity has been cut in half in order to easily trace critical outlines for understanding the scene. The tracing has been done with Adobe Illustrator's pencil or brush tool. The pen tool is far too slow for this process. This vantage point focuses the attention on the mobile phone.

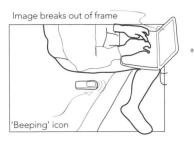

Image breaks out of frame · 'Beeping' icon

6. With the photo removed all textures and colour are gone except for the red icon that focuses the viewer's attention very specifically on the beeping phone. In this particular scenario texture would be extraneous to the story. The focus has been narrowed to just the essentials.

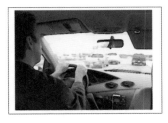

7. This photograph reveals the challenges faced by photography to convey simple information directly. The driver in the photo, which was shot from the back seat of a moving car, is difficult to make out except for the hands on the wheel. The main focus here is the traffic.

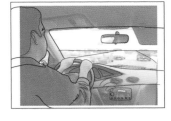

8. The goal of the storyboard was to convey the challenges posed with mobile communication devices over long distances given obvious distractions like loud music or driving. Traffic has been removed for greater clarity and the converging lines of the road emphasized.

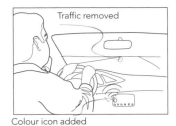

Traffic removed · Colour icon added

9. With the photo removed it is easy to read this image as a man driving on a road. With the traffic removed the scene becomes much quieter, but now the emphasis might be on distance rather than noise or confusion. The colour coded icon links the earlier frames of the story together.

Captions can be added to the images to help clarify the story's trajectory.

Caption goes here.

.....beep beep beep. 'someone's trying to reach me, better pull over.....'

Voice bubbles can be added for internal thoughts or conversation within the story.

Tutorial

Sketching a phone

Nokia's N97 smartphone represents an integrated product that transforms from a mobile phone to a palm-top computer via an elegantly engineered sliding hinged screen that, once opened, reveals a small keyboard.

Sketching such an articulating product requires understanding how the mechanism works, which is often easiest to visualize in the orthographic that reveals the mechanism (see sketch below). This tutorial focuses on sketching the articulating components of the N97.

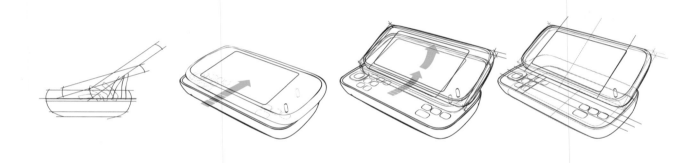

(Left) Original sketches for the Nokia N97 phone. Note the attention paid to small details such as buttons.

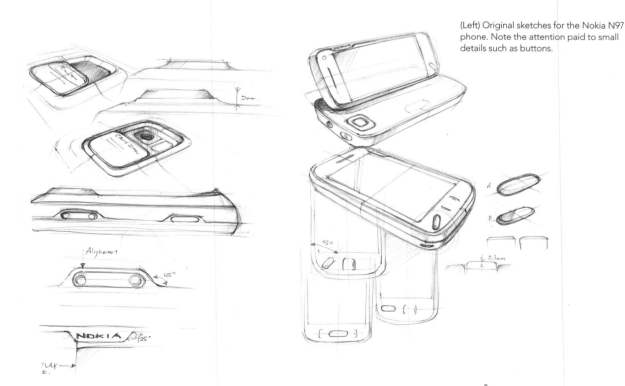

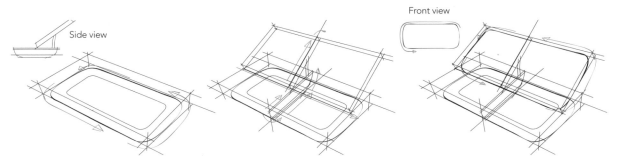

1. Begin sketching the envelope for the bottom half of the phone. The sides of the box slope outwards to accommodate the geometry (see detail). Given the vantage point of this sketch, the bottom surface won't be viewable but it has been sketched anyway for clarity. Sketch the radiused corners as shown.

2. Sketch the side-view profile on the centre plane as a reference for sketching the envelope for the top half of the mobile device. Sketch a line across the lower box (envelope) to establish where the top half of the phone will rest when opened. Remember to keep all construction and ghost lines as light as possible.

3. With the top envelope roughed in, sketch the base profile for the upper half of the phone. Look at the two profile sketches and make any adjustments if necessary. It's always useful to have small orthographic thumbnail sketches of any geometry for quick reference. Next will come the second profiles for top and bottom.

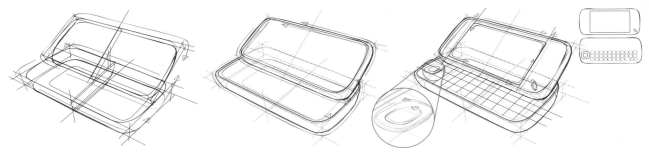

4. Sketch the next set of profiles with the aid of the ghost lines, paying attention to the parallel sets of edges. The ends of the product consist of very shallow arcs while the front and back edges remain perfectly straight. Sketch through the object while sketching the bottom half. This results in better and more confident sketching.

5. Use a heavier line weight to define the outline. This will differentiate the top from the bottom. The next step is to offset the profiles to suggest thickness on both the top and bottom. An offset edge will help define the case that encloses the circuit board and buttons. Sketch carefully, paying close attention to the geometry already present.

6. Be sure the keyboard and screen geometry is understood before lightly sketching some ghost lines to help line things up. A ruler is useful for laying out reference lines for the keypad. The top screen is simple enough: lightly sketch a rectangle and then radius the corners. The same goes for the large and small buttons on the bottom half.

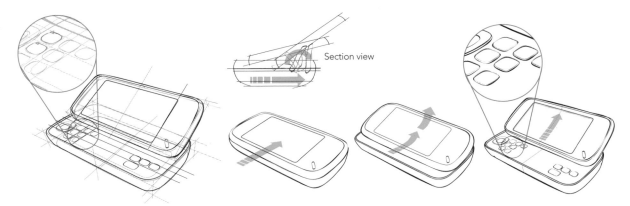

7. Sketch in enough buttons to suggest the keypad. This sketch has required a lot of ghost lines and may need to be retraced over a lightbox. Sketching in Illustrator with a Wacom tablet allows you to create ghost line layers that can be turned off or lightened substantially. The underlay geometry can be confusing to many.

8. The final step is to create a simple animation to demonstrate the movement of the hinge. The product has been sketched in three states based on the original side elevation, demonstrating the movement of the hinge. This process repeats what has already been covered. The addition of arrows helps further clarify the movement.

9. With all ghost lines removed and a few contour lines added to better define the transition between the screen and the body of the product, the sketch is complete. Note the light lines added as edges to the buttons to make them more 3D. Small details like these can make a huge difference.

Tutorial

Sketching an exhibit

Plan view

Front elevation

Given the complexity of the set-up for this sketch, the best approach might be to use it as an underlay. This way only the lines necessary to convey the concept will be retraced. Again, use the heaviest line to outline the columns and walls. The grid lines are helpful in reading the sketch and can be left at the weight usually reserved for contour lines. It is also advisable to place a figure in the final sketch in order to provide context.

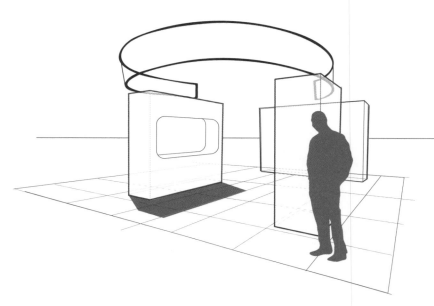

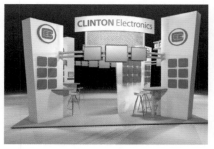

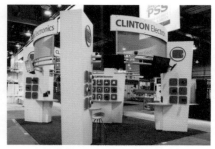

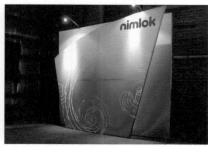

(Above left) Orthographic/perspective thumbnail sketch of the exhibition concept.

(Left) A range of computer visualizations, and actual exhibition photographs. Given the size and nature of the exhibits (temporary and mobile) there are custom-designed 'systems' for ease of constructing and disassembling (Nimlok, Chicago.)

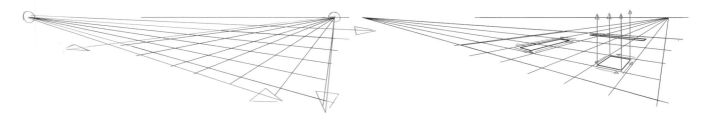

1. For this sketch I've generated a gridded floor plan in Illustrator using the grid and 3D extrusion tools with a depth of zero. Orient the floor accordingly and print out. Otherwise, establish a horizon line and vanishing point to sketch the floor of the exhibit. For speed this is done by eye using a ruler to create straight lines and approximating the grid spacing.

2. The grid helps to accurately place the 'footprint' of the display walls in space rather than projecting them back to their respective vanishing points. These sketches will be extruded upwards vertically in space. Begin that process using very light lines. Do not worry about the height as this will be determined by the vanishing points in the next step.

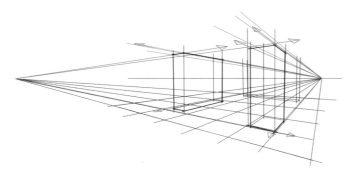

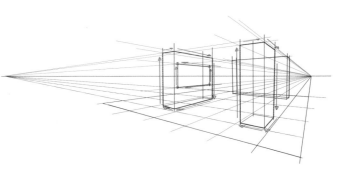

3. From either vanishing point project a new series of lines to intersect with the previously projected vertical lines. This will determine the height of the walls and columns. Just like the rotated plan tutorial (p. 74) the sets of intersecting lines will determine all the edges of the object. Because these objects are rectangular prisms, the geometry is very simple to create.

4. Sketch a bold and continuous outline to define each object and use a lighter line weight for the internal edges. To sketch internal geometry (such as a cavity) on the face of any of the prisms, first sketch the verticals that define the outline edges and then sketch lines from the vanishing point that intersect with these points at the appropriate horizontal heights.

5. The cavity will have radiused corners. In order to create those, sketch either full ellipses at the corners for reference or simply sketch the quarter round corner by eye connecting the straight lines. For the circular banner suspended above the columns and walls, sketch a plane if necessary as a reference for the ellipse. This helps to locate the banner more accurately in space. A second ellipse will be repeated slightly above.

6. With the second ellipse sketched, determine if the banner is to be a full or partial circle and sketch the appropriate verticals to truncate it. Sketch outside edges to connect the two ellipses and close the form. Sketch a single continuous outline to define the back edge. Finally, to add a shadow place a light source above the partition wall and project (as described on p. 125).

PUTTING IT
ALL TOGETHER

Research phase: ethnography

photo caption

8% 13% 2% 2%

75%

Unlimited texting
Limited plan
No #s/m pay per message
Not sure
Phone can't text/teens

MOBILE-eyes

p. #4

Everyday teenagers use their mobile devices to communicate and connect with their network of friends. Parents are often locked out of this technology because the teenager can choose to take a call or reject it. Even sms or text messages can be ignored at whim. Such a scenario causes consternation amongst parents who feel increasingly excluded from their teenagers' lives.

While parents are the ones who pay the mobile phone bill the majority of the time, they feel their children are taken advantage of what appears to be a teen requirement. If a teenager is without a mobile device they are cut off from their peers and often ridiculed for their lack of technology.

How can parents regain the security they desire without impeding on their kid's sense of privacy?

Visual communication

So far the primary focus in this book has been on the micro level – how to create good drawings, renderings and information graphics. The macro level deals with how to put all these components together into a compelling presentation: the story. Central to any good story is its composition: the overall shape and dynamics of the container that holds and connects the individual parts. Whether that story is contained within a single poster, a booklet or projected as a series of connected slides on a screen (slide deck) it is essential that it be designed and formatted for maximum effect. This requires the product designer to understand some of the fundamental issues of visual communication: use of the grid, composition, visual hierarchy, type basics, etc. It also requires greater familiarity with the graphic software that most product designers use on a daily basis (such as the Adobe Creative Suite).

While a good sketch or rendering is critical to the micro reading of a design concept it is only one small piece of a much larger whole. For a presentation to be effective it must have an overall Gestalt: the whole must be greater than the sum of its parts. Digital presentations can be created in a number of different programs. The most common ones are Powerpoint and Keynote, but increasingly designers are creating presentations that can be exported for viewing with Adobe Acrobat as a PDF (portable document format). The PDF has become the de facto file format for graphically rich documents, in part because it handles type efficiently, allows embedding of video and interactive buttons, and its compression engines are very efficient; they make large documents much smaller and therefore easier to share. The PDF is a now a common file format for saving most presentations, including Powerpoint and Keynote.

The basic anatomy of a graphic layout

Let's begin by breaking down a graphic layout into its constituent parts.
A graphically rich page usually organizes 'chunks' of information along the vertical axis (columns) or along the horizontal axis (rows). The head or top of the page is referred to as the header while the bottom of the page is called the footer. Helping to structure these elements is the grid which, although invisible, is present as a set of guides for aligning and spacing elements. Let's place components into the various place-holders to explore the issues more closely.

Fig. 1
The typical presentation layout can be divided into the following structural components, defined either with a grid or without a grid: columns, rows, headers and footers. These are the basic building blocks that can be arranged to bring order and clarity to a document. The grid is the standard structural tool for determining where the components go and for repeating that structure across multiple pages or spreads (double-page units). With a page layout program such as InDesign, a grid can be set up on one or more 'master pages' for ease and speed.

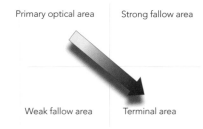

Primary optical area · Strong fallow area

Weak fallow area · Terminal area

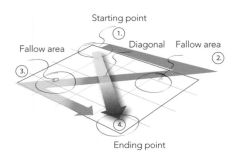

Starting point
1.
Fallow area · Diagonal · Fallow area
2.
3.
4.
Ending point

Fig. 2
The Gutenberg Diagram (top) asserts that a reader's eyes tend to naturally begin reading at the top left corner of a page, moving across and down, which mimics Western reading habits.

Fig. 3
(Right and below) Viewing the presentation board straight on reveals the power a grid has to impose order on a page. It helps to organize the columns and rows for greater consistency. Note the variation in type point size and colour.

The power of composition

American typographer and teacher Edmund Arnold devised a model called the Gutenberg Diagram, which asserts that a reader's eyes fall naturally at the top left corner of a page and move across and down. This diagonal movement of the eye across a page – left to right and top to bottom – mimics Western reading and is referred to as 'reader's gravity'. The key quadrants are therefore the upper left and the bottom right (see fig. 2). The other two quadrants are considered 'fallow' areas to which less attention is paid.

In the illustration below I have added some content in the place-holders established on the previous page (fig. 1) to begin exploring what composition is all about. While there is no such thing as an ideal template, there are basic rules of composition that go back to the ways in which we perceive and pay attention to information. While page composition is typically thought of as a flat two-dimensional activity defined by the x and y axes of Cartesian space, I believe it is essential for the product designer to think of the 'chunks' as having a third dimension or depth. In other words, certain elements on a page need to jump out at the viewer. The most basic way to accomplish this is through the use of colour, size, placement, grouping and orientation.

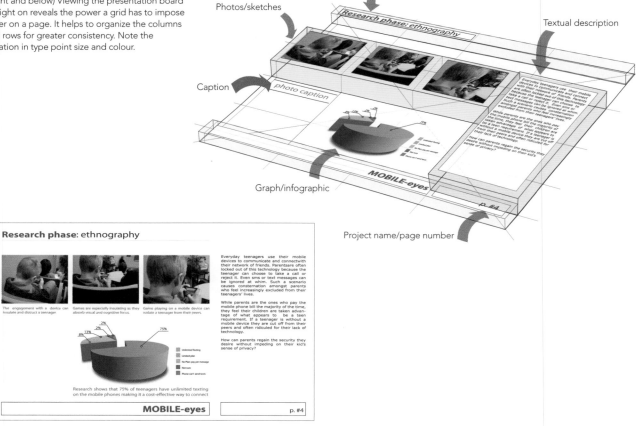

Photos/sketches

Criteria/topic

Research phase: ethnography

Textual description

Caption

photo caption

Graph/infographic

MOBILE-eyes

Project name/page number

p. #4

Row

Hierarchy + size +
colour + style (bold)

Grouping + colour

Column

Row

Row

Row

Row

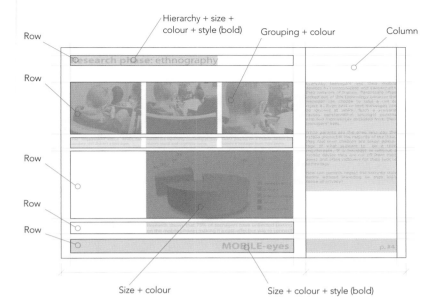

Size + colour

Size + colour + style (bold)

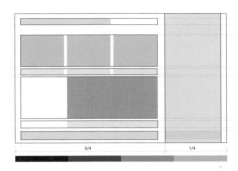

3/4

1/4

Fig. 4
Overlays are applied to the presentation to help clarify the compositional structure. The illustration on the left notates the various elements and their attributes, such as colour, size, style, etc. On the above illustration the columnar and row structures are indicated along with the underlying grid; note the overall proportion is approximately 75:25.

Applying colour to an otherwise white/plain page guarantees it will be noticed. Increasing the font size of a select group of words in a paragraph or the size of an image in relation to other images on the page imparts a sense of priority (think of newspaper headlines). Likewise, placing a chunk of text or an image at the top of the page where the eye tends to land first will increase the likelihood of it being noticed sooner than later. Clustering images together can create blocks or groups that can also draw the eye in more readily. Finally, orientation can impact the way an image is viewed, although this must be dealt with carefully. For example, a text box oriented vertically (90 degrees off the horizontal) will attract attention but may also impair readability, while a colour slug turned vertically may simply balance a composition. Some of the most basic layout fundamentals go back to Gestalt principles like the law of similarity and proximity: similarly shaped chunks will be considered related to each other just as chunks in close proximity are.

Fig. 5
Icons imply more than mere simplified resemblance. These examples, redrawn from signage in London's Heathrow airport, map departing flights along a Western reading bias, and in so doing suggest that departing flights are the primary activity while arrivals are secondary.

Fig. 6
Signage relies on a clear use of hierarchy while leveraging the power of colour: a traffic light, for example, places the red light above the green light even though this puts it slightly further away from the viewer. Our natural inclination is to associate height with importance: stopping is more important than going and red is equated with caution. Presentations like a well-designed book or magazine spread rely on 'reading conventions' or 'reading gravity'.

Compositional strategies

The rule of thirds is a 'rule of thumb' compositional strategy employed by photographers to create dynamic images. Dividing the photograph into thirds horizontally and vertically creates nine equal rectangles and four nodal points (indicated in red in fig. 7 below). Composing an image so that the areas of interest fall on one of these nodal points supposedly creates more tension and energy.

The presentation board (fig. 8) is one of several hand-drill concepts created for Bosch. The composition's 'non-centralized' approach places the largest rendering in such a way that Bosch's logo nearly coincides with the top right nodal point. The second full rendering (upper left) is composed in such a way that the light falls more or less on the horizontal line dividing the upper third of the image. Whether the designer did this intentionally or not is hard to say, but the overall composition is strong.

The layout of a presentation must take into consideration the size of the paper (or, more likely, the aspect ratio of the computer screen and projector) as well as the distance from which the work will be viewed. When creating multi-page documents that will be projected, it is important to lock down repeating elements such as headers, footers, page numbers or anything else that reappears consistently. This will avoid the out-of-registration effect of elements 'bouncing around' from slide to slide. For this reason, most presentation software allows the creation of guides which span the entire slide deck and facilitate quick and accurate composition, but don't display during the presentation.

Fig. 7
(Above and right) The law of thirds divides the photographic image in to three equal rows and columns with the four points of intersection creating areas of interest.

Fig. 8
(Right) This presentation board was created for Bosch by Ignite USA. Its seemingly unstructured layout uses the law of thirds to draw attention to key features of the product.

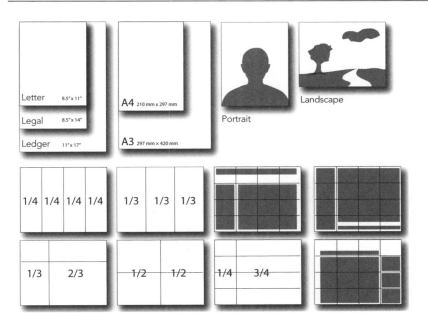

Fig. 9
These examples represent a basic range of strategies for dividing up the space of the page to create generalized zones for placing images or text.

Fig. 10
This illustration is a blank presentation screen with a set of intersecting guides for the slide's centre, as well as a left and top guide for orienting text or images.

Physical constraints

The grid can subdivide a page into very fine divisions or into larger more generalized areas, but it still has to adhere to the various media's constraints: page size and format, and screen aspect ratio. Printed materials, for example, are commonly restricted to A4/A3 or US letter/legal/ledger sizes, whereas plotted material can be printed much larger and cut to a custom size. With printed media the orientation is less of an issue as both portrait and landscape work fine. However, when the presentation is to be projected there are physical constraints: the typical video graphics array (VGA) projector and computer monitor has a landscape orientation so anything laid out in a portrait orientation will not maximize the available space (screen real estate) resulting in black bands on either side. The examples above (fig. 9) demonstrate various ways to divide the page using a standard grid. The possibilities are endless; however, the desired goal is balance and consistency for each page as well as across the entire presentation.

A good presentation is also constrained by time. Few clients want to spend more than 15 to 20 minutes reviewing a proposal or new concept. They expect the presenter to lead them through compelling material in an engaging way: visuals, in other words, are only one part of the process. The story must be conveyed in a confident and focused manner; the visuals simply reinforce or illustrate the speaker's main points. Often a project may have two versions – the printed document and the live presentation. The difference is simple. A print document is meant to be read by a client alone while the live presentation is meant to be seen and heard. A live presentation should condense or summarize excessive text and be spoken, not read, by the presenter. Text, when it is used, should be minimal and be a highlight to a summary. Formatting (composition) is just as crucial in a live presentation as it is in the print version because a client should not have to relearn the structure every time the slide changes.

Useable screen real estate

Useable screen real estate

Fig. 11
The image aspect ratio is the width-to-height relationship of an image, expressed as two numbers separated by a colon. The common aspect ratio of a computer screen is 4:3. Pages using a portrait orientation lose valuable screen real estate (the black areas are the 'dead zone').

Composition at the micro level

Finally, let's look briefly at the micro level of composition: how the designer can compose a sketch or rendering in a manner that leads the viewer's eye through a sequence that emphasizes certain aspects over others. The sketch below by John Muhlenkamp (idsketching.com) successfully demonstrates this. He controls the composition through the manipulation of scale, colour and vantage point to direct the viewer's eye through the space of the paper (fig. 12).

The rendering attracts the eye first because of the isolated use of colour and the higher fidelity. The strap of the backpack and the runner's trainer fall in the centre of the soft grey background and draw the eye to the trainers and the backpack, thus providing greater context. The runner's direction away from the picture plane reinforces the image's depth. The third and final step moves the viewer's attention over to the final chunk – the ideation sketches where a range of views and alternative designs reside, created with no colour and the lightest line weights of the whole composition.

In all likelihood, this sketch rendering would go into a larger presentation where it would have to work together with other elements: a design brief, a research component, a competitive matrix, computer data, higher fidelity renderings and so on. So while the format breaks from the traditional Gutenberg Diagram used for newspapers, magazines and websites, it demonstrates the power of colour, size and hierarchy to lead the viewer's gaze where the designer wants it to go on a micro level. The partial frame in the left-hand corner serves the same purpose as a header or footer, identifying the product and manufacturer's names along with a date. While the possibilities are many the end result will be achieved only through experimentation and a clear sense of the 'story'.

Fig. 12
This presentation board effectively leverages scale, colour and proximity to help lead the viewer's eye intentionally through a specific sequence.

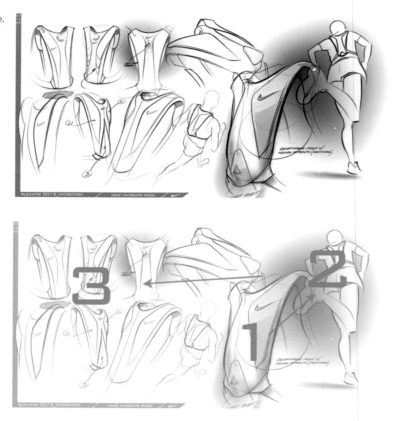

Conclusion

A lot of ground has been covered in the past eleven chapters, including history, psychology and a logical progression of sketching, rendering and presentation techniques. What ties all of this together are a few simple ideas, which are summarized here:

1) The past remains connected to the present despite advances in technology.
2) Drawing, while increasingly done in the computer, still requires analogue knowledge.
3) Ambiguity, while a good thing in early ideation, should be avoided as the fidelity is increased.
4) Sketching, though illusionistic, has a very direct connection to real space.
5) Line weight is an additional layer of meaning without which a drawing remains very flat.
6) Colour, shade and shadow are critical components for higher fidelity concepts.
7) Information needs to be visualized in ways similar to good sketching.
8) Finally, presentation is very important because it's the glue that holds everything together.

There are no 'secrets' or 'cookie cutter' approaches to presentation or sketching and rendering. The theory and practice contained within these chapters and tutorials have been intentionally woven into a much larger story so that the design student begins to see all the aspects of design visualization as interconnected. However, students must internalize (generalize) the lessons learnt in the book and begin to apply them to their own work because mastering a tutorial is not the ultimate goal. The real goal is to enable both sides of the brain to work together in a creative and analytical manner.

Drawing a product requires visualizing a problem and then visualizing and explaining the possible solutions. Doing this repeatedly will build the physical and mental muscles required to see what is not yet there: the future.

Tutorial

Creating a presentation

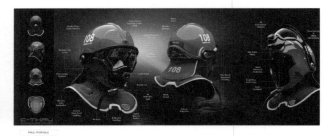

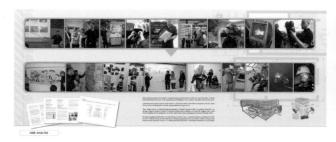

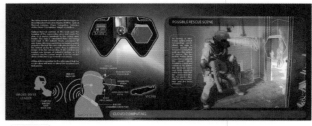

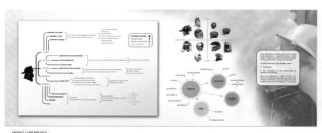

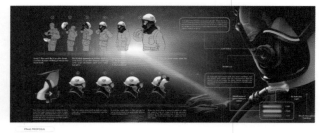

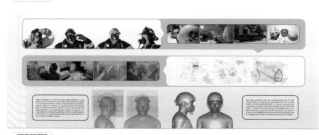

Omer Haciomeroglu's presentation demonstrates a range of strategies for presenting a complex product design project. The C-THRU Smoke Diving Helmet was designed while completing the post-graduate Advanced Product Design programme at the Umea Institute of Design. The 10-week project required the designer to work in cooperation with the Umea Fire Brigade. The studio's focus was on emotional design and required a deep analysis of the motivations, habits, work life and personal life of firefighters to determine potential unmet needs on the job.

Except for the front page, the layouts tend to favour a symmetrical approach with either two and three columns or two and three rows. And while there is no strict reliance on a single underlying grid, there is a consistency that makes the presentation easy to understand. Software on the project included Alias, Hypershot, Photoshop, Illustrator and InDesign to assemble the final presentation, which was then exported as a seven page PDF. On the following page is a brief analysis of specific parts of the presentation including formatting and other visual assets.

Small column Large column (1 unit high x 2 units long)

Page title

'Hero shot' window Footer

1. The first page of the project consists of a hero shot of the product rendered in a typical scene. The page is composed of two columns: one large window for the contextual shot and one small window which serves as an informational panel. The page layout includes a footer (used throughout the presentation) with a description for continuity and easy navigation.

2. The larger column is made up of two equal-sized squares with the fireman centred in the first box for maximum effect. The product name, in a modern sans serif font, is centred at the top of the information panel in all caps. The font colour is an appropriate deep red. The smaller informational text briefly describing the project is a grey sans serif font.

1 column (half of page) 1 column (subdivided into 2 chunks)

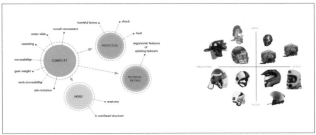

3. The product /user research page is split in half with a large mind map on the left listing the considerations a firefighter must weigh in the line of duty. The right half has two smaller diagrams used to help identify the potential problems to be explored. All of the diagrams have been laid on top of an evocative photo of a firefighter engulfed in fumes.

4. Two of the three diagrams have been isolated on this page for discussion. The first resembles a traditional mind map creating linkages between four criteria: head, comfort, protection and technical details. This vector map uses radiating lines, arrows and colour to create connections. The second diagram is a four square matrix comparing head gear.

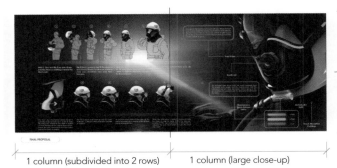

1 column (subdivided into 2 rows) 1 column (large close-up)

5. This page employs a symmetrical layout split approximately down the middle of the page. The left-hand side is cleanly split into two rows with two sequences of process-oriented visualizations. The upper sequence is a mixture of vector outlined figures and raster-based photoreal renderings. The lower sequence consists of photoreal orthographic side view renderings.

6. The use of a central axis to split the page in two to create opposing zones reinforces the micro/macro reading (long shots and close-ups). The large cropped image on the right provides enough visual information to merit numerous call-out details to help understand the product more thoroughly. The background colour reinforces the difficulties faced by firefighter every day.

Glossary

A

Additive process Forms are added to existing objects to expand and focus their function or appearance.

Algorithm A process or set of rules to be followed in calculations or other problem-solving operations.

Articulation Articulating products have moving parts that allow them to be transformed, for example, a hinge on a container.

B

Boxing-in Sketching the basic envelope that the object occupies in space.

C

CAD Computer-aided design.

CAM Computer-aided manufacturing.

Cartesian axes Three intersecting axes – called x, y and z – that correspond to the three dimensions of length, height and depth.

Cartesian node The point at which the three Cartesian axes meet.

Compound curve A double curve.

Contextual cue An easily recognizable and appropriate object placed in a sketch to provide information on scale and use.

Contour line The contour line is an artificial line – a drawing convention to help explain and visualize form. In sketching, contour lines are useful for visually describing compound curvature and organic forms.

D

Dominant view The view than an object is most recognizable from, for example, the side view of a car.

E

Emotional line A type of line used in sketching to convey ideas expressively.

Envelope The cubic volume that a full object occupies in space.

Exploded view An assembly with all its components exploded apart along one or more of the Cartesian axes.

Extrusion A design technique whereby a sketch is pulled along the z-axis to create a 3D form, for example, extruding a 2D circle will result in a cylinder.

F

Filleting A common CAD operation whereby the transition between two adjoining surfaces is softened typically with a third surface tangent to the existing surface.

Foreshortening The visual phenomenon whereby an object projected forwards and closer to the line of sight appears shorter when compared to other views.

G

Geons (geometrical icons) A visual library of simple shapes, such as cubes, cylinders and cones, which combined, can create millions of recognizable objects.

Gestalt psychology A German school of psychology that explored the visual and cognitive mechanisms behind pattern recognition, and subscribed to the theory 'The whole is greater than the sum of its parts.'

Ghosting Not to be confused with 'ghost lines', this is the process of changing the opacity of the product's housing in order to reveal internal components. For example, revealing the engine inside a car.

Ghost lines An initial set of sketched lines, laid down so lightly that they are barely visible. Ghost lines provide scaffolding for the drawing.

Glass box metaphor A metaphor used to demonstrate how each view in an orthographic drawing is projected from the object parallel to the opposite face of the glass box that theoretically encases it.

H

Hatching A series of lines indicating shade cast on an object or as part of a shadow. Generally used to quickly convey initial ideas.

High fidelity Refined and realistic sketching – including colour, highlights, shade and shadow.

Horizon line (HL) A horizontal line across a perspective sketch; its placement determines the viewer's vantage point. Vanishing points are situated on the horizon line.

I

Isometric drawing In isometric drawing, the three primary planes (top, front and side) are visible and parallel lines on the object are depicted as parallel in the drawing.

L

Lofting Lofting is a CAD procedure involving connecting together multiple sections or sketches on various planes to create a single surface – usually a compound curved surface.

Low fidelity A simple and unrefined sketch. A recognizable doodle is considered low fidelity.

M

Major axis The longest diameter of an ellipse; this always bisects the minor axis at a 90-degree angle.

Minor axis The shortest diameter of an ellipse; this always bisects the major axis at a 90-degree angle.

Modelling Highlights, shading and shadow.

O

Optical occlusion The phenomenon whereby the edges of an object that are not visible to the eye are still understood by the brain to exist, and can be included in a sketch.

Orthographic system Assumes that the viewer is infinitely far away from the object so that only one of three planes can be seen, along with anything that is parallel to that view. There is no distortion, which means the various views provide accurate dimensional information for construction. The convention is to display a top, front and side view that are aligned.

Outline A continuous line that defines the outer boundaries of an object.

P

Partial section A partial cut through an object in two directions (length and width) that reveals an important internal element.

Parting line The parting line refers to the boundary edge where the two halves of a mould come together, resulting in a visible line.

Perspective drawing Perspective drawing is closest to the way humans naturally perceive the world. In perspective, the three primary planes (top, front and side) are visible and all parallel lines on the object recede to either one or two vanishing points (situated on the horizon line).

R

Rapid prototyping Prototypes rapidly formed on advanced machinery using CAD design data.

Revolve A CAD procedure involving a 2D sketch that is rotated around an axis to create a 3D form. Half a circle revolved around its centre will result in a sphere.

Reading gravity The natural movement of a reader's eye across a page, from top left to bottom right.

Rule of thirds The rule of thirds divides an image or page into three equal rows and columns with the four points of intersection creating areas of interest.

S

Scaffold metaphor The 'scaffold' or reference necessary to sketch confidently in illusional three-dimensional space. The scaffold might be a quickly sketched plane or a section accurately placed on a transparent plane.

Section cut Allows the designer to cut through an object or space and peer inside. Sectioning may be thought of as slicing through an object at any angle to reveal what lies beneath the external 'skin'.

Sequencing Using sequential images to reveal how an articulating object moves or how a 'time-based' interaction unfolds over time (temporally).

Shape invariance The human ability to recognize objects regardless of the vantage point from which they are viewed.

Shape morphology Manipulating form through sketching or computer modelling by adding to, subtracting from, or otherwise 'morphing' form through manipulation.

'Sketching through' Sketching through objects as if they are transparent is an accurate way to visualize and ground them.

Subtractive process Morphing an object by removing material to focus or define it.

Sweep A CAD procedure resulting from the interaction of two sketches: a profile sketch and a path. The sketch profile tracks along the path to create a complex form.

T

Torus CAD terminology for a doughnut-shaped geometric form.

V

Vanishing point (VP) Points positioned on the horizon line of a perspective drawing to which all lines on the object must recede.

Vignette A drawn partial frame intended to set off a sketch on a sheet of paper or computer screen and create a greater illusion of depth.

W

Wireframe A CAD technique for representing 3D objects, where all surfaces are visibly outlined including internal components and surfaces that are normally hidden from view.

Index

Numbers in bold refer to illustrations

Index

Picture credits

Unless otherwise stated all drawings featured in the book have been created by the author. The author and publisher would like to thank the following institutions and individuals who provided images for use in this book. In all cases, every effort has been made to credit the copyright holders, but should there be any omissions or errors the publisher would be pleased to insert the appropriate acknowledgment in subsequent editions of this book.

Front cover
Evan Solida's Rael concept bicycle

Back cover
Nelson tool sketch by TEAMS Design, Chicago

Introduction
p7 Fig. 1 courtesy HLB Boston
p8 Fig. 2 courtesy IDEO; Fig. 3 (left to right, top to bottom) courtesy Michael DiTullo for Converse; courtesy Bill Verplank; courtesy Daniel Lipscomb, Fiskars USA
p8 Fig. 4 courtesy Gravity Tank; Fig. 5 courtesy Emiliano Godoy
p9 Fig. 6 courtesy Teague Design

Chapter 2
p31 Fig. 15 serving plates by Crucial Detail. Photos: Lara Kastner
p37 Figs 24 and 25 sketches © Cooper, San Francisco

Chapter 3
p43 Fig. 1 courtesy IDEO
p44 Figs 2 & 3 courtesy Dave Gray @ Xplane
p45 Fig. 4 courtesy Bill Verplank; Fig. 5 © Dan Roam 2010 www.backofthenapkin.com
p46 Fig. 6 IDEO's Palo Alto office, courtesy IDEO
p47 Figs 7 & 8 RKS Design for Zyliss
p52 Fig. 18 courtesy Greg Clark
p50 courtesy HLB Boston

Chapter 4
p76 Sketches by Josh Handy, Method. Other images courtesy Method

Chapter 5
p90 Fuseproject's Mission Motorcycle
p92-93 sketches and process photos of Myto chair courtesy KGID
p94-95 sketches and photos of Mission One Motorcycle by Yves Behar and fuseproject

Chapter 6
p101 Fig. 8 ÑOM ÑOM ÑOM, designed by Emiliano Godoy
p107 Fig. 19 Michael DiTullo for Converse
p108-109 Mario Bellini for Olivetti

Chapter 7
p116 Mission One Motorcycle by fuseproject
p120 Fig. 8 courtesy TEAMS Design, Chicago
p121 Fig. 11 Microsoft Arc mouse by One and Company, San Francisco
p122 Fig. 14 courtesy Astro Studio, San Francisco
p123 Figs 15 & 16 courtesy TEAMS Design, Chicago
p124 Fig. 17 Scott Wilson for Nike; Fig. 18 Matthew Boudreau for Reebok
p125 Fig. 21 courtesy Omer Haciomeroglu
p126 Fig. 22 courtesy TEAMS Design, Chicago; Fig. 24 courtesy Daniel Lipscomb, Fiskars USA
p127 Figs 25 & 26 Philippe Starck for Kartel
p128 courtesy Dyson
p129 courtesy Vessel Ideation

Chapter 8
p134 Fig. 3 Maarten Van Severen for Vitra
p135 Fig. 4 Maarten Van Severen for Vitra
p138 Vico Magistretti for Artemide
p140 Polyphemus flashlight by Emilio Ambasz
p142 Mayday lamp by KGID
p144 Alberto Meda's Titania Light fixture for Luceplan
p146 Product shots and early form study model courtesy Mario Bellini
p150 Panton chair by Verner Panton, photo courtesy Vitra
p152 Vållö watering can by Monika Mulder for IKEA

Chapter 9
p157 Fig. 2 sketches courtesy Emiliano Godoy
p158 Fig. 3 courtesy Daniel Lipscomb, Fiskars USA; Fig. 4 Chuck Harrison for Casco
p159 Fig. 6 © Edward Adelson
p164 Fig. 20 courtesy Radius Design, Chicago; Fig. 21 TEAMS Design, Chicago; top right and fig. 22 © Thomas Maguire
p165 Fig. 23 Michael DiTullo for Converse; Fig. 25 courtesy Bosch
p166 Fig 26 courtesy Morrow Design, Chicago; Fig. 27 courtesy Astro Studios, San Francisco
p168 Fig. 37 Ignite USA, Chicago for Bosch; Fig. 38 Michael DiTullo for Converse
p176-177 courtesy Daniel Lipscomb, Fiskars USA

Chapter 10
p178 Sketches and photos courtesy Insight Product Development, Chicago, and Herman Miller
p180 Fig. 3 courtesy Dyson; Fig. 4 courtesy Astro Studios, San Francisco; Fig. 6 courtesy TEAMS Design, Chicago
p181 Fig. 8 courtesy Astro Studios, San Francisco
p183 Fig. 14 Michael DiTullo for Converse; Fig. 15 courtesy Daniel Lipscomb, Fiskars USA
p184 Fig. 18 courtesy Golden Section, Berlin; Fig. 19 courtesy Gravity Tank
p185 Fig. 20 courtesy Cooper, San Francisco; Fig. 21 courtesy Nokia
p.186 courtesy Dyson
p187 courtesy Golden Section, Berlin
p190 courtesy Nimlok, Chicago

Chapter 11
p198 Fig. 8 Ignite USA for Bosch
p200 Fig. 12 courtesy John Mohlekamp, idsketching.com
p200 All images courtesy Omer Haciomeroglu

Further reading

Bramston, David, *Basics Product Design: Visual Conversations*, Ava Publishing 2010

Campos, Christian, *Product Design Now*, Collins Design 2006

Clay, Robert, *Beautiful Thing: An Introduction to Design*, Berg 2009

Duff, Jon M., and Greg Maxson, *The Complete Technical Illustrator*, McGraw Hill 2003

Eissen, Koos, and Roselien Steur, *Sketching: Drawing Techniques for Product Designers*, 5th printing, BIS Publishers 2007

Eissen, Koos, and Roselien Steur, *Sketching: The Basics*, 1st edition, BIS Publishers 2011

Giesecke, Frederick E. et al, *Technical Drawing*, 12th edition, Prentice Hall 2002

Gill, Robert W., *Basic Rendering: Effective Drawing for Designers, Artists and Illustrators*, Thames & Hudson 1991

Gill, Robert W., *Perspective: From Basic to Creative*, Thames and Hudson 2006

Hannah, Bruce, *Becoming a Product Designer: A Guide to Careers in Design*, 1st edition, Wiley 2003

Hudson, Jennifer, *Process: 50 Product Designs from Concept to Manufacture*, 2nd edition, Laurence King Publishing 2011

Koncelik, Joseph A., and Kevin Reeder, *Conceptual Drawing*, 1st edition, Delmar Cengage Learning 2008

Lefteri, Chris, *Making It: Manufacturing Techniques for Product Design*, Laurence King Publishing 2007

Lidwell, William and Gerry Manacsa, *Deconstructing Product Design*, Rockport 2009

Milton, Alex, and Paul Rodgers, *Product Design*, Laurence King Publishing 2011

Morris, Richard, *The Fundamentals of Product Design*, 1st edition, Ava Publishing 2009

Pipes, Alan, *Drawing for Designers*, Laurence King Publishing 2007

Robertson, Scott, *DRIVE: vehicle sketches and renderings by Scott Robertson*, Design Studio Press 2010

Slack, Laura, *What Is Product Design?* Rotovision 2010

Terstiege, Gerrit (ed), *The Making of Design: From the First Model to the Final Product*, 1st edition, Birkhäuser Architecture 2009

Ulrich, Karl, and Steven Eppinger, *Product Design and Development*, 4th edition, McGraw-Hill/Irwin May 2011

Wallschlaeger, Charles, and Cynthia Busic-Snyder, *Basic Visual Concepts and Principles for Artists, Architects and Designers*, 1st edition, McGraw-Hill 1992

Author's acknowledgements

The best part of writing this book has been channelling the insights of so many smart, talented and generous people into a new and much needed narrative about design visualization. Indeed writing a book gives one a bit of licence to shoot off the anonymous email or phone call and ask what might be an ill-formed question. In every case, my queries were met with both grace and patience. In the process I made a lot of new friends including: cognitive scientists, researchers, interaction designers, experience designers, information architects, historians and technologists. One goal in writing the book was to connect the various ways in which the design process is visualized: from research to final presentation. If I've succeeded it's due in large part to the contributions and comments of those listed below who encouraged me to think more holistically about every aspect of the process…. and to connect the dots.

Let me begin by thanking everyone at Laurence King Publishing who tolerated an extremely slow and fastidious first-time author – especially Sophie Drysdale and Gaynor Sermon. The next group includes scientists like Charley Chubb (University of California Irvine) who helped me to understand some of the fundamentals of cognition early on; Don Norman who graciously answered countless questions on psychology and whose own writing has been a constant inspiration; Barbara Tversky whose crystal clear writing, email exchanges and conversations helped shape my thinking; Edward Adelson whose theories of colour perception were vital to my explanations of rendering; and Bill Verplank who talked and sketched simultaneously like only he can do.

The remaining list include designers, historians, comic book artists, researchers, assistants and everyone in between: Victor Margolin, Jim Elkins, Dave Cronin (Cooper) Gretchen Anderson (Lunar Design); Ivan Brunnetti, Chris Ware, Scott McCloud, Michelle Looney (HLB), Elizabeth de Montfort Walker (HLB), Joey Nakayama (HLB, Gravity Tank), Paul Hatch (TEAMS Design), Craig Berman (Gravity Tank), Jan Schwochow (Golden Section), Josh Handy (Method), Daniel Lipscomb (Fiskars, USA), Michael DiTullo (Converse, Frog), Jane Fulton Suri (IDEO), Emiliano Godoy (Godoylab), Martin Kastner (Crucial Detail), Dan Roam (Digital Roam), Dave Gray (XPlane), Chris Glupker (RKS), Greg Clark, Omer Hacıomeroglu, Lorenza Cappello, Yves Behar (fuseproject), Scott Wilson (MNML), Konstantin Grcic (KGID), Tony Ruth (Vessel Ideation), Phillipe Starck, Matthew Boudreau (Reebok), Kyle Swen (Astro Studios), James Dyson, Katharina Weisflog (Vitra), Vico Magistreti (Flos), Bradley Whitermore (Emilio Ambasz & Associates), Alberto Meda, Corin Assenzio (Artemide), Anna Re (Mario Bellini Architects), Christine Soner (IKEA), Monika Mulder (IKEA), Chuck Harrison, Dan Ramirez (Radius Design), Thomas Maguire, Chandra Lewis (Bosch), Jim Morrow (Morrow Design), Evan Ward (Ignite USA), Tara Prasad (Insight), Steve McPhilliamy (Insight), Tarja Österberg (Nokia), Jacqueline Latour (Nokia), Katie Wharton (Nokia), Dave Fugiel (Nimlok) and John Muhlenkamp (idsketching.com).

My final thanks go to my parents, Tom and Nancy Henry.